NORMAN COLQUHOUN

painting : a creative approach

A GUIDE TO MODERN METHODS AND MATERIALS

[*formerly titled:* Paint Your Own Pictures]

second revised edition

Dover Publications, Inc. / New York

Published in Canada by General Publishing Company, Ltd.,
30 Lesmill Road, Don Mills, Toronto, Ontario.
Published in the United Kingdom by Constable and Company, Ltd.,
10 Orange Street, London WC 2.

This Dover edition, first published in 1969, is a revised
and enlarged republication of the work originally published in 1953
by Penguin Books Ltd., Harmondsworth, Middlesex, England
under the title *Paint Your Own Pictures*.

Standard Book Number: 486-22000-1
Library of Congress Catalog Card Number: 68-21280

MANUFACTURED IN THE UNITED STATES OF AMERICA
Dover Publications, Inc.
180 Varick Street
New York, N.Y. 10014

preface to the dover edition

This is a revised edition of the book originally published in England in 1953 by Penguin Books under the title *Paint Your Own Pictures*. This title, however, no longer seems appropriate; it implies a routine, purely constructional approach to painting, whereas I have been at pains to emphasize a personal and creative approach. Hence the new title, *Painting: a Creative Approach*. I have taken advantage of this edition to incorporate other changes. Sections have been added on new materials, such as 'plastic' paints, which were not in use when I wrote the book, and I have made numerous revisions throughout the text (the book was originally written at a time of severe shortage of materials following World War II). Subheadings to chapters have also been added, as these are an aid to quick reference, especially in the technical sections, and a general index has also been incorporated, without, however, dispensing with the glossary of technical terms at the end of the book.

This new edition, therefore, is not a reprint of the old but has been completely reset in a new format and is much improved in presentation. In all essentials, however, the original text remains intact, for with the lapse of time I have had no occasion to make alterations in principle.

June, 1968 NORMAN COLQUHOUN

contents

introduction

This is a book for those who would like to paint, but have no idea how to begin; and perhaps more especially for those who mistrust their ability even to make a start. Of course this book won't teach anyone to paint: no book can do that. But it aims to clear away some of the initial difficulties, and set the reader on a path which he can henceforth discover for himself.

The only assumption made is that the reader knows nothing about how to paint. Otherwise it is assumed that he is very much like other people, and that when he essays anything for the first time he does so with considerable misgivings and some apprehension. These are real obstacles. In many cases they are sufficient to prevent a person from venturing into the field of painting at all, and thus deprive him of an activity which might be the source of great happiness. The real difficulties of the beginner are not so much inherent in the materials and the medium, as in himself and his mental approach.

So important is this point considered to be that it will largely dictate the form of the book. We are not going to treat the subject of painting as divorced from the individual who paints. He is approaching something for the first time, and the degree of confidence he can have in doing so will be all-important.

To those who feel particularly apprehensive of their ability to paint — and this perhaps includes the majority of would-be painters — a word of encouragement may be given at the outset. In the author's experience it is precisely the people who most mistrust their abilities at first who ultimately do well. When once the initial fears are dissipated and a start is made, a new world of pleasure is opened which would have seemed impossible before. No one should be deterred if he failed abysmally at school and feels that he 'cannot draw to save his life': strangely enough these are often encouraging rather than discouraging signs.

1

It is assumed that we wish to paint simply for our own pleasure. We do not intend to make a living out of painting, and this book is not written for the commercial artist or even for the art school student. We have no illusions about producing masterpieces, and are not attracted by the idea of starving in a garret. It may be that we are getting on in life and have already formed the essential pattern of our existence. We may have a somewhat humdrum job, but nevertheless it is our livelihood and we certainly harbour no romantic notions of giving it up. Yet we feel — perhaps only in some vague way — that we would like to paint.

Let us clear away one difficulty at once. We may say that we are not 'artistic.' But this book is not written for artistic people. Indeed it is one of the assumptions of this book, which will be considered more fully later on, that no 'artistic' faculty is necessary in order to paint, if by artistic is meant some special endowment or flair for the arts. Painting may be undertaken as a serious activity by people who have never considered an artistic preoccupation to be their *métier*.

I use the word 'serious' deliberately. Just because we are going to paint for pleasure, it does not follow that our work is not to be taken seriously. To be serious it is not necessary to be solemn; indeed solemnity is often an assumed attitude, a kind of camouflage for what is essentially frivolous. Let us rid ourselves at the outset of what may be called the 'museum' attitude to art, the sort of attitude which places art on a pedestal above the ordinary experience of man — out of reach, as it were, and dehumanized. Art is, on the contrary, part of the experience of each one of us, heightened and expressed in its most intense form. It enriches our humanity, raising our common experience to new levels of achievement and bringing a widened significance to life. More will be said of this later on. Here it is merely the intention to dispel the idea that art is a sacrosanct activity confined to a favoured few, and that it is something in which the ordinary person had better not actively participate. Not many of us will become artists in the sense in which creation becomes an overriding passion and a life-work; but what we can do is something which is of the nature of artistic activity and which will enormously enlarge our understanding of all that the world of art has to offer us.

Few people realize the vast field of experiment and achievement which lies before them in painting. Here is a recreation which

stimulates the mind and at the same time calls into being the instinct for using and shaping materials. It satisfies both eye and hand, and brings into play our capacities for discernment, observation, and judgment. The medium of painting has a fascination all its own. It offers untold possibilities of refinement and subtlety, and yet adapts itself to the requirements of differing temperaments. Although its secrets may take a lifetime to win, it casts a spell from the beginning; and it is hoped that this book will be the means of introducing its pleasures to many who, for one reason or other, have so far passed them by.

Everything that we do simply for the pleasure of doing it, without thought of an ulterior objective, becomes invested with a certain form which, ultimately, derives from personality and so is a symbol of unalterable human values. In this way painting can become much more than a mere pastime or time-absorbing occupation; it touches the life of the spirit, and may have a rôle to play in promoting well-being and health. One of the diseases of our civilization is boredom. In the midst of ceaseless rush and activity the spirit is starved of the real satisfactions, and seeks solace in manufactured entertainment which evokes no creative response in us. Painting, by contrast, can become a recreation in the true sense of a re-creation of the spirit through its own resources.

The reader will not find in the following pages a mass of rules by observing which he will be induced to paint in a certain style. The method adopted is intended to leave full scope for the development of his own individuality, and will consist of broad, general lines of procedure which he can adapt to his own ends. Too often the beginner is expected to master a series of hard and fast conventions, directed to the formation of a definite manner of painting which may be far removed from what it is in his nature to do. More disastrous still, it is possible that by dint of sheer labour and exertion he may succeed in moulding himself to such a remote pattern, and then find that he cannot escape from it.

It is also important that the beginner should not unconsciously set himself an equally rigid set of rules by his own preconceived idea of the ends to which he must work. If he does so he is likely to be disappointed if he does not achieve his intentions, and if he does achieve them it may be that they are formed on a conventional pattern which he has prescribed for himself from only a casual acquaintance with pictures.

I would only ask the reader therefore at this stage to approach the subject in as simple and 'unattached' manner as possible. One cannot, of course, divorce oneself from one's predilections all at once, but as far as possible he should regard the whole matter as an approach to a new kind of adventure.

1 □ the fear of painting

It is a commonplace to say that what is unknown is often the source of unreasoning fears, and this is never more true than when the unknown is some subject of study of which we stand in ignorance — despite, it may be, our efforts to come to terms with it in the past. Perhaps it is true that to say we find any subject or activity 'difficult' or 'impossible' is just another way of saying we have a dread of it. Certainly the effects of fear are crippling, withering, and wholly negative. It dams up the flow of our energies, deprives us of incentive, and induces a state of mind in which no kind of achievement is possible. More important still it deprives us of that delight in a subject which flows naturally from a sense of achievement, and by doing so stultifies our efforts and turns what should be pleasure into a dreadful labour. Not until this fear is removed are we in a position to do justice to ourselves.

I have found again and again that people have within them resources of creativeness which they never dreamed of, and which painting is the very means of drawing out. It is no doubt only one means, but its directness and colourfulness give it an immediate appeal; and though he would be a bold person who said that 'anyone' can paint, yet I am convinced it is true that anyone who has any desire to do so can paint. It is also true that I have known many people who had no initial inclination in this direction, who began more in a spirit of devil-may-care than anything else, who nevertheless discovered a permanent interest in this kind of expression.

The fear associated with painting is quite easily understood, but may take various forms. It may be well to consider some of these.

Many people have a horror of painting because they feel, somehow instinctively, that their results will be revealing, that they will 'give themselves away.' It is curious that this should invoke any special fear, for is it not true that we give ourselves away, in this sense, by everything we do? No doubt our friends see us as very

5

different people from what we imagine ourselves to be. All our actions are revealing to a discerning person, and painting is no more revealing than the others. But why, in any case, should we be afraid to give ourselves away? The policy of holding on to ourselves, of isolating ourselves, as it were, in a strong-room, is itself revealing enough; and it is only by giving ourselves wholly to the activity in hand that we can become absorbed to the extent of identifying ourselves with it.

There is also the feeling that, at any rate when we are beginning, we may be in danger of making fools of ourselves. No one wants to be made a fool of, or to become an object of ridicule. But in painting this does not arise; it simply is not relevant. We shall see later on that we cannot put down colours, lines, and shapes on paper in our own way without doing something perfectly logical and understandable, and at the same time creating something of interest. Such is the nature of things that by this procedure we create relationships of real value, and anyone who can find in this an occasion for ridicule is merely revealing his own lack of knowledge and understanding. It is when we try to be clever, to do the spectacular, to display any powers we may have for slickness in copying, that we do something, not indeed ridiculous, but lacking in meaning.

There is a fairly common belief that in order to paint one must be a 'born artist,' or at least born with a special gift which some people have, and others have not. If you happen to be deprived of this faculty, so the argument runs, it is no use trying. No one of course would deny that genius is a special endowment. No doubt Rembrandt was born with powers which are denied to the majority of people, and it is vain to suppose that mere application to work can compensate for lack of the original and essential germ of greatness. But we are not here concerned with genius, which in any case is a law to itself; and so far as the majority of us is concerned I am sure the argument is false. Ability to paint does not depend on any special endowments, or rather it depends on endowments which we all possess but which are so often unrecognized. This is well shown by the fact that all children paint, almost by a natural instinct. Have we forgotten that at one time we probably painted ourselves, and did so with gusto and abandon; and that if we did not, it was only because we were never given the opportunity to do so? And we painted then, not because we were children, but because in this respect we had no fear. Children are quite unin-

hibited in the use of colours, are unconcerned as to any interpretations which may be placed on their results, and are completely absorbed in their work while it lasts. If adults could attain to this degree of abstraction from their surroundings and be equally unconcerned, they would paint as readily.

Now this quality of creativeness is possessed by young children, but when they get older something happens: they lose their spontaneity, their freedom and their originality, and instead they exhibit in various degrees the ability to copy objects placed before them. And now the element of boredom enters into their work, for this copying process is dead before it starts — dead, because it has not grown out of but has replaced a living process. What accounts for this total extinction of creativity, and of painting for the sheer delight of doing it? It is simply that with increasing awareness of our adult world children become self-conscious, and with self-consciousness comes the element of fear, and so the vicious circle is born. The natural flow of creativeness stops, often never again to be revived; but we must not for this reason suppose that it is eradicated. It is smothered under forces which for most of us are overwhelming; but if we can rid ourselves of fear we can again capture all the excitement of painting which as children we achieved by instinct.

Let us not be deceived into thinking that in doing this we are being childish. An adult paints with an adult's awareness and consciousness; but this does not mean that there is not much we can learn from the directness and spontaneity of children. Too often we associate the idea of maturity with complexity, as if to act in a simple way were childish, and so we create difficulties for ourselves.

This brings me to a further question of age. A person who has say passed middle life is sometimes inclined to think that he is too old to start painting, because at that age he feels he cannot break new ground. Let me say at once that in the course of an experience which has brought me in contact with people of all ages, I have never found that age in itself is any obstacle, except in so far as people are convinced that this factor is against them. Once we have convinced ourselves of a disability like this, a real disability is created; but it is purely of our own making and is not inherent in the circumstances themselves. The fact is that no age limit exists. The illusion that there is such a limit is self-imposed, and arises at any age when we close up our shutters and say we are 'too old.' There is for example the case of Alfred Wallis, a rag-and-bone man

of St Ives, who did not start painting until he was over seventy, and then began entirely on his own, without instruction of any kind, using the familiar scenes of boats and harbours for his subjects and familiar materials for his medium — pots of paint and pieces of wood and cardboard. Yet he created a delightful world from these familiar things.

There are people who meet any challenge to a new activity by saying that they do not like to attempt anything unless they can do it well. They set before themselves a rigid standard of perfection. They like to shine at everything they do, and would rather not venture into a new field than risk failure in it. Such an attitude easily becomes a hindrance. It presents another aspect of fear, of holding back; and a person who on this account refuses to take a risk in an unknown activity is merely allowing reasonable caution to become a stumbling block. He will miss the spur of adventure in unknown paths, because he prefers to keep to those which are well tried and in which he feels himself secure.

There is here a wrong orientation of attitude. We are inclined to fasten our attention on results, as if they were the sole end of our activity; but if instead we were to concentrate on what is to be gained in the doing, we should find that the results can, and will, look after themselves. I do not suppose that the masters of the past, and the greatest least of all, have been satisfied with their results. In some cases they have shown an almost ruthless lack of interest in their paintings once they had finished them. They did not set out to paint masterpieces, but to gain new insights into nature; the masterpieces came by the way, but their reward lay in the process of discovery.

What is a real hindrance to many people is the fact that they were considered a failure at school. So often have people said to me that they were 'no good at school,' and have subsequently revealed a genuine capacity for creativeness, that I have come to regard such a statement as an encouraging sign. One gains the impression that a majority of the present generation have passed through art classes at school conducted on the old lines. For the generation now growing up things are no doubt improved. But the adult to-day who says that he had no success in drawing at school is merely saying that he failed at something in which to succeed might well be no occasion for satisfaction. 'Art' consisted mainly in using a pencil so as to put on paper a fine line which reproduced as accurately as possible the

shape of some symmetrical object, such as a vase, presented in front of the class. Mathematical instruments, the most obvious way of achieving this task, were banned; but proportions could be gauged by holding the pencil at full length from the eye and measuring off with the thumb along its length. By dint of repeated soundings of this kind some semblance of the vase's shape could be reproduced, but usually the results were dismally 'out.' The fact that the whole procedure was quite unconnected with a person's experience of a vase did not seem to be of importance. More often than not painting was not essayed at all, but if it was it consisted in 'filling in' with colour the spaces between the boundaries which the pencil line had previously made.

Whatever failure may mean in regard to these activities, it certainly does not indicate an inability to paint. Indeed it may be said to have no relevance at all to painting. What however is more significant is that success may even be detrimental, for success in a mechanical process may blind a person to the wholly different approach required in a creative one. And anyone who has acquired the knack for illustrative sketching with a pencil may find that, when he comes to paint, he tends to think in terms of his pencil lines and the kind of detailed effect which is obtained characteristically with a pencil, and we shall see later on what difficulties this may bring in its train.

Closely allied to this question of failure at school is another commonly expressed difficulty, that which is contained in the statement 'I cannot draw.' This means in effect that the person concerned is conscious of having been entirely unsuccessful in reproducing the vase at school — a fact which should really give grounds for hope. But it does nothing of the kind; indeed drawing is, of all the difficulties of the beginner, the most formidable, for it is seen as the one thing needful, and the simple statement 'I cannot draw, therefore I cannot paint' seems to put an end to the matter.

The whole difficulty arises out of a limited conception of the nature of drawing. It is taken for granted that drawing is essentially a process of reproducing the external world by the use of lines on a flat surface. To do this one has to consider the optical laws by which the human eye registers objects, and it is always assumed that we remain in one fixed position while the drawing is going on. In actual fact our experience of objects is never confined to looking at them from one fixed point of view, and we never think of them in

terms of lines because they are not made up of lines at all. In other words the conventional idea of drawing has little to do with our actual experience of real things.

Again, what we see in the world around us is, much more than is generally realized, a product of what we expect to see and of what we want to see. Different people looking at the same scene will all notice different things about it, and they would all record quite individual impressions if, for example, they were to take a walk down any high street. This is not so much a matter of differing powers of observation, as of the differing interests of the people concerned. A motor engineer would notice the motor vehicles in the road — something I would be likely to miss altogether. A dress designer would automatically register the clothes of passers-by and in shop windows, while a signwriter would appraise the lettering over shops and in advertisements. And so on. We see what we want to see and very often only what we want to see, and the rest we miss. It follows that the wider our interests the more we see, and painting has an important bearing on observation which we will go into later on. For the moment it is only necessary to say that observation is a highly selective process, which consists of extracting or drawing out from a mass of visual impressions what is of significance to the individual. And in turn we may consider drawing in this basic sense of 'drawing out.' When we talk of 'drawing a person out' we do not mean that we accept them as they are at first sight, but on the contrary we mean that we lead them by sympathy into a larger revelation of themselves, so that we can know them more completely as they are. We shall not succeed in drawing out every aspect of their character, but only those aspects with which we can establish contact. So in painting, drawing is a process of drawing out from the world around those aspects of nature which have become part of our real experience through sympathy and interest. This will involve a great deal of selection, which will be characteristic of ourselves as individuals. Drawing then is not a mechanical thing, a clever trick by which we can reproduce, using freehand only, lines and shapes which could more easily be recorded by instruments; it is something we create out of our perceptions, and which will draw upon our instinct for making shapes and patterns. It is something we can achieve in our own way by the use of brush and paints, and which will come quite naturally with increasing use of our materials, when once the fear created by a limited conception of drawing has

vanished. Drawing then will become part of the adventure of paint-
ing, and an increasing revelation of our experience of the world of
nature.

It is not pretended that all the beginner's misgivings have been
mentioned, nor would it serve any useful purpose to do so. I have
referred to some of the more typical and urgent difficulties which
beginners have raised with me in the past. But the mere intellectual
disposal of difficulties will not remove their emotional force. If the
reader finds that his own particular case has not been met, he can be
assured that it is in the actual process of beginning, when he has the
brush in hand and the paints before him, that he will find the
resolution of his fears, and this leads us on to the next chapter.

2 □ making a start

Equipment at the start. Before we can go very far in painting we shall have to know something about the use of materials. Technical questions are, however, discussed later on, but at the start it does not very much matter what physical means we employ of spreading colour over a surface, which is essentially what we need to do. Certainly we need not think in terms of buying expensive equipment; we can use whatever lies nearest to hand, such as coloured chalks or crayons, or it may be a child's water-colour box. It will however simplify description if we consider one particular medium, and for this purpose it is convenient to choose poster colour. This is simply a thick type of water-colour paint (rather like strongly coloured distemper), which may be freely thinned with water or applied as thickly as desired. If we are not going to use this medium we can without difficulty adapt the following description to suit our case.

Two preliminary points should be noted. First, it is desirable not to use too small a piece of paper (or too small a brush), as this unnecessarily restricts our scope and is liable to lead to a preoccupation with detail which should be avoided at this stage. Furthermore we are not going to start sketching, which small sheets of paper seem to imply, and we need to prepare ourselves for a more expansive treatment of broad masses of colour. Secondly, it is desirable that the paper should be pinned to a board and placed vertically, whether on an easel or not. This allows us more freedom of action than is possible when we work seated at a table, and we are not handicapped by always viewing the paper at an oblique angle.

With brush in hand, then, we have placed ourselves before the paper and are ready to begin. So far, so good. But what next?

Breaking the blankness. Many people find that under these conditions the plain white surface stares back at them with an

12

almost paralysing blankness. It is so empty. We have to make a start at some point, but the difficulty is to know where. If we were confronted by an odd bit of paper on which already there were some splashes of paint this difficulty would probably disappear. We could at least add a few more dashes of colour by way of experiment. But when there is nothing there at all the blankness becomes a void which offers no stimulus whatever, and we are frozen into inaction.

First of all therefore we have to rid ourselves of what might be called the 'fear of the blank surface.' Here, right at the start, is a challenge. It proceeds something like this: before me is a perfectly clean white surface; whatever I do with it is bound to be a failure; therefore do nothing! This may sound elementary and even naïve, but I am sure it expresses a deep and fundamental paradox which can be an effective means of strangling one's creativity at the start. Some painters never lose this fear of the white surface. They are always tentative and over-anxious, and they never find the exhilaration of freedom in their work.

This first challenge, incidentally, is never lost; one can never start a picture without feeling it. It puts us on our mettle and creates that sense of urgency and tension which is perhaps essential in any kind of real expression. But it need not be a hindrance; on the contrary it can become positively an incentive to action.

What we have to do is to break the blankness of the surface, so that no longer need we feel that a barrier exists between ourselves and the paper. This can the more easily be done if we do not attempt to calculate the kind of effect we are going to make, and if we realize that it is the simple act of breaking up the blank surface, and not the manner of its breaking up, that matters. We should not hold the brush an inch or two from the bristles, so that it is used like a pen by moving the wrist and fingers, but it should be held at the end of the handle so that the whole arm is brought into play. In this way we take up some paint, choosing any colour we like, and with a broad sweep of the arm apply some to the paper — it does not matter where. If we are able to do this we have already started to paint. This may seem far-fetched, but in reality it is not so.

Let us take a look at what we have done. Suppose for the sake of example we chose yellow as our colour; then by a sweep of our brush we have created an effect of yellowness on the blank paper. But we have done much more than this. We have broken at once the blankness of the white surface, and we have created a relationship

upon it. The yellow patch of colour has a certain shape and size; moreover it has a position on the paper. All these factors at once and automatically establish a relationship with the rectangle set by the four sides of the paper. If the yellow patch, for instance, is somewhere near the middle, it creates a different effect from its position, say, near one corner. One cannot put into words precisely the nature of this effect, but one senses it for oneself. Near the centre the colour is more likely to produce an effect of balance, inasmuch as the painting (as I will call it, even at this stage) will not seem weighted on one side in particular. If the patch is near one corner there is an effect of unbalance, because the total result is one-sided; the yellow area at one corner seems to demand something on the other side to even things up. It is rather like putting a clock on an empty mantelpiece right at one end; one feels instinctively the sense of tension between the position of the clock and the length of the mantelpiece. Usually a clock is put in the centre, not because it can be seen any better there, but because in that position it satisfies some instinct for rightness of form or order. If the reader is capable of sensing this kind of relationship, not merely intellectually but as something felt, then unquestionably he has the sensibility for painting.

Of course it is not only the position of the colour area which contributes to the relationship set up. Shape and size also make their contribution. Curved shapes react differently from angular ones, and a line is different from both. Lines have direction, and a horizontal line sets up different tensions from a vertical, and a diagonal is different again.

I mention these points in order to show that our first attack upon the white surface is something perfectly serious and important, although it may be done without calculation and quite spontaneously. We have started upon an adventure which may lead us far into the world of paints and colours — and an adventure, moreover, in which we are not called upon to play the rôle of passive observers. If we can feel this sense of adventure about every effect we create with colours we shall be saved from falling into the habit of performing mechanical and stereotyped operations which, so far as painting is concerned, simply signify that the life and happiness have gone out of it.

Freedom of choice. But to continue with the painting. We have started with one colour; now let us try another — say blue.

In the same way as before we put a patch of blue on the paper. We will find it curious that, having already started with yellow, we are no longer 'free' to put the colour just wherever we please. Of course physically we are free to do so, but actually we will find that the size, shape and position of the yellow (as well as its degree of yellowness) will largely dictate, even if unconsciously, where we put the blue. Our sense of relationship — what I have called our instinct for form or order — will now come into play and limit the possibilities of free choice. This is not a restricting limitation, for without it painting would not be possible. Let us go back to the analogy of the clock on the mantelpiece. If I elect to put the clock at one end I might feel the necessity of adding some other object, such as a vase, to redress the balance of the clock's position. But this very necessity implies a limitation, for I will not place the vase right up against the clock, but in some position such that they look as well together as possible. If I knew I had only the two objects to arrange, I would not place either at the extreme end or even in the centre; I would be most likely to place them at distances from the centre such that the total effect is one of balance. Their actual positions would depend on their relative size, and perhaps colour. What dictates that I should act in this way may perhaps be called a law of my being. But it is not a law which I feel restricting. It is more in the nature of a response of my being to some innate sense of order. I could disregard this law if I wished, but the result would merely be that I should feel out of harmony with the result I had achieved. I should feel dissatisfied. In the same way, a great deal of painting is concerned with this striving to achieve harmony. It is part of our incentive to paint.

And so we put an area of blue on the paper. We need have no hesitation in doing this. The forces which dictate where we put it will be largely unconscious; we may put it where we wish. At once we shall find that a new relationship is set up. Whereas before we were merely concerned with the interplay between the yellow and the white rectangle, now a relationship is established between the yellow and the blue. The two colours react with each other as we look at them. Again I must use the word tension to describe the effect. Being very different colours they are markedly in contrast to one another, and we judge how they go together. We will note how the presence of the blue changes the character of the yellow. This can only be described by saying that its effect of yellowness is

changed: perhaps enhanced, perhaps reduced. This will depend on the kind and quantity of blue used and on its position in relation to the yellow.

This concerns only colour relationships, but it is obvious that the shape and size of the blue will relate themselves to the yellow area; and what has already been said about the relationship established by the yellow to the rectangle of the paper is relevant now to the blue area.

If all this sounds rather confusing, it is largely the result of using words to describe what is essentially a visual process. This process no doubt is far from being a simple one; but my meaning will become clear at once when we start to paint, provided we can sense relationships of the kind I am talking about.

My intention is to make it clear that, from the start, we are doing something of fundamental importance. Indeed, we are doing something which is of the nature of artistic activity. This is not to say we are creating a work of art. No formula for the creation of a work of art in any case exists, and we may as well leave aside this aspect of the question altogether. But we are doing what every painter is concerned with in making a picture. He has to find the right shapes, the right colours for his paintings; they have to be searched for and in the process there may be much experimentation, but in the end it is his judgment alone which can finally settle the issue. No one can decide it for him. And we are doing something of the same kind. We must decide our own colours and the satisfactory relations of shapes for ourselves.

A field of discovery. So far we have considered the use of only two colours. Having got these two down we are well under way, and we will have no difficulty in introducing others. As each new colour goes into the picture the result is that a new situation is created, and this in turn creates new conditions to be exploited. We have therefore on the one hand an ever-widening field of discovery, yet at the same time our effective choice of colours and shapes becomes increasingly limited, until at last we feel that there is nothing more we can usefully add. The picture has worked itself out. There is no need to cover all the paper. Some of it may be left uncovered; it will now have lost its character of blankness, and will instead contribute whiteness (probably a rather creamy whiteness) to the general effect.

Now let us step back and look at what we have done. We have painted what may be called an abstract picture — simply a collection of coloured shapes arranged in the form of a pattern. It is not meant to represent anything. We may not have consciously attempted to make a pattern, but we will have instinctively put down our colours and shapes in some relationship. There is nothing surprising in this. Indeed the surprising thing would be if we had succeeded in assembling colours which bore no evidence of cohesion or arrangement. If we will try the experiment for ourselves we will find it almost impossible to set down colours freely without some arrangement or design emerging. It is simply the human way of doing things. This does not mean of course that the pattern is entirely satisfactory, and we will probably feel that this or that colour and shape might be altered to advantage. It is well, however, not to attempt alterations at this stage. We have put down our colours directly and they will have a freshness which will be lost by second thoughts. Moreover, when one alteration is made we may find that it so changes the general aspect of the design that further alterations become necessary. This kind of thing can go on indefinitely, and may mean virtually painting a new picture on top of the old. So it is best to let things stand directly as they came.

It is surprising how much we may gain from this first painting. It may be the first introduction we have had, by actual experience, to the problems the artist has to deal with, and it may lead us to a far wider appreciation of paintings than we had before. Our sensibility has been brought into play, and at the same time we have discovered what it is like to handle a brush and put paint to paper. I do not, of course, expect that we will necessarily proceed step by step along the lines I have indicated. I have merely outlined a general procedure for beginning, which must be simplified for the sake of description, and it is meant to be freely adapted to suit individual needs.

When it is realized how many brush strokes, how many shapes and areas of colour go into a painting, we will begin to understand what an endless world of variety and scope painting opens up for us. In our first painting we have been concerned with only a few broad colour areas, and have found how much of interest can arise out of their juxtaposition and relationship. As we build up more varied structures we will find how fascinating it is to relate form with form, colour with colour, each of our own making, with a diversity that can never be exhausted.

Some fundamental features. I am well aware, however, that at this point the reader may have a feeling of disappointment, perhaps even of exasperation. He may feel inclined to say that he has no desire to paint abstract pictures and wonders what the mere application of colours has to do with painting. To him, a picture is essentially something represented and is not a collection of 'meaningless' lines and shapes. If these are his feelings I would ask him to have patience and bear with me a little longer before he passes judgment. The kind of beginning outlined above is adopted for a definite purpose, and though that purpose may not be apparent yet, it will be found to be part of a general scheme which will be gradually unfolded.

I use the word meaningless above because it is the one often employed by beginners to describe a picture which is not representational. But we should not be too hasty in reaching conclusions of this kind. A picture is by no means meaningless because it does not portray some objective thing, and the absence of the representational element brings all the more sharply into focus certain fundamental features of painting which are often overlooked because they are taken for granted.

There is first the obvious fact that a picture is bounded by four sides. Our surface is a rectangle (rarely a square) of a certain area, and whatever goes into the picture must of necessity enter into relationship with this area. Be it a line, a mass of colour, a representation of a house or an apple, it is never an independent thing, but a thing which is bound by the necessities of the picture space. This means that a picture has its own internal relations, no matter what external relations it may have with the world of nature; and these internal relations must come first, because it is by them that the picture will stand or fall.

Again, a painting has a flat surface, and this should never be forgotten: it imposes a limitation which is part of the art of painting. Every art form imposes limitations, and these limitations cannot be ignored without doing violence to the whole structure. Painting would not be better off if in some way the surface of the picture could be made to exhibit real three-dimensional distance. It would simply be a different art form. In painting any effect of distance is not meant to be an optical illusion — we are not meant to be deceived into believing that the canvas physically recedes in space; it is a symbol of our experience of nature in terms of colours on a

flat surface, and however it is brought about it must conform to the system of satisfactory relations imposed by this surface.

It is for reasons such as these that a painting is quite different from a photograph. A photograph is mechanically produced; it is a record of three-dimensional nature imposed on a flat surface in accordance with certain optical laws. It is a record of some aspect of appearance caught in a second of time — frozen as it were into immobility at the precise moment the shutter is released. We look at it in order to be reminded of something else, that is of certain conditions which we assume existed at that precise moment — assume, because we could never take them in instantaneously ourselves. But a painting is not mechanically produced and it can never be instantaneous, it involves a prolonged vision which searches out and selects, it passes through the wholly unmechanical process of the painter's sensibility, and it is to be looked at as a record of creativeness, whatever it may record for us of the world of nature. A painting does something more vital than to reproduce appearances; it reveals to us a world of objects, not caught momentarily in a second of time, but expressed and related in a unity which the painter achieves by selection and judgment. In other words, a painting reveals the connexion between things, a connexion which is not always apparent in nature. When we look at a scene we may be unaware of any evident connexion between the objects we are looking at — say a tree, a house, and the sky; but when we come to paint the scene we relate the tree, house, and sky on the flat surface of our canvas, and so reveal them not as isolated objects but as parts of the unity of our painting.

Nature and ourselves. In this way painting may enable us to look on nature in a new way; we will not see the objects of the physical world as so many isolated, discrete units spread out before us in space; we will perceive a new harmony everywhere. Trees become united with skies and fields, vases and tables are seen as parts of their surroundings. All nature takes on a new unity and is invested with a heightened significance. What is more important still, the painter is able in some sense to identify himself with the world of nature; he is able to see his own connexion with the scheme of things, since it is through his own perceptions that he is brought into oneness with the world around. In this way the world becomes an altogether more friendly and more meaningful environment. No

longer is it out there, so to speak, detached from me and infinitely remote; it is seen to be but part of a wider unity in which I also have a place.

This is but one aspect of the adventure we are engaged on: an adventure of the spirit in the world of nature. If we can catch something of its worthwhileness from the start and can feel any sense of urgency in our new undertaking, then we will have no difficulty in going ahead.

Variety of effects. It is suggested that we make several paintings along the lines indicated above. New shapes and organizations will soon occur to us, and left to our own resources we will soon achieve a whole variety of effects which are much better left to come in their own way, rather than that we should follow any prescribed course. We will find great interest at this stage in mixing up different colours on the palette, and on odd pieces of paper the effects of colour mixture may be tested out. We should experiment freely with combinations of all kinds, so as to familiarize ourselves with the workings of our pigments. The question of colour mixture is taken up in Chapter Eight, but a few suggestions will not be out of place here (these suggestions apply particularly to poster colour).

Even before any mixture is made it will be noticed how the appearance of a colour changes according to whether it is painted thickly or thinly on the paper. When it is well diluted with water it spreads itself like a transparent film over the surface, which shines through the colour and lights it up with brilliance. This does not happen if the paint is laid on thickly, for then the surface is obliterated and the colour has a heavy and solid look. We should try the effect of mixing colours with white, so as to render them paler, and we will note how the character of a colour changes as more white is introduced. We will discover that there are two ways of rendering a colour paler; one is to thin it down with water and let the white paper show through, and the other is to mix it with white paint. In the latter case the paled colour can be painted thickly so that it will cover over a darker colour under it. Any thick paint will cover over other colours, and thus we may make alterations and adjustments if we want to. Good effects can be obtained by superimposing one colour over a larger area of another, so as to achieve direct effects of contrast (say red over green or, for less obvious contrast, light

green over dark green, and so on), and it is often interesting to start a painting by covering the paper entirely with one colour and then, when it is dry, painting other colours over it, so that they react against a coloured ground instead of a white one.

White has great interest in its own right, apart from its effect in mixture with other colours. It will probably be noticed that the white paint is actually whiter than the paper, which by contrast looks more of a light cream. There are degrees of whiteness, and this is further illustrated by painting side by side two whites, to one of which a touch of yellow has been added, and to the other a touch of blue. We will then see the contrast between a 'warm' white with yellow and a 'cool' white with blue. Both would be called white in a general way, but painting sharpens our perception of such slight differences of colour. Then black should not be overlooked. It exercises a strong effect, especially against the lighter colours; see, for instance, how an area of yellow is intensified when ringed round with black. Thus although black is often regarded as sombre and dull it may, when placed alongside other colours, actually increase their brilliance. When mixed in with other colours it darkens them, and then it does reduce their brilliance, and with yellows and reds it tends to produce muddy or brownish mixtures. Mixed with white it makes greys, which may range from very dark to very pale, and this will enable us to see that 'black' and 'white' are only relative terms, for there is no definite point at which we can distinguish dark greys from black or very pale greys from white. We can mix a pale grey and then work into it some other colour from the palette, and so obtain pale subdued colours of the kind which are sometimes loosely described as 'pastel shades.' Black itself may be varied, like white, by being 'warmed' or 'cooled,' with the addition of a touch of red or blue — another instance of the fact that black is relative only and that one black may differ from another.

Of course a great part of the interest of colour mixture lies in the fact that it enormously increases the range of possible colours available from a given number of pigments. This aspect of the matter is dealt with in Chapter Eight, where we shall see that we can rely on mixture to produce many of the colours we need, instead of having to set out a large number of pigments on the palette. Naturally this offers unlimited possibilities, but first it is well to see how single colours behave and how they can be made to vary by different treatments, such as those described above. At the present

stage we need not seek to extend our colour mixtures beyond those which inevitably arise as we 'work' the colours about the palette.

Hold-ups — and the way out.

It is quite likely that in the course of building up our pictures we shall find ourselves hopelessly 'stuck' on occasions. These hold-ups are unfortunate because they seem to become more formidable the longer we remain in their grip, until finally it seems impossible to go on; whereas if only we can break through them the way ahead becomes quite clear. For instance we may find ourselves in the position of wondering whether a particular colour is a suitable one to introduce into the picture. Unless we have the power to visualize colours very clearly (and this, I think is not a common experience) we shall find difficulty in imagining the effect of a colour before it is put down. Under these conditions it is better not to think about the matter too long, because no amount of thought will really decide what the effect of the colour is going to be. It is best to be quite bold and put the colour down. Sometimes the result will be disappointing; but it is quite as likely to be surprisingly successful. It is often the colours one hesitates to use because they seem too improbable or too unusual that give just that extra fillip to a design which will be lacking if we always allow ourselves to play safe. Designs which are restricted to the safe harmonies of colour may be pleasing enough, but they lack altogether the force and originality of the more daring relationships. We need to have the courage to risk all in a painting, for only so can we do justice to ourselves.

If we find that the colour we put down does not succeed, we can paint over it and change it; or we can often adjust the other colours we add so that the offending colour can be made to hold its own. All is not lost if our venture does not succeed, but if we do not make the venture at all we are denying ourselves the possibility of new discoveries.

Again, it will often happen that we are in the position, not of wondering whether a particular colour might be used, but of not knowing what colour to use at all. As before, we shall find great difficulty in formulating a mental picture of the desired colour, and therefore we should not spend too much time in turning the matter over in our minds. It is much better to take a look at the palette and see what suggestions arise from that quarter. We will probably find that a good many colours have run together and have produced a varied, almost kaleidoscopic effect on the palette. Many colours

will have come together in this way which we might never have thought of, and they may well give the clue to what we want. If still nothing satisfactory arises, we should work the brush about the palette so as to make various mixtures: we will probably be able to reject several of them at once, but sooner or later we will find something that is worth a trial. We put it down and see the result. If it is not perfectly satisfactory it may still lead us to what we want. By trial and error, by keeping the brush working among the pigments so as to keep the colours 'moving' instead of being just static blobs on the palette (of little use to the imagination), we shall find that these colour problems solve themselves. All along, the imagination is being stimulated by the objective experience of looking.

It will be seen that there is no need to keep the palette in a state of meticulous cleanliness. We need not worry if it becomes completely swimming in colour. Our palette is not merely a receptacle for pigments; it is part of our means of expression and will furnish many ideas, and if it is too 'empty' and clean it cannot serve this function. It is an easy matter to wash off any dirty paint that is not needed. Many fortuitous mixings of colour on the palette will be found the source of some happy inspirations; they may be called accidents perhaps, but they are the sort of accidents we should expect to happen.

A foundation for the future. If I have carried the reader with me so far, a fact of some consequence will now reveal itself. He will have painted several pictures without concerning himself with that troubling question of the beginner, 'What shall I paint?' (How many pictures have been left unpainted because this question stood unanswered at the threshold!) Instead, he has found that his paintings have arisen naturally and directly out of a first decisive step. One colour has led to another, and so it has gone on until no more colours could well be fitted in. The whole picture has developed as by a process of growth, which has been a give-and-take between something he has put down and seen, and his reaction to the thing seen. It has not been a purely subjective process, or a purely objective one. He has looked at an effect created on the paper, and then looked at his palette; and the result has been the addition of another colour and shape. His imagination is stimulated step by step as he proceeds, and in this way the painting comes to completion. He will find that what he has done has great relevance

for his future work, and that he has laid a foundation on which he can build.

Finally the reader may be surprised to find that in painting he is not called upon to make use of mental attributes which are remote from his workaday experience — as it were a kind of sixth sense that somehow endows him with an artistic sensibility and makes him a person of extraordinary emotions. He is merely employing powers which are brought into use every day, but directing them into new channels. This is what was meant in the Introduction by saying that art is no remote activity demanding unique and peculiar powers. Sometimes the appreciations that are made use of in the world of art are designated by the word 'aesthetic,' but too often unfortunately this appears to separate them off from the experience of the ordinary man. The fact is we all have aesthetic experiences every day, only we do not recognize them by the name. We are always arranging and disposing objects in such a way as to satisfy our sense of form. Whether it be the furniture in a room, objects on a shelf, or flowers in the garden, we constantly deliberate and decide the issue not merely for reasons of utility or convenience, but simply because a certain arrangement pleases. All such judgments are aesthetic in nature and do not differ from those used in painting, where however they are more specialized and more deliberately undertaken. Thus it is that we need not concern ourselves about the possession of an artistic sensibility; it is something which is part of our nature, often indeed neglected and sometimes dangerously so, to our disadvantage, but always potentially there.

3 □ representation

Pictures that 'look like something'. In the previous chapter we made a beginning; we have put paint to paper and, perhaps in spite of ourselves, have painted our first pictures. These may not be at all what we expected to do or, for that matter, what we want to do. This is understandable enough, and it is not suggested that we should never essay to paint pictures that go beyond the making of patterns and designs. I have known people whose interest in abstract work was such that they never felt the need to go outside it, and certainly the field that it opens up is inexhaustible; but such people are, I am sure, a small minority. Most of us want to do something more directly connected with the world of nature; and it is just here, it seems, that our difficulty lies.

The question that arises, then, is quite simply, 'What next; where do we go from here?' The reader may feel that this is a crucial stage. In the work so far considered — call it abstract, pattern, design, or what we will — he may think that we have been concerned with mere preliminaries and that the real business of painting is yet to start; that, in other words, we have been shelving the main issue and concentrating on something altogether more easy. His conviction is that the real difficulty starts when we come to paint pictures that are intended to 'look like something' — so that one can tell what they are meant to be.

Yet herein lies a fallacy. Abstract pictures are no less 'difficult' than any other kind — any more than red is more 'difficult' than green — and the considerations that have been advanced so far are fundamental to our future work. Unless they have been grasped we will make no headway at all.

But this does not dispose of the fact that the difficulty which actually confronts people at this stage is the thought of representation, that is to say the thought of making pictures in which the world of nature is portrayed in some form or another. I emphasize

that this is a *thought* only — it has nothing to do with our capabilities; nevertheless it rises up before us and seems to bar the road to further progress. 'I could never paint a picture which looks like anything,' is often said as, with a shrug of the shoulders, someone dismisses the possibility of painting as the wildest of dreams.

Ideas taken for granted. Of course such an attitude does not arise out of the blue; it comes hand in hand with ideas which are accepted and firmly rooted, and though they are seldom clearly defined, they are perhaps all the more powerful for this reason. Out of the welter of accepted notions that people bring with them to painting, it is possible to pick out two which act so naturally as deterrents to the beginner that we must give them some consideration.

The first has already been mentioned; it is the old question of drawing, which is taken to be an activity quite distinct from painting. The 'outline' figures prominently here: drawing is seen in terms of a firm delineating outline which, it is held, must first be satisfactorily established before we can proceed to the use of colour, the purpose of which is to make the drawing appear more realistic. The supposed order of procedure is important: first the outline, then the colour — colour being regarded as a factor contributing to realism and not anything to be looked at for its own sake.

The second notion is more difficult to describe. It involves an assumption that a painting must in some sense exist, more or less complete, in the mind of the painter before it is started. It is felt that the artist — to be an artist — must be capable of visualizing the finished product before he starts; and perhaps the idea is given more force by the thought that his 'inspiration,' his incentive to make his picture, occurs first as a powerful visual impression, and that it is only when an urge of this kind is sufficiently strong that he may expect to get a satisfactory result. He works, furiously and at white heat, under the emotional force of his inspiration. However the idea is presented the inference is always the same, namely, that the process of painting consists largely of transferring to canvas a preconceived picture and involves the technical ability to transfer the visual image to a flat surface. The effect of this view of painting, so far as we are concerned, is obvious: people who are aware that they do not have visual impressions of this sort or, if they do, are only too conscious of not possessing the technical skill to render them

in paint — such people naturally are convinced of their inaptitude for painting.

How often have people said to me in effect, 'I should like to paint, but I can't; I know what I would like to do, but I could never capture it in paint.' This argument on the face of it seems unanswerable. Always implicit in such a statement are the two ideas I have noted: the picture existing as a preconception, coupled with the technical inability to make it actual. Both these ideas are really aspects of one overriding principle, namely that a painting is a deliberate realization of an intended result.

No wonder then, if it is the deliberate realization of intentions that we set before us, that the whole thing seems beyond us! We shall have to look into these ideas and see if they really confront us with the impasse they seem to make.

This chapter will therefore take the form of a discussion of ideas. No apology is made for this. Lest anyone should think that this is an abstract way of dealing with a practical activity, let it be said at once that ideas are by no means the antithesis of action; on the contrary they are the mainspring of action. In the wider world it is ideas which set armies on the march and bring about the vast spectacle of social change. Techniques can provide the means, but cannot inspire the incentive for activity. And while some ideas act as stimulants and widen our vision, others have the reverse effect. Very few of us ever realize our true potentialities, and it is ideas which limit our achievement more than any deficiency in ourselves. We may have powers that lie dormant throughout our lives, because they are never awakened to life.

It is worth while therefore to note the powerful effect of ideas in connexion with the activity we are engaged on. That many people have found pleasure in painting who never imagined that they had any capacity to do so is a simple fact of experience; and what at one time closed the door to them was simply that they clung to ideas which ruled out any possibility of achievement in this field. It has been pointed out before that such ideas are often not consciously thought out; they take the form of assumptions with regard to the nature of painting which have been accepted without much consideration over a period of years, and have never been questioned. They are simply taken for granted. The important point here is not whether this or that idea is more 'true' than another, but that some ideas have the depressing effect of limiting a person's achievement.

Their removal is accompanied by a sense of relief while new horizons are opened up, and as a consequence interest is awakened. This is not the same thing as an intellectual assent to opinions of whatever kind; mere assent is valueless unless we can see the relevance of an idea in relation to our requirements — unless it 'works.' This after all is a very practical philosophy: if an idea 'works' it does something for us, it is a means to an end, it starts us on our way; and if it will serve us as a means, let us not hesitate to use it. The crucial test is whether it widens our field of vision, rouses us from hopelessness, and enriches the pattern we can make of our lives.

Drawing: outline and observation. It will be well if we turn our attention first to the subject of drawing, that dreaded subject which stands so often as an ominous barrier on the very threshold of painting. The very word 'drawing' has a frightening sound and harks back to our failures in the schoolroom; we feel that we cannot draw and therefore cannot paint. Here at the outset is the distinction made between drawing and painting, as if the two activities were separate; so that we see ourselves first endeavouring to establish the 'outline' and then, if it is good enough, proceeding to colour it.

It is not always realized that drawing may be considered from a very different point of view which renders such a distinction meaningless, and which at the same time deprives drawing of its terrors and places it within the reach of all. Drawing is not really a question of cleverness or sleight of hand; indeed we shall find that these dubious attributes deliver us into a labyrinth of trickery, whose deception is not very convincing.

If we are asked to draw something, how do we immediately set about doing it? Nearly always we will attempt to make an outline of it; and we will almost invariably use a pencil rather than a pen, because we will feel that our outline is not likely to be right first time and a pencil gives us the comforting assurance that we can rub out our mistakes and start again. It has not the awful finality of a pen, which commits us irrevocably to everything we put down.

This is all very well if we are making a scientific diagram, where the whole point of the drawing resides in its accuracy of illustration; but drawing in relation to painting is not this kind of thing at all. It is an entirely individual way — unique for each person — of

using a pencil, pen, or brush, and every mark we make, like every word we utter, is a contribution to our particular form of 'expression.' To rub out is like going back on a statement. It is a negation of the creative process. Hence it is actually better to draw with a pen, which cannot go back on itself and which draws out the whole of what we have to say.

Take again the question of drawing by outlines, the prejudice for which is very deep rooted. Let us see what it really amounts to. It carries with it intrinsically the idea of separation, because we cannot put an outline round anything without separating it off. For example, when a tennis court is marked out, the lines will separate the playing area from the rest of the grass. In the same way when we draw an object by an outline we separate it from the rest of the paper we are drawing on. We are making an act of separation, all the more binding because it is deliberate.

This act of separation, in its turn, arises out of our way of looking upon the object we are drawing as an isolated thing which we place on a particular part of our paper. We extract the object from whatever setting it may be in, and in our mind's eye we narrow it down to a thing-on-its-own; and it is this which we proceed to outline on our paper. But in actual fact objects are never things-on-their-own; always they are seen, under certain conditions of light, in association with their surroundings. These surroundings cannot be dissociated from the object without doing violence to the whole process of observation.

The way in which we approach drawing will be closely bound up with the way in which we use our eyes. If we are going to paint, we shall find that we increasingly use our eyes; and it is no exaggeration to say that, so far as a great part of the visible world is concerned, many people are quite unaware of what their eyes are capable of revealing to them. They use their eyes only in order to recognize what is already familiar in the world around; they never use them as a means of real discovery. They look at objects, but they do not observe them. Their eyes are never made the instruments of pleasure, but only to serve the practical requirements of living. In this way a whole world of experience is lost to them.

To make clear what I am driving at, let us consider what is involved when we look at some familiar object, such as a bottle. The word 'bottle' is simply a label which we are prepared to attach to objects of a certain class, so that when we set our eyes on such an

object we can recognize it as belonging to this class and pronounce it 'a bottle.' There are other glass objects, such as flasks and decanters, which serve much the same function, but which nevertheless do not come within the category we confine to bottles. Obviously we carry in mind a conception or idea of what we understand by 'bottle,' and when we see an object of this kind our curiosity regarding it is at an end; it is safely recognized and disposed of as a familiar and known object. In other words, our interest in the bottle as an object to be looked at ceases; we have placed it among our world of familiar objects and may use it for any purpose it is known to fulfil; we see the bottle — we identify it — but we do not observe it.

This is the way we are accustomed to use our eyes in the ordinary course of practical living. We know that cups are made to drink out of, knives to cut with; that tables and chairs, spoons and forks all have their prescribed uses; and we look at these objects first in order to identify them and then, if need be, to use them. And familiarity breeds for them a visual contempt.

Now what happens when we come to draw one of these objects, shall we say a bottle? We will try to make our drawing conform to our preconceived idea of the isolated thing 'bottle' and, much more than we think, we will project this idea on to any bottle we are looking at, so that instead of observing it we will see it as an object which conforms more or less to our conception. And what better than to make use of an outline as a ready-made contrivance for isolating the object on our paper! If, as so often happens, the drawing does not conform very well to our conception, we say it is a very bad bottle or not a bottle at all, and dismiss it as a very bad drawing. This is what we mean by saying that we can never make a drawing that looks like anything. And this explains the sort of remarks one often hears made about beginners' paintings (or for that matter about some professional paintings too), such as 'What is it meant to be?' — remarks made often with an air of superior jocularity, as if the person making them had hit upon some crucial point of criticism. But all that such remarks imply is that the person is unable to connect the shapes and colours he sees with any conceptual object he has in mind. He is looking at the painting as he probably looks at nature — merely in order to identify objects, to pick them out of the painting like numbers out of a hat; and when he finds one he cannot identify he is totally nonplussed (and sometimes a little annoyed) and asks a foolish question which

reveals that he is out of his depth. Yet such questions are often depressing to beginners and it is well that they should be seen for the questions they are — rather meaningless and not very illuminating.

When we go a stage further and start colouring our drawing, what havoc the outline can cause! We will quickly discover that a line has two sides, an inside and an outside, and that between the two it stands as a tantalizing hairbreadth separation. Almost inevitably we will proceed by filling in the areas between the boundary lines, and the painting will resolve itself into a meticulous series of sharply separated colour areas laid on in piecemeal fashion. There will be no freedom of brush stroke and no sense of the colour flowing freely about the painting. The lines will be like railings that fence us in, and the thought of not spoiling everything by going over the razorlike edge will be with us all the time.

So much for drawing as related to a view of nature in which identification is our primary concern. But when we cease to be concerned with identification, our observation of nature becomes something altogether different. Then we do not see the objects around us as so many separate items to which we have to attach a label. Instead we look and see certain relationships of colour and shape; these are the things of interest, no matter what the particular objects are that give rise to them. It is a kind of visual harmony which reaches us directly through the senses without the intervening intellectual process of identification, which indeed is a very effective barrier to the direct enjoyment of visual experience: almost as if in listening to music we had to keep asking ourselves what natural noises are suggested by the sounds we hear, a procedure which would be killing to any direct appreciation of the music. To look at nature with the observing eye transforms it from a mere catalogue of facts to an ever-changing panorama of shapes and colours, in which nothing is commonplace because everything is unique; and it is this quality of uniqueness which gives to observation its continuing interest. We can easily try for ourselves the experiment of looking at a scene, no matter how familiar, and instead of saying to ourselves 'that is a house, that is a tree, that is a road,' look at these things for their shapes and colours alone. It will be surprising how much more we will see.

To look at nature and see it in some sense whole — to see it in its character of relatedness — is to see it with the eye of a painter. And in a painting it is the entire relationship of the shapes and colours

we derive from nature that matters, not whether these can be separately identified. This puts the question of representation in a different light, for we have already seen in the previous chapter how a pattern of relationship can be built up, and have done it for ourselves. The difference now is that the stimulus for our pattern making comes directly from the observation of nature. We need not think that as a result we are simply producing variations on abstract themes. When we cease to be concerned with identification, the frustration and anxiety go from drawing; and then strangely enough we shall find that we are all the more free to represent the world of nature, and represent it in a way that is part of our experience of seeing and of our instinct for relationship; part, that is, of our expression. Instead of extracting individual objects from their surroundings and attempting to 'draw' them in isolation, we have the far more stimulating task of composing a design which draws upon a whole visual experience. The instinct to draw in this sense is, I believe, inherent; we can all draw when drawing awakens some active response in our natures. Now a pencil with its fine point and its meticulous line is not the best thing to start us on our way. A brush with its variety of strokes and its placings of broad areas of colour is the very thing we need to draw with; we then draw and paint at the same time, and the two activities merge into one. How all this can be related to the practical side of painting will be made clear later on.

An example may help to illustrate some of the points I have made so far. I call to mind an occasion when a student was making a drawing of a cottage set against a background of trees and sky. Instead of adopting the usual procedure of setting down an outline of the cottage first, he began on the surroundings and sky, which he indicated with a series of hatching pencil strokes, and against this background the roof and chimneys of the cottage gradually unfolded themselves — woven, as it were, out of the background and inextricably connected with it. Another student who was watching this procedure with great interest remarked to me that the drawing appeared to be 'inside out,' and indeed this is exactly what it was, judged by the ordinary methods of outline drawing. But there is no better example I can give of drawing as a process of 'drawing out': drawing out one thing from another, in this case an object from its background. This after all is a very natural thing to do, for an object is not just 'there,' distinct from its background, but the latter

reveals it and is part of its creation; and an object may arise as much out of our treatment of a background, as a background may be necessitated by an object. What the student was doing, then, when he was drawing 'inside out,' was the reverse of a process of isolation; he was instinctively recognizing the essential relatedness of everything he was creating on the paper. He was not isolating a 'cottage' on his paper with a boundary line, and filling up the unwanted spaces with some perfunctory background; he was symbolizing on paper an experience of observation which we all have, for, if we think about it, roofs and chimneys do rise up before us with a sense of being carved 'out' of the sky and clouds and trees which come behind them.

I do not, however, wish to imply, in what I have said above, that the use of lines as such is to be avoided. Far from it. Line is one of the most ancient and certainly one of the most effective of artistic conventions, and it need not be restrictive in the sense in which I have been speaking about the 'outline.' But line inevitably raises the troubling question of draughtsmanship. We do not need to be reminded of drawings by the masters which have an accuracy of statement altogether beyond our reach, and we may wonder how by comparison our work can amount to anything which is really worth while. When we are held up in this way by thoughts of draughtsmanship it is not lines in themselves but this problem of their accuracy that comes to the fore. We find that no sooner do we put a line down on paper than our reason asserts itself and tells us it is 'wrong.' We rub it out and start again and force it into a new direction; and still it does not seem right. And so it goes on. Thus all confidence and spontaneity depart from drawing, and all pleasure goes too. Yet what makes us judge the lines to be wrong? It is our critical sense which relates them to some standard outside the drawing itself; they are wrong in relation to the object which is before us or which we have in mind. But in insisting on accuracy in this sense we lose much that is valuable in other directions. We lose the sense of lines speaking for themselves, as having their own logic and meaning because of their very nature as lines. And this is the point of the master draughtsman's work (as opposed to that of the mere illustrator or skilled practitioner). Lines are to him symbols of his expression, informed always with his sensibility; their function is creative and not mechanical. They carry with them the conviction of completeness and inevitability; they have a logical necessity

which must be felt to be understood. And such is the high degree of co-ordination of his eye, hand, and sensibility that his lines can have all these qualities and yet at the same time correspond with great precision to exact characteristics of the object. Such is the miracle of great draughtsmanship, and it is the work of genius. But master draughtsmen are few and far between; they are born and not made. We do not expect to be among their number, and we are not concerned with draughtsmanship of this order. But real difficulty arises when what is substituted in its place is the concept of accuracy or illustration which leads only to hard, wooden, characterless sketches, displaying at best nothing more than cleverness in a rather pointless direction, and serving no creative function whatsoever. But there is no need for us to depart into futility like this. We will not have the master's high degree of co-ordination and our drawings cannot have the same relevance to the world of fact; but though they will be of a different order, it does not follow that they need be of a different kind. As with our first paintings, where we found that in placing colours on paper in our own way we could do something of the nature of artistic activity, so now in drawing. By keeping to our lines because they are ours, and not destroying them because they do not conform to something outside the drawing, we acknowledge that they have a life of their own; and they too can become symbols of our expression. They may not be closely related to the facts of appearance, but they will have logic and meaning; and moreover they cannot fail to excite our interest. We will find that, if we let them, lines do have a compelling force of their own and have a way of working themselves out in their relationships; our sensibility will not fail us if we do not attempt to be clever and instead are content to feel the power of lines for ourselves.

Herein lies a paradox. In the popular estimation — and this sometimes reveals itself in classes where beginners make their first attempts — the 'good' drawings are those which most nearly reproduce appearance, while the more expressive ones are dismissed and even derided as crude and childish. But how wrong such an evaluation is, and how misleading to the beginner! How often has one seen 'crude' drawings full of distinction and revealing a true instinct for creation, which have been deemed worthless because of a false judgment relating them only to accuracy. The beginner needs the courage to keep to them despite everything that is said. They are full of promise if only he will accept them as having genuine value.

On the other hand, there is something almost frightening about the clever sketches, because they are so devoid of sensibility. They resemble those expensive life-like dolls, whose eyes open and shut, who walk and talk and even cry; but do not live.

Intentions and their realization. Let us now turn our attention to the notion that a painting begins as a mental picture which the skill of the artist transfers to canvas. I have often heard the remark made by beginners with regard to their work that it is not what they wanted or what they had in mind — meaning that they have failed in what they set out to do, and feel a sense of disappointment for this reason. How often must failure to achieve intentions have been a real stumbling block at the beginning! 'I know what I want to do but I can't get it,' a student said to me one day, and epitomized a whole world of difficulty at once. It is casual remarks which reveal the truth about a person's difficulties more often than any direct statement; and remarks of this kind, which could be quoted again and again, do imply that some conception of the finished product is held in mind from the beginning, and when it does not materialize in the picture a sense of failure is the inevitable consequence.

There is nothing very surprising in this way of working. In many activities the attitude of deliberate realization of intentions holds perfectly well. A man building a television set has a pretty clear idea in his mind of how it is going to turn out, and if he is clever enough at his job he is not disappointed. Engineers and architects work to plans and blue-prints; they have everything, to the smallest detail, worked out before any construction is undertaken; and in the humbler pursuit of dressmaking the 'pattern' is the thing that matters. The method works so well in many directions that, on the face of it, it is not surprising that it is carried over into painting. But it is here that the mistake is made; in painting it does not necessarily apply at all and, so far as the beginner is concerned, its consequences can be quite fatal. Yet so firmly is this line of approach taken for granted that it is seldom questioned; and the idea that a painting need not proceed at all from intention to realization, that it may develop according to its own laws and as it were take possession of itself when once a start is made, finally becoming something not imagined or expected at the outset — this idea is very often not contemplated at all. Yet it so happens that this is the

idea that can lead to a flowering of results when all attempts to 'get what one wants' are still-born and yield nothing but frustration.

The beginner usually attributes his inability to get what he wants to his lack of technical skill. But this is misleading, because it assumes that technique is something quite distinct from his 'expression.' What is so often overlooked is the fact that what comes in a painting, the sort of picture that arrives, is to a great extent a product of the materials used. For instance a picture in water-colours will be different from one painted in oils; and in the same medium a picture will differ according to the size and type of brushes used, the pigments set out on the palette, the size and texture of paper or canvas, the light in which the picture is executed, and so on. These are all factors that affect and in certain definite ways determine the result, and to a great extent they are outside the individual's control. The beginner simply uses the materials that are to hand, and these have to be accepted as imposing limitations which are part of any artistic activity. Now a beginner who sets out with a picture in his mind is very rarely thinking of this picture in terms of his materials at all. He is wanting his painting to conform to some idea — whether derived from observation, memory, or purely from imagination — and he is thinking of his idea as an end without considering the means. No wonder then he does not get what he wants. Not only is it something he cannot expect to get, but should not expect to get.

This influence of the materials on the products derived from them can scarcely be overstated. It is well illustrated in the case of a student I knew who had been painting for some weeks and had consistently used small sheets of paper and fine, soft hair brushes. The results, as might be expected, were precise, detailed paintings which often took several hours to complete. Then one day she decided suddenly to use a large bristle brush and a much larger sheet of paper, and working rapidly she completed in less than an hour an imaginative picture of the sea dashing against rocks. The change in style was startling; gone was the precise detail, and instead were broad effects of a kind which could only be obtained by the use of a large brush. Here was a different type of picture brought into being by the use of different materials.

A painting should look like a painting, and nothing at all is gained by trying to disguise the fact that it is made with paints, brushes, and canvas. Half the troubles of the beginner arise out of

his failure to make a distinction between the world of nature and the world of painting. The one is natural, the other artificial. A painting is an arrangement of coloured materials on a flat surface; it is bounded by the picture space — a world within a world. In the process, nature is transmuted and re-created in terms of a medium. As soon as we take up a brush and put down a line or shape we are under way. We have committed ourselves, and everything else will derive from the start we have made. In this sense a work of art is finished from the beginning, as Whistler said; and if we are ever-lastingly changing what we put down — and how strong is the tendency to do so! — we are destroying any chance of logical development and are in effect continually starting new pictures. Nothing then follows, nothing derives, nothing makes sense; and indecision only adds to our confusion and exasperation, and para-lyses our creative powers. But if we do commit ourselves at the beginning, if we keep to the start we make, we will find that a purpose unfolds itself; and our creative energies are set free to develop and enrich the implications of what we have begun. There is no formula for this development any more than there is a formula for starting; it does not follow a preconceived pattern but takes shape freely while we paint. It will not be 'what we want' if we have fixed a rigid picture of our intentions beforehand; but it will be new and unforeseen.

We are now able to see our way to the conclusion we have been driving at, and it is this: that *a painting can be looked upon as an organic thing which grows as we paint and may develop into something quite unex-pected.* This after all is the principle of life itself; it means that we must take risks, but this is only another way of saying that it opens the way to adventure. We simply do not know what we are starting when we begin to paint; we cannot even visualize what may happen, and the only means of finding out is to get started.

The bogy of imagination. We must follow this prin-ciple of development further, because it has a direct bearing on another bogy of the beginner — imagination. Many people are rather frightened by the word imagination, because they feel it is likely to make demands upon them which they will not be able to fulfil. Such a fear nearly always resides in a limited if not mistaken view of the imagination and I suspect, if the fear is present at all, it has nothing whatever to do with lack of imaginative power. A really

'unimaginative' person, if such exists, would not be likely to be aware of any deficiency in this respect.

Nevertheless, a genuine difficulty is often summed up in the words 'I am afraid I have no imagination', and it is all the more strongly felt because it appears to imply a personal lack which no amount of practice can possibly overcome. But the complaint nearly always means nothing more or less than that the person concerned is unable to imagine, that is evoke in his mind, a picture or vision of what he is going to paint before he starts, or even to formulate any very impressive ideas at all. Try as he will, he cannot conjure up his picture first; and the consequence is often a depressing feeling that he cannot possess the temperament for painting. This is equally true, whether he is painting direct from nature or 'out of the head,' as the expression is. The scene or object suggests nothing positive to go on — he cannot look beyond the scene to the painting; and as for painting out of the head, the process seems to yield not the remotest hope of success. And curiously enough the more effort is made to produce a picture in the mind, the more difficult it becomes. It is like trying to remember a name that eludes us; the more we try to capture it, the farther it seems to recede.

Whatever may be the nature of imagination, this is how it is often assumed to work — from a deliberate imagined idea to its fulfilment in a painting. But it is a limited and one-sided view; it looks to the mind alone as the source of imaginative power and seems in an unfortunate way to set great store on our subjective feelings. It makes it imperative that we should get to work on ourselves and rouse up the sleeping dogs of the imagination, however that may be done. But the imagination simply will not be roused by the most energetic attempts at waking it, nor will it come by probings into the unconscious — as many people have found to their dismay. When we are thrown back on ourselves our ideas wither and lack variety, even if they do not dry up altogether. What is needed is to take a more objective view of the situation; instead of getting to work on ourselves we want to forget about ourselves if we can. Imagination, which refuses to be forced, will freely respond to what stimulates it from outside; and it will always respond to a sense of the unknown and to adventure. It has no use for the cut and dried; few people, for instance, could be imaginatively roused by a railway time-table or a book of statutory regulations: these things leave nothing unknown for the imagination to

seize on and reconstruct for itself. The same thing happens when we sit and stare helplessly at a blank canvas. We have to be able to look beyond the concrete to what we can participate in ourselves, and by so doing find ourselves in the realm of new experience and discovery. Imagination then is a reaching out to the unpredictable, it is never far from mystery, its essence is freedom, and adventure is in its very nature; and in the process self-awareness is swallowed up in the urgency of one's response.

We need have no fear about having no imagination; it is only a question of whether or not it is stimulated, and this depends very much on our attitude of mind and on the way we work. People complain that they have no imagination when really they have never given it a chance to develop, because their method of working has been virtually its complete negation. And it so happens that the approach to painting along the lines of what may be called 'intentional results' is just such a negation. When we labour to produce something intended we expend our energies in achieving what we have already settled we *ought* to achieve, and our minds work constantly with reference to whether we are fulfilling our intentions. So it goes on: a continual reference back from results to preconceived ideas, and we are weighed down all the time by the thought 'is this right?' It is this exercise of the critical faculty, which gnaws away at us unremittingly and wears us down, which fetters the imagination and holds up the flow of ideas.

It has often been noted how doodling is a process of drawing while the mind is occupied with something else. In this way, while the critical faculty is in abeyance, we find ourselves capable of making imaginative drawings which could never come about if we deliberately set ourselves out to do them. It is interesting how the awkward, slavish attempts at correctness which most people aim at when they make conscious efforts are abandoned entirely in doodling, with results which are full of fancy and often highly imaginative. Moreover, in doodling we are never concerned about a lack of ideas because, not being concerned, we find that the ideas develop freely; and we have no difficulty about starting because we do not start off with any fixed intention of what we are going to do.

If we can approach painting in the same kind of way, so that our imagination is freed from the weight of constant criticism and decision, we shall find no difficulty about a lack of imaginative ideas. We will not expect to get ideas by staring at a blank canvas,

but as soon as we put something down our imagination is set free to work on the thing seen. Instead of waiting for ideas, an act of creation, by making something objective to look at, can stimulate the imagination at once, and as more is added, so more ideas will flow. Like a rolling snowball the painting gathers more to itself as it goes on, and it proceeds under its own impetus. As it develops, so it will undergo changes; but these changes will be part of the inevitable consequences of its growth, and not the result of corrections intended to force it into a mould which has no organic connexions with the form it is taking. We accept what comes, work on it, and see where it takes us. 'This is not what I wanted' is changed to 'this is what I have got; let's see what I can make of it'.

Of course the fund of imaginative experience we can draw upon in painting will need to be constantly refreshed if it is not to grow stale. But painting is rooted in nature, and it is here that we will find the secret of never-failing variety and stimulus. How painting can itself be a means of adding to the imaginative significance of nature will be dealt with in the next chapter, but here it may be said that nature will never be a source of stimulus if we see it always as something we 'know', because then it will be like a time-table, a record that is fixed and exact. It is only when our eyes are opened to perceive nature imaginatively that it can add to our experience and yield that enrichment which is so necessary in our work.

Instinct, creativity, and expression. Let us now take stock of the position we have reached. The impression I would like to leave in the reader's mind as a result of this chapter is simply this, that in approaching drawing or painting we should not create difficulties for ourselves. There is a tendency in most of us to try always to worry out the reasons for our doing things, and then to bring a critical analysis to bear on the results. But in so doing it often happens that we get involved in difficulty where none need arise. The fortunate people are those who can take the activity of painting quite simply! For instance there are people who will worry about their inability to draw, when really all that is necessary is that their interest should be aroused in the world of forms and colours, and then they are moved out of their own desire to find their own means of expression, which will not be denied. But to think of mastering some technique called 'drawing' when this desire is not present is simply erecting an impassable barrier of our own making.

The instinct for painting finds its starting point in something quite simple. There is a strange satisfaction which comes through making 'our mark' on paper and it eludes explanation, nor need we concern ourselves with reasons — if there be reasons — for the existence of such a fundamental impulse. It is perhaps part of some inner need to fashion and mould material to the satisfaction of inherent desires. There are few people who do not respond to this need in some form or another. A person who would never consider himself an artist will gain some inexplicable satisfaction in making a flourishing signature. The flourish evidently conforms to some sense of form or pattern which pleases. Often idly on paper we make marks which vaguely satisfy an impulse towards arrangement, or at least are evidence of a desire to make shapes in our own way. As children we used pencils, crayons, or paints and, feeling quite undeterred, drew and painted freely without fear or shame. And among the earliest records of primitive man are drawings and paintings made under most difficult conditions on the walls of caves hidden from the light of the sun; and of their kind they have never been improved on. It is often said that the instinct for form and pattern is strongly developed in primitive societies to-day, and this is no doubt true; but it is not lost under civilized conditions, only it is somehow driven underground and we rather ashamedly and self-consciously allow ourselves the satisfaction of a few scribbles only when our minds are otherwise engaged.

Such vague beginnings are never developed because it is felt that to all intents and purposes they are meaningless and that in any case they bear no relation to the more conscious processes of drawing and painting. Hence all our instinctive pattern-makings are consigned to the waste-paper basket and considered as nothing more than the effusions of an idle mind. But potentially they are so much more than this: they are evidence of an original impulse of a specially valuable kind, because it is spontaneous and springs out of a desire to impose our own pattern on the materials we use; and it is in an impulse of this kind that painting finds its beginning, for painting is rooted not in duty but in the affections. But the impulse is often checked and still-born, because we are held up before a great gulf fixed: the gulf between our spontaneous pattern-making and an arbitrary standard of attainment which seems final and necessary — a standard which we have come to accept as the only reasonable criterion of value. Perhaps such a standard always has existed

and always will exist; but to-day the form it takes is that of the sort of reproduction with which the camera has made us familiar, and we forget altogether the notion of re-presentation which is the distinctive function of painting; a re-presentation in terms of our materials, moulded and formed by our own use of them. Yet such representation is actually part of our human heritage; it is not mechanical, and has value precisely because we are human beings and not machines. It gives a heightened significance to the individual, because each one of us has his own way of shaping his materials, as distinctive as his own handwriting. If only we can come to accept our drawings and paintings as our own productions, having their own characteristics because they are ours, we need not thwart our delight in the creative process because we cannot adapt ourselves to a mechanical mould which actually crushes out the variety and subtlety of human expression. This joy in creativity is in marked contrast to the frustration which so often accompanies slavish copying; it betokens the realization of freedom which, by its nature, imposes the conditions of expression and fulfilment.

And painting is a truly human activity in another sense, that its 'expressions' do not come in any very different way from those of life. In ordinary living we do not have to invent or rouse up our states of feeling, and adjust them appropriately to the occasion. When they are most deeply felt they are so closely woven into the pattern of our existence that they are completely integrated with it; and when this integration is not made, emotions become displayed for their own sake and then are meaningless and false, and — it must be said — distinctly irritating. The same thing happens if we try to select emotions and make paintings express them. We must not think that 'feeling' or 'expressiveness' is something we drag out of our experience and deliberately infuse into the pictures we paint. The expressive character of a painting is part of its pattern, and comes in no more deliberate way than the pattern itself. It is by working directly in the world of our materials in the 'unintended' way that has been suggested, that true expressions of feeling can find their way into our paintings; they unfold themselves in an activity in which we lose ourselves. They come because we cannot help their coming; they are unforced and therefore not obvious; and they are not superimposed on the painting, but integrated with it.

Thus paintings are all the more powerful and carry the greater conviction for not being deliberate worked-up expressions of emo-

tional experience. A battle scene of the type that was common in the nineteenth century — charging horses at Balaclava or the British Square at Waterloo — were not after all very powerful expressions of experience under battle conditions. The agonized expressions of the horses as they plunged to their death, the harrowed looks of the infantrymen determined to do or die; they were not after all more than conventional expressions of grief or anguish. A true expression of an intense experience might take a very different form, and might not rely at all on accepted gestures or what passes for appropriate facial grimaces. We cannot with any conviction borrow our expressions second-hand from life; we can do no more than re-create through our medium what is true in our experience.

This book aims at no exclusiveness; it attempts to make a synthesis of painting in terms of the requirements and capacities of the ordinary person. But of course it adopts a point of view, and in particular it implies that paintings are not expected to conform to any one pattern or type. It must therefore be said that a person to whom painting means only conformity to natural appearance, to whom the criterion of judgment is simply likeness to some recognizable object — such a person will not find in this book the kind of approach he needs. He may feel a sense of frustration in reading it, and indeed we may have been talking at cross-purposes. For him there are numerous books which, with a wealth of illustration, demonstrate how to draw various objects in nature, and in them he will find the information he needs. This is not to say that paintings should not 'look like' things, and I do not wish to imply that a person who is interested in portraying nature should at this point lay down the book; I am simply referring to the person whose interest is confined to literal reproduction. And lest the reader should protest that he has not formulated any definite ideas on the subject at this stage, I would say that I have known many people who started with no thought-out idea of what they proposed to paint, and if asked might well have replied that they wished to reproduce some aspect of appearance on paper; but they found by *painting* the secret of representation rather than reproduction.

4 □ the re-created world

Away from the abstract. We are now in a position to take up the practical side where we left it in Chapter Two, and can consider entering upon the field of representational painting. But in dividing representation, as we are now doing, in a separate chapter from the patterns and designs of Chapter Two, we create an unhelpful division which in practice may scarcely exist at all. Many people will find that in their first trying out of colours they will make attempts at representation, and some people are disinclined to make pure patterns of any sort, but start right away with themes derived from nature. So strong is this tendency that we are not so much faced with a difficulty in moving away from the abstract as with a difficulty in putting down shapes and colours which do not turn out to be representational. Representation, indeed, would seem to be the natural result of using a paint-brush, and I do not wish to give the impression that we should necessarily begin with pure designs. These are helpful at the beginning because they serve to concentrate interest on some fundamental aspects of painting which are often obscured by the presence of the represented image. But there is no reason at all why we should not begin with 'themes derived from nature', and many people will in fact do so. But left to ourselves we would almost certainly discount our first efforts in this direction, and indeed would regard them as providing sufficient evidence of our inaptitude for painting. It is here that the principles established in the previous chapter may help, but it must be left a good deal to the individual to decide what use he makes of them. In an experience which has enabled me to deal with many hundreds of beginners I have found that individuality does assert itself at the outset, and that in painting things have a habit of taking an unpredictable turn which throws all neat categories and distinctions to the winds.

For example, it was urged in Chapter Two that the beginner

should select large sheets of paper and large brushes and paint out
vigorously in a broad, free style; but there are people to whom such
advice is anything but helpful. It is almost terrifying. I remember a
middle-aged woman who attended a class for beginners, and was
watching some younger students who were starting out in this free
style — and, to all appearances, enjoying themselves. But the effect
on this woman was not in the least encouraging; she was more
depressed than elated by the sight. She said to me, 'To paint in that
way scares me; everything that I do must be very neat and exact;
I cannot use a brush in that way'. It is useless to urge upon people
who feel like this a course of action totally at variance with their
instincts; they will have to start on a more reduced scale and with
more precise brush strokes.

This does not matter in the least. If people must start in a precise
way, let them not hesitate to do so; it will be their way of working,
and that can be no disadvantage to them. So long as we bear in
mind that our own individuality will be at work, building up a pic-
ture from whatever start we give it, we need not be concerned about
the actual mode of our beginning. We have seen the lines along
which we can approach representation, and in this chapter it is
proposed to follow these lines in certain directions which have been
found helpful on different occasions in the past.

Painting 'from imagination'. It is definitely recom-
mended that we begin by painting 'out of the head' or, as it is
sometimes called, 'from imagination'. It will be realized from the
last chapter that both these expressions are misleading, because they
seem to imply that paintings of this kind are wholly the result of a
mental effort; and this no doubt explains why it is that the very idea
of painting out of the head often appals people, as if it demanded
quite exceptional powers. It is hoped that this difficulty has already
been disposed of. The expression 'from imagination' is particularly
misleading in this connexion, because it creates the impression that
there are two kinds of paintings, imaginative and otherwise; and
that a painting done before an object belongs to the second class.
This of course is absurd; there never was a painting that came to
anything worth while that was not imaginative. Whatever may be
the source of a painting, whether from nature or not, at every stage
the painter's imagination is at work; and we can go a step further
and say that there is no need to make a distinction between paintings

made from nature and those which come out of the head. In one sense, all paintings come out of the head; in another, all are ultimately derived from nature; and it is not very useful to make a distinction which rests upon whether a painting has a known local counterpart in the world of fact. The likelihood is that we will discover counterparts in nature which we never knew existed, when once our eyes are opened to them by the painter's work.

We need not then approach 'imaginative' work as if it were something different in kind from work done before nature, and it has many advantages to offer at the start. It gives unlimited scope in subject matter, it does not entail the necessity of finding and deciding upon an object, and above all there is no object to be seen with all its details, in the light of a 'standard' to which constant reference must be made.

'Drawing out' a pattern. Now to consider how 'imaginative' paintings may be carried out. It is perfectly possible to 'draw out' a painting from a pattern of colours which are set down freely without any particular motif in mind. There is nothing mysterious about this. Colours and shapes have a way of evoking associations with the world of nature, so that almost any freely developed pattern is likely to give rise to certain definite suggestions. Blues and greens, reds and browns all have their counterparts in earth or sky; and if we look into a free pattern our fancy will discover a world in which rocks and cliffs, the sun and moon, vegetation and the sea, sunlight and shadow, hills and plains — all these and countless other suggestions exist in a vague or rudimentary state, to be brought out and developed as we wish.* It is essential in the first place that we put down a freely flowing mass of colours, which can be spread easily and worked about the paper with the brush. It is best to work rapidly and without hesitation. Then by painting on top of this preliminary pattern we can pick out and emphasize the suggestions we wish to develop, and in the process new suggestions may arise. (The technical means of doing this will be described later on.) Often the slightest suggestions are enough to work on, and

* Leonardo da Vinci in his *Treatise on Painting* says: '. . . if you are looking at walls with all sorts of stains on them, or on a mass of rocks of many colours, and if you have to paint a landscape as a background, you may see in the stains and the rocks images of various landscapes, outlines of mountains, rivers, crags, trees, broad plains, and manifold valleys and hills.' (Quoted by A. Vallentin: *Leonardo da Vinci*.)

when we have got the necessary starting point, the shapes and colours can be strengthened here, reduced there, lightened or darkened, painted out where not needed, and so on, the palette making its own contribution in the colours and ideas it suggests — the whole procedure being one of developing a more controlled and meaningful composition from an initial indefinite mass. It is a method which naturally does not lend itself to description, and we can but try it for ourselves. I have seen it work well on many occasions with beginners, and it is well worth giving it a trial. For those who can manage them, such paintings are exciting events. They germinate, grow and develop; they change, ripen and come to fruition — like a living thing that springs from the brush and is in a true sense a creation of the painter. Drawing here presents no difficulty; backgrounds and foregrounds come along together; and one is not proceeding from outlines to coloured drawings, but from broad masses of colour to the shapes that spring from them. These may be added to or changed, but they arrive without the conscious effort of 'drawing' them first. Such paintings, as indeed all paintings, are finished only when one feels that there — in that particular case — one can go no further.

Although paintings can be developed in this way quite spontaneously and without any planned idea of what is to come, it is of course true that our predilections, depending on our experience of nature and our disposition, will come to the fore in deciding what we look for and 'draw out' from the preliminary suggestions, and even at the start many personal factors enter into the choice of colours and the setting out of a free pattern. No two people will extract the same ideas from a given pattern, but it is hardly appropriate here to speak of a pattern as distinct from the person who created it. It belongs to him, it is made in his own personal idiom from the start, it contains his own flux of ideas; and he alone can develop it, as it were, from the roots. It may be that we begin with some generalized idea in mind, even if it is only the idea 'landscape'; or early on the pattern may take a form that makes us 'landscape conscious'. Under these conditions the colours and forms are looked for in terms of landscape motifs, while at the same time we will tend to set down motifs of this kind. It is important however even here not to force these motifs too deliberately, or we will be held up by the conscious effort of inventing them, and the flow of ideas will be limited by the appearance of the usual stereotyped

images — say field, tree, and haystack — which come only too readily when we confine ourselves to what we can deliberately think up.

Motifs from imagination. It is useless to discuss whether the method is difficult or easy; to some people it seems to come almost as second nature, while to others it is all but meaningless. Certainly there are people who find it almost impossibly difficult to strike out into the void with little or no idea of what is to come, and with such people it sometimes helps if they can have some concrete idea in mind as a starting point. There is of course no objection to this so long as it is remembered that the idea is only a starting point and that the picture which comes will be different, and perhaps altogether different; so long in other words as the idea is not seen as a fixed standard which must be realized at all costs. This is especially so in the case of people, probably only a minority, who think habitually in terms of powerful visual images; for them the danger is always present that they will try to capture an image in paint and feel disappointment at their failure to do so. But for most people the imagery is more vague, and it may be that just 'landscape' is enough to start them going; or more definite ideas may come through memories, not recollected in detail, but providing a general starting point which is something to hang on to at the beginning. Attempts to force the image, to conjure up details, will only add difficulty by rendering the image more static. But we should not forget images which are wholly imagined and remote from the experience of our workaday world. They can arise in a variety of ways. They can come through poetry or powerfully descriptive writing in novels, travel books, and the like; through a reconstruction of history — in particular, perhaps, the more remote history of classical antiquity with its associated hoard of highly descriptive legends; or again through a geographical sense, by the mere mention of a place or country to which we have never been. In this connexion it is interesting how words themselves can be the means of drawing out the imagination. 'Mediterranean', 'Blue Mountains', 'Egypt', 'Pacific Island' are all words that no doubt produce visual responses in our minds even though we may have no experience of their counterparts in the real world. These responses are no doubt highly coloured by reading and by hearsay, and also by photographs; nevertheless an imaginative leap is necessary for

each of us in order to piece together the scraps of information we receive into some coherent picture. In taking an idea for painting we shall often find it best to choose one which is not a conscious memory or too nearly related to experience; in this way the imagination is given full rein and is not tied to a visual reconstruction of actualities.

There is a difference of course in working from a very general idea like 'landscape', which may be left to take on any character, and one in which, however free we leave ourselves to work it out, there are certain specific characteristics or features we wish to incorporate into the picture. But there is no need to change our general mode of procedure. We can still start from a free assembly of colours, and from them extract the features we wish to emphasize; the difference will be that our choice and arrangement of the colours will be dictated by the picture-character we hold in mind. For instance, 'landscape' can be qualified by saying 'autumn landscape', 'sunlit landscape', 'moonlit landscape', or even 'tropical landscape', and in each case a different character is suggested. With 'autumn landscape' we might begin by setting down a matrix of oranges, reds, purples, browns, and from them build up the autumn character of the scene; while 'tropical landscape' might lead us to start with brilliant spectrum colours, especially perhaps the yellows and greens, with strong contrasting colours. The principle is that we use the brush to give us suggestions in the first place, and then these are drawn out and developed as the picture takes shape. This is very different from using a brush to impose a preconceived picture; it means that the painting grows out of its own roots, and is in turn a product of the sort of roots we give it.

Thus it is not difficult to see how suggestions of many different kinds can be brought into a painting. For instance, we can qualify our autumn landscape further by saying 'cottage in an autumn landscape'. In introducing a specific item like 'cottage' we are faced with having to fix its setting in the picture. But there is no need to visualize a particular cottage or even a particular setting for it; it is above all a cottage in our landscape painting, and its character will be as much a part of the painting as are the autumn colours themselves. We could begin as before with the general landscape colours and see how a setting for the cottage arises out of the massing of the shapes and tones. We might find that a red, yellow, grey, or white fits into the scheme, and at first a patch of the colour is all

that is necessary to establish the relationship of 'cottage' in the picture space. The form we give it finally, and its degree of detail, will depend on how we develop the other forms, for 'our' cottage will take its place in 'our' landscape. Whether detailed or generalized, strongly patterned or set in space, it will be a product of our technique at this stage. We might on the other hand suggest the relationship of 'cottage' at the outset, by placing a patch of, say, pale yellow on the paper to begin with, and then the question asserts itself more definitely where to put it, and what size to make it. But this need not concern us if we can see that, wherever it is placed, and whatever the size, it will establish certain relations in the picture space and the other forms will take their place in relation to it. If we make it large, it will simply have a more prominent position and will come nearer to the foreground; if small, it will take a more distant position, and we will be less 'cottage conscious' and more 'landscape conscious'. We might place it left, right, or centre on the paper, but no matter; it will simply mean that the painting will take a slightly different turn in each case, and we need not be troubled by constant revisions of its position and size. Again, the colour we start with will influence the colour scheme that follows, and if we start with pale yellow, this will at once set up different relationships from red or grey; and the particular pale yellow we use will also make its influence felt, and though we may modify it later on, at first we need not hesitate to keep as our starting point the yellow that comes from the palette.

If this principle of working has been made clear, there will be no difficulty in extending it to a landscape which is more qualified still. We might wish to develop a landscape which incorporates several specific features: fields, hills, trees, cottages, winding paths; or our fancy might turn to a waste and rocky territory with stagnant pools, dead tree trunks, and overhanging branches. Under these conditions the question which puzzles people is how to make a start which will somehow accommodate all these features; and more specifically the problem is which item should be selected as the starting point. But we have already seen how this question can be answered. There is no need to visualize a settled arrangement of these features, and it is not a question of proceeding in formal rotation from one item to the next, as is often the tendency in beginners. At the start things are in a fluid state, and we are feeling our way with suggestions of colour and shape. It is true to say that any inconsequential marks put down at the outset are invaluable

aids in starting us off; they are the first tentative feelers in the organized creative act of painting, and may set free our store of pent-up ideas which only need to be liberated. Paintings of the most varied kinds can grow out of the slightest suggestions even when we feel — I am tempted to say especially when we feel — that all our creative resources have dried up. We may find that a particular item immediately suggests itself as a starting point, but if it does not it is often a good plan to begin by establishing a general pattern of landscape colours, and let the formal arrangement of specific features spring out of the setting which arrives. In this connexion it is worth remembering that it is often better *not* to start with features which come prominently into mind, but at more remote points: it is easier then to feel free in putting down the colours, and we are not so likely to attempt to isolate our main features and separate them from a mere background that fills up the spaces. Some people find it convenient to start with sky colours, which can be broadly treated, and which incidentally help to create conditions of light which modify local colours, as will be made clear in the discussion of light and colour in Chapter Eight. It may be, however, that the character of the landscape we have in mind suggests some definite form which needs to be seen at the outset, as for instance if an overhanging branch in the foreground is going to establish a sweeping curve which will be echoed in other parts. A feature of this kind might then be made the starting point, and once down as a preliminary statement it begins to set the stage, and the rest will follow. That is to say, we may hold in mind this character of 'sweeping-curve-in-foreground', but not till we have put down an actual curve, in certain colours and with a certain brush on a certain piece of paper, will we know just what its character, derived from a creative act, is going to be. So for the rest of the features we hold in mind.

I have seen imaginative paintings of the greatest variety which have been built up along these lines. It often happens that people will reveal their own special interests which they draw upon in their paintings. I remember a woman student who was especially interested in the civilizations of the East and of classical antiquity, and she painted Tibetan landscapes and reconstructions of Grecian, Egyptian, and Babylonian themes (for example the 'Hanging Gardens of Babylon'), in pictures of great individuality. Yet when she first considered the idea of painting she was quite sure it was beyond

her, and began with the greatest trepidation. And I recall another
student who was interested in the sea and ships, and who painted a
series of pictures not only of traffic on the waters, but of underwater
marine life: a world hidden from view. I mention these examples in
order to show that there is simply no limit to the range of invention
in imaginative work, and indeed a limit is only set when we con-
sciously restrict ourselves to conventional themes, to the sort of
pictures we think we ought to paint, which are often enough scenes
of artificial prettiness having no connexion with what is really our
concern.

I hope I have made it clear that the principle of the organic
growth of a painting out of its beginnings is one thing, but that the
form these beginnings may take is another. Not everyone will
proceed by developing free-flowing patterns of colour, and indeed
there are people — like the woman I mentioned who felt she had
to make precise statements — who find that this method simply does
not meet their case. They will not aim to get at the start anything
in the nature of an 'over-all' effect which is worked up to more
meaningful shapes; they will paint out directly the shapes they mean
to keep to and the picture will gradually come to completion as,
brick by brick, more colours are added to the edifice. They will
need a great deal of encouragement, because the white paper will
only gradually be covered and the picture will go through stages
when, the paper only partially covered, everything will look
disconnected and out of joint; but if they will persevere they will
find that this method of working is perfectly capable of achieving a
unified result. Indeed, some of the most interesting pictures I have
seen from a beginner's brush were painted by a man who always
started, not by covering the paper with broad masses of colour, but
by working in small dabs and patches, which were not localized in
particular areas but scattered through the painting. The effect in the
early stages was rather like that of a patchwork quilt. As the picture
space was filled up the patches were all brought together, like the
pieces of a jig-saw puzzle, and in the end the picture presented a
medley of varied colours, having the rich texture of a tapestry. I
do not mean to suggest that he did not change some of his colours
by painting over them as things proceeded; but the painting did
develop in this patchwork way. Now to a person who works like
this, the idea of covering the paper with a broad pattern of colours
at the start would simply make no appeal, and would destroy the
individuality of his work.

Again, some people find it very helpful to begin by drawing with a pencil or charcoal; and here it will be realized that it is not lines as such which create difficulty, as the effect they often have of presenting deliberate static shapes which, furthermore, are often felt to 'be wrong.' But where a person is able to ignore these factors, and where the need for some preliminary lines is strongly felt, they can be useful means to an end. A few very rough lines with a pencil can often be the starting point of a picture which afterwards loses all sense of restricting linear divisions, the lines being mere props which are afterwards covered with paint.

Re-creation of nature. The method of starting from a free association of colours is, however, very generally useful, and it helps to illustrate another aspect of painting. In speaking of the method we used expressions like 'drawing out' and 'extracting', meaning that shapes and colours are selected from a varied mass and reduced to more settled order, and made more meaningful and controlled. This is a very good clue to the treatment of nature itself, when we come to paint direct before an object or scene. The world of nature is revealed to us in all its variety and profusion, while painting bears witness to the distinctive human work of selection and arrangement, which is the essence of a creative process. The difficulty in painting before nature is this profusion of detail, and the tendency is to try to put too much into a picture. We might speak of the confusion of nature, for everything lies before us indiscriminately, often from our point of view badly disposed, and wherever we concentrate our gaze we are met with detail upon detail — the separate twigs and leaves of a tree, the innumerable facets and markings on a garden path, the minutiae of the grains of wood in furniture. We have to draw out what we need and simplify nature according to our requirements. Yet for our purpose this is not only a matter of selection, as if we were cutting out bits from a photograph and putting them together again in a simplified re-arrangement. It is a two-way process: there is the drawing out and selection from nature, and there is the adaptation of what is selected to the needs of the picture space. With simplification goes re-presentation. Yet the two are scarcely separate, for we are bound to simplify as soon as we use a brush, and we must re-create as soon as we handle a medium. In practice we put down colours and shapes that arise out of the suggestions we see in nature, and these

are built up and arranged on our paper as before. There need still be no preconceived picture, for what we 'draw out' and 'simplify' from nature are not mental pictures, but brush-marks and colours on paper. It is these which will be the source of our imaginative re-creation of nature.

Suggestions for a still life. Suppose we have before us a simple still life, consisting perhaps of a blue jug and some fruit on a tablecloth, with a coloured curtain behind: how are we to set about painting it? In truth we may feel that these objects offer little to stimulate us, and we might conclude that first of all we should address ourselves to the task of studying them, in the hope of being able to formulate ideas about the proposed picture. But it has to be remembered that what our observation reveals to us *as painters* will be closely bound up with our use of paint; and what this still life is going to yield to us — the sort of picture it will enable us to pro-duce — will be a give-and-take between our observation of this group of objects and our reaction to the effects of shape and colour we put down. Therefore the sooner we put something down the better, because the sooner then this give-and-take can get under way. Let me illustrate what I mean. We look at the still life and see the play of light and colour about the objects. The blue jug assumes a prominent position and sets a strong note of colour, and we might feel that this is the natural starting point. But it has already been said that it is not always a good plan to start painting from a prominent object, and we have seen that backgrounds can help to create the form of objects which stand out against them. We might therefore begin with a touch of crimson which is suggested, let us suppose, by the curtain. This note of crimson illuminates one area of the paper, but it does more than this: it lights up for us the still life in a new way. When we look at it again we carry with us the consciousness of our effect of crimson, and now we might suddenly see how a pale green from an apple is just the colour that would react against it in a way we would like to investigate. So we mix up a pale green and put a touch of it at some distance from the crimson; now a new effect is brought into being, and we carry this effect with us as we look once more. So we are stimulated to make fresh dis-coveries. Thus if at first we were inclined to look upon our assembled objects as lacking in interest, we can now see them in a very different light, for they are constantly lit with new meaning in the interplay

that goes on between them and our painting. In this way painting
gives to observation an interest which cannot be obtained by any
other means, for however much we may train ourselves to observe
the objects of nature set in light and space, it is only when we paint
ourselves that we can see these objects illuminated by our own
creative endeavours.

Perhaps now we will be impressed by the luminous shadow on an
apple, the shadow taking on a suggestion of crimson by reflection
from the curtain. We find that by mixing green and crimson
together we get a grey that also reflects crimson, and we put this
down somewhere near the pale green. It helps to bridge the gap
between the two contrasting colours, and it increases our awareness
of shadows. We look for more shadows that reflect crimson, and it
will not be long before we are searching the blue jug which, with
its glazed surface, takes on lights and reflections from all directions.
So we are led to what may be the primary motif of the painting,
but in coming to it we have gathered a varied experience, which
we bring with us in our observation and treatment of the jug. Of
course it is not pretended that this is necessarily the order in which
we make our discoveries; it is a general anatomy of approach and
not a case-history. We might have made the jug our starting point,
in which case our discoveries would, as it were, spread themselves
outwards from the jug to its surroundings. The important point is
to see the relation between our observation of nature and the
creative activity of painting. We try to see the group as an entire
thing from the start and do not treat it item by item; its inter-
connexions are gradually perceived as we are led from one point to
the next — led by our interest into increasing awareness of what is
offered us.

And what do we have in the end? In the first place the painting
is evidence of an adventure of discovery we have made for ourselves
and is therefore nothing copied or secondhand. It will be in the
broadest sense a pattern — and every painting is in one sense a
pattern. But it is also a pattern derived from a particular facet of
nature, a corner of the world that has been lit for us with excitement
and meaning through the medium of paint. And moreover I would
say this, as a result of my experience: if we have been working
disinterestedly in the world of our perceptions, and not trying to
carve out slices of nature and fix them to our painting, we may well
be surprised at the way in which the painting is a true representation

of the objects we have been working from. By losing ourselves in our activity we will gain, what we could never gain by deliberate attempts to copy, a world of re-created objects that carry with them conviction, and this despite the fact that our shapes may not correspond 'accurately' with those of nature. At first we may seem to have lost something — the world of objects which we know and handle; but in the end we will have gained them in greater force than before. Paintings that are genuine expressions of sensibility take on a reality of their own, and only so can they make a reality of what they present of the world of nature. It is a reality distilled in the essence of experience and, like all true experience, it carries conviction with it. And with this heightened sense of reality goes a sense of completeness, which is the result of the entire unity of feeling throughout the painting. Nature is reorganized, and the little world of the picture space is at one with itself. This sense of unity is a remarkable feature of beginners' work. Perhaps their very inexperience, and their lack of awareness of technical tricks, are real assets in enabling them to rely on their own sensibility, and so to produce pictures which are whole things. (Later on, when we think we are getting more expert, the danger is that we will try to make technique a substitute for sensibility, and then nothing but disaster faces us.) The 'wholeness' of a painting is perhaps one of its most satisfying qualities; it involves colour, shape, technique — everything that goes to the making of the picture; and in itself it is quite independent of superficial likeness to nature. The word 'distortion' is sometimes applied to shapes which do not accurately reproduce those of nature; but the word has an uncomfortable sound, because it seems to imply a deliberate attempt to falsify, which is no part of our intention. Distortions are convincing only when the final effect is one of integration, when they enter into the unity of feeling in the painting; and *deliberate* attempts at distortion for distortion's sake are often far from convincing.

Of course, in speaking of our approach to a still life painting, we have touched only the fringe of its possibilities. For instance, we have spoken about 'touches' of colour at the start, but these touches may in fact be much more in the nature of a freely-disposed pattern. And again, we have spoken about shadows and reflected lights, but we may be more interested in the jug for the sake of its blueness than for the sake of any modulations of light and colour on its surface. Under these conditions we might start with a 'flat' blue shape

derived from the jug, and then we might see the curtain as a mass of crimson which would enter into relationship with this blue; and then we might find that, for the sake of contrast, we need to emphasize the yellowness of the apples, and we might represent them as yellow or yellow-green areas suitably placed in relation to the crimson and blue. The result might be that we find ourselves working towards a painting in which colour is emphasized, and effects of light and shade suppressed; and the shapes of the still life would appear as components in a decorative pattern in which the colour is unmodulated, and therefore flat, and confined to separate colour areas. We might like this effect and wish to embellish it, and this could be done by adding more decorative features in the way of lines and other patternings. Lines that encircle shapes tend in any case to flatten them by drawing attention to their contours, and so in flat patterns lines and other embellishments naturally take their place.

Again, we might make a preliminary statement in blue and then find, on looking at it, that crimson is not the colour we wish to put beside it; we might feel that we want to throw the blue out more strongly and that yellow is the colour we need. So then, for the purposes of our painting, we change the crimson of the curtain to yellow, and having done this we will now see the apples in a different light — in say a more red light than before. Thus it is that an ever-changing relation goes on between our painting and whatever aspect of nature is before us. So far, for the sake of convenience, we have considered a still life, but if for this we substitute 'landscape', or 'girl reading', or 'the summer-house', we need not alter our line of approach. We have at hand the means by which we can ourselves start on the great adventure of discovering nature anew with a paint-brush. The field is inexhaustible, and in a lifetime we will not feel that we have more than scratched the surface.

Abstracts again. Although representational pictures, whether painted directly from nature or not, will probably provide our main interest, we should not forget the wide scope and appeal of abstract paintings. The word 'abstract' is not a good one, and indeed is rather misleading. It suggests the idea of remoteness from nature, and of the painter's succeeding in abstracting himself from life itself. That is quite a mistaken idea. We have already seen that a great part of the appeal of nature is abstract in the sense that it

does not depend on being 'something', and we have had reason to see that the habit of always having to recognize objects is an effective means of depriving us of much of nature's beauty. Abstract painting confines itself to one side of nature, the side in which the reality of objects is lost sight of in the interests of relationship and design, but it is not for that reason 'unnatural.' In painting abstract pictures we are not becoming abstracted individuals or losing contact with nature; and for many people, to look at nature for its abstract qualities is a new experience and a new incentive to paint.

In this book abstract work has been taken as a starting point from which we have gone on to consider representation. But it has already been pointed out that this order of events by no means necessarily follows, and certainly there is no intention to imply that abstract pictures are in any sense inferior or anterior to the representational. On the contrary it can be seen how closely knit the two are, and it would be hard indeed to draw a distinction between shapes which are purely abstract, and others which are 'abstracted' but have not lost the element of representation. The very word abstraction means taking away and withdrawal, and this sufficiently describes the painter's treatment of nature; but unfortunately the word is often taken in its meaning of something purely theoretical.

Abstract painting tests our inventiveness and our perception, and calls for a reliance on nature, no less than does representation. If we go on painting abstract pictures, and at the same time cease to have any real contact with the forms of nature, we shall find that we repeat ourselves endlessly and our invention, lacking all stimulus, will dry up.

Abstract paintings are not necessarily flat patterns, and a sense of volume and recession can be obtained by the relationship of colours and tones which advance or recede from one another. Colour itself is given full scope and is limited only by the resources of the palette — and of course by the shapes themselves, for we shall find that in a certain context, shapes will 'carry' certain colours and not others. The contours and shapes of nature are infinitely varied and may be echoed and brought to order in the harmonies of line and shape in an abstract painting. There are the obvious contrasts of uprights, horizontals, and diagonals; of smooth curves and jagged rocklike shapes; of circles, ovals, pyramids, and rect-angles. There are shapes that radiate from a point, as in the petals of a flower and the 'rays' of the sun; the whorling shapes of leaf

buds and the fan-like shapes of leaves on a stem; the arch-like shapes of the overhanging branches of a tree. There is the entire tranquillity and repose of the lines of a calm sea, and by contrast the vigorous descending lines of a waterfall; and if we look at nature more closely still, there are the myriad shapes of individual living forms.

All, as I say, is brought to order in a painting, and to a sense of balance; but with balance goes stability, and too much stability is inclined to be rather dull. A circle can be described as harmonious and balanced, but by itself it would not hold our attention for long. With harmony, vitality is required, and this is brought about by the interplay of relationships that are not too easily or too obviously perceived, as they are in the exact repetitive patterns of a wallpaper frieze. In this connexion I have often heard people complain that they are unable to get certain shapes completely symmetrical or repetitive, when it is the very asymmetry of their designs that give them rhythm and vitality. Repeating and undulating shapes set up movement and rhythm by carrying the eye on from one point to the next, and may be set in contrast to the more stable uprights and horizontals. Sometimes one shape will take dominance over the others and will establish the main theme, to be echoed and contrasted in other parts of the painting.

There is another respect in which abstract paintings can symbolize effects in nature. Every surface, quite apart from its colour and shape, has a texture of its own, which is characteristic of the material itself. In paintings, effects of texture can be induced in a variety of ways by the manipulation of the paint, as will be pointed out in the sections on technique; and the brush also, by spottings, stipplings, hatchings, and other treatments can be made to create effects of surface texture.

5 □ paints and pigments

Technical knowledge. Every trade and craft has its own technical side, and this is probably its most frightening aspect to the uninitiated. Even an ironmonger's shop can present difficulties in this respect, for we can find that nails and screws are to be distinguished by terms which are outside the vocabulary of the ordinary person. The law itself is well known for its technicalities, which render it inscrutable to the layman: the effect of such technicalities being to make matters appear obscure which are perfectly straightforward when once the technical expressions are understood. Every activity, even lawn tennis or cricket, must make use of specific terms to give a precise meaning to those who are engaged in them, and painting is no exception. Artists' materials necessarily call into being their own terms of reference, which seem to bring with them an aura of mystery, but this disappears when once their meaning is understood.

To go into an artists' shop for the first time is to be thrust into a new world of tubes, brushes, canvas and the like, about which we may know little or nothing, and we are inclined to feel at a distinct disadvantage in asking for whatever it is we want. Indeed, we may have only a vague idea of what this is.

The purpose of this chapter is to explain in simple terms what the beginner needs to know about the most fundamental of all the materials used by the painter — his paints and pigments. Here, as elsewhere in this book, we start at the beginning, and no previous knowledge is assumed. It can be said at once that the whole matter for all practical purposes will be found much more simple than might be imagined, and a few guiding principles will provide us with the key to an understanding of these materials, and the rest will follow from our own use of them.

To the painter, a knowledge of materials has far more than an academic interest. Painting involves a constant handling of materials and to be in ignorance of them is to be working to a great extent in

60

the dark. We shall then find ourselves tied to a routine of rule-of-thumb methods which make no appeal to the understanding and do not explain themselves. Furthermore, we are all inclined to stand in fear of the unknown, and knowledge can help to promote confidence. What we have knowledge of we can also control, and all painters will like to experiment with their media. This can only be done intelligently when we have the requisite knowledge. Of course a great deal of this knowledge is bound up with experience, and is the kind of thing we must find out for ourselves; but on the other hand there are facts which no amount of experiment will teach us, and which in any case are more easily acquired by reading. As with all branches of knowledge, the facts are much more easily assimilated when our interest is aroused; and this chapter will take on a different complexion when the reader has made himself familiar with paints and pigments by actually using them.

Essentials of paints. Let us begin by considering what painting consists of, when considered purely from the technical point of view. It is nothing more than the application of a pigment to a flat surface in such a way that the pigment adheres permanently to it. The various media of painting deal with this problem in different ways. The simplest case to consider is probably that of a pencil line drawn on paper. Here the pigment is graphite, a form of carbon, and the mark it makes is simply explained by the fact that the pressure on the pencil causes minute particles of the soft graphite to come away on to the relatively rough surface of the paper, just as a file will tear off particles of a metal dragged across it. No adhesive is necessary; the particles adhere directly because they are exceedingly small and become enmeshed in the grain of the paper. With a hard pencil the particles are attached so firmly that they cannot easily be disturbed by rubbing with the fingers; but in the case of a soft pencil, from which more of the pigment comes away, the particles are not attached so well and can readily be smeared by rubbing.

A lead pencil can be considered as a medium of painting in monochrome — in various tones of grey. But for most people painting implies the use of colour, and here the simplest medium to consider is that of pastels. Pastels are in essence similar to chalks. They are softer than pencils, and when they are made to mark paper more of the pigment comes away, and the particles transferred to the paper are larger and coarser. These particles are therefore

only very loosely attached and may easily be rubbed off, and a pastel painting has to be protected from damage by setting it behind glass. But so long as it is protected from damage it has great permanence, and many eighteenth century pastels have retained their brilliance to the present day.

Here then is the simplest and most direct way of performing the technical operation of painting — to apply the solid pigment to the surface so that it adheres at once. But such a method is restricting in many ways. Again for most people painting means using a brush, and for this purpose the pigment must be applied in a liquid or semi-liquid form. To accomplish this, the solid pigment is ground to a fine powder so that it can be contained in a liquid medium and spread with a brush; and the problem is then one of ensuring that the particles will adhere to whatever surface is painted on.

The most obvious liquid to use is water and the most obvious fixing material is gum. This is actually what is done in water-colour painting. The powdered pigment is mixed up into a paste with gum: this constitutes a water-colour paint. When the brush is dipped in water and applied to the paste some of the gum comes away with the pigment, which when painted out on paper is stuck to the surface as soon as the water has dried off. It is essential that the pigment should be ground very finely because large particles could easily be dislodged and rubbed off, apart from the fact that they would create an unpleasant grainy effect. In very thin washes of water-colour, where the paint is much diluted with water, the amount of gum is very slight, but the particles are so small that they get caught up in the interstices of the paper and adhere directly, just as do the particles of graphite from a pencil. In the thicker types of water-colour known as gouache (which we will go into later on), where the paint can be put on in quite thick layers, the gum is essential to make the pigment stick to the paper.

The principle of using gum with water is very old. Before oil painting was discovered many pictures were painted in what is called tempera, which in principle is a thick type of water-colour in which the gum is obtained from the yolk of egg.

To-day a 'plastic' substance has replaced gum as the binding material in water-colour paints of the 'plastic emulsion' variety. This material differs from gum in that, when dry, it becomes completely waterproof and fixes the pigment in such a way that water will no longer affect it.

Since the discovery of oil painting, the oil medium has taken precedence over all the others, and is the most popular one to-day. The essential principle of oil painting depends on the property of certain oils to 'dry' when exposed to the air. Of these 'drying oils', as they are called, linseed oil, obtained from the seed of the flax plant, is by far the most important. The word drying as applied to these oils is misleading, as it suggests a comparison with the drying of water. It actually means something quite different. When we say that water dries we mean that it evaporates into the atmosphere and disappears altogether in a state of vapour. Now the oils we are concerned with do not evaporate in this way. The majority of oils with which we are familiar, including all lubricating oils, remain oily for an indefinite time in the air; or else, like petroleum and paraffin oil, they evaporate as does water. But in the case of the drying oils a slow chemical reaction takes place when they are exposed to the air, the effect of which is to change their nature altogether. The oil absorbs oxygen and turns into a transparent, slightly elastic solid called linoxyn. It is this change from liquid to solid which constitutes the drying of the oil. The solid adheres very strongly to the surface on which the oil is spread and so provides the means of another method of getting a pigment dispersed in a liquid to adhere to a surface, and a method which offers certain advantages over the water medium.

All that it is necessary to do is to grind the finely powdered pigment in linseed oil, which being transparent and practically colourless does not obscure the colour of the pigment; and we now have an oil paint. When this is painted out the particles of pigment are enclosed in a film of oil, and when the oil dries they are firmly locked up in the linoxyn, which serves the double purpose of binding them to the surface and of protecting them against damage. It also bestows a characteristic depth and lustre on the colours themselves, and it is here perhaps that the main attractiveness of oil paint resides.

There is nothing, therefore, very complicated about 'oils', as painters call them: they are simply finely ground pigments contained in linseed oil. Just enough oil is added to make the mixture of a soft buttery consistency, as this is found most convenient in use. House paints are essentially the same, except that they contain more oil in relation to pigment and hence are more liquid; and they usually contain certain other ingredients, such as varnishes and what are

called 'driers' — chemicals which have the effect of speeding up the drying of the oil, a matter of convenience in house painting.

These then are the principal methods by which the painter solves the technical problem of applying a pigment to a surface: direct application of the solid pigment so that it adheres at once; application in water, with gum or other adhesive; application with linseed oil as binder. Each of these methods brings into being a distinct medium of painting, whose special problems we will consider in later chapters.

Essentials of pigments. We have spoken a good deal of 'pigments', and it is now time to make it clear what we mean by the word. It should be mentioned that the same pigments are common to all the media of painting, the only difference being in their mode of application and the means by which they are made to adhere to the surface. Pigments are solid, coloured substances which are capable of being ground up into fine powders. They remain solids always; that is to say they do not dissolve in water or linseed oil, as sugar dissolves in water, but the tiny particles remain dispersed or suspended in the liquids. Substances contained in coloured solutions, whose effect is merely to stain a surface, do not constitute pigments for painting.

Two types of pigments can be distinguished. The first are the true pigments: solid mineral substances which are either dug direct from the earth and are ready for use after suitable treatment and grinding (hence they are called the 'earth colours'), or they are compounds made artificially by the chemist. But in addition to these there are dyestuff colours which again may be found in nature (a well-known example is the red dye obtained from the root of the madder plant), or they are manufactured artificially. Now these dye colours typically form true solutions, and hence to be of any service as artists' pigments they have first to be rendered in a suitable insoluble form. For this purpose they are brought into association with some insoluble intermediate substance (such as alumina), which acts as a substratum on which the dye colour is deposited. This is essentially a dyeing process, the intermediate substance playing a part similar to that of cloth when it is dyed. Pigments made in this way are called 'lakes'. Some dye colours, however, can be made directly into pigments without this preliminary treatment; but it is true to say that dyestuff pigments in general are not so satisfactory as the mineral

pigments. They are inclined to retain the unpleasant staining quality of dyes, and in oils they have a habit of 'breaking through' other colours painted over them. It is best therefore to restrict ourselves as far as possible to the true pigments.

Colour range. It is obvious that there is a vast output of colouring matters of every description from industry to-day; we see them on all hands in coloured fabrics, on advertisement hoardings, and in the rather startling brightness of plastic goods. It might therefore be thought that the painter has at his command an unlimited number of potential pigments, and that he has only to think of a particular colour he needs, to find a pigment which matches it. This most emphatically (and perhaps fortunately) is not so. The number of satisfactory, true solid pigments is strictly limited; and although dye colours are poured out in the greatest profusion, there is a factor which renders all but a handful of them valueless to the painter. This is the question of their resistance to fading in daylight. We all know that colours are liable to fade, and some more than others; and the fact is that the majority of dye colours are not sufficiently permanent to be worth considering as materials for painting. This single factor indeed — resistance to fading in the light — is the first requirement of any potential pigment. It is a sort of limiting factor; it is not that a light-proof pigment is necessarily a good one, for it may have little strength or have no very useful colour, but unless it exhibits this quality of permanence it cannot be considered at all.

The result is a great simplification of the question of artists' pigments, and the beginner can take heart at once. He is not confronted with a bewildering mass of equally desirable pigments from which he has to make an invidious, hit-or-miss selection. He will find that his choice is extraordinarily limited — strangely so, for it is surely remarkable that despite technical developments in the field of paints the range of artist's pigments has not been greatly extended in modern times. This is not to say that a glance down the list of any artists' colourman will not present us with a sufficiently lengthy string of names, but it has to be remembered that these lists include pigments which are not — and are not claimed to be — permanent: they are supplied because they are useful for certain purposes where permanence is not an important consideration. Then again many of the pigments listed are dye colours and these, as we have seen, are

best avoided where possible. It should also be noted that one basic material can exist in several varieties, which are not always recognizable from their names. Thus there are many varieties of ultramarine, some of which go by the name of new blue, French blue, and permanent blue; there are varieties of Prussian blue called Antwerp blue and Chinese blue; there are many colours which are derivatives of the basic dyestuff alizarin. Naturally all this makes the list appear more formidable than it really is; and when we narrow everything down we shall find that, for each principal colour, the range of fundamental pigments is quite small, and our problem is to make the best selection from those that are available.

Each pigment (allowing for the existence of different varieties) has a colour which is constant and characteristic for the material itself. Thus it is not surprising that the name of the pigment comes to stand also for its colour, and this gives rise to a situation which is often puzzling to the beginner. His instinct at first is to refer to his pigments by loosely describing their colour, as for instance 'dark green' or 'bright red.' But these words are very indefinite and unspecific, and may mean different things for different people; and the painter is in the habit of referring to the 'colours' he sets out on his palette by the actual names of the pigments — as say 'viridian' or 'cadmium scarlet' — for these names not only convey a more precise reference to colour, but also serve to indicate other characteristics of the pigments concerned. The beginner will undoubtedly find it most helpful to adopt the same nomenclature himself, which will come naturally enough when he has had some experience of handling his materials.

Transparency and opacity. Each pigment has an individuality of its own, which is a product of its physical properties, and this is one reason why it is best to use only a few basic pigments and rely on mixture to supply the other colours we need. In this way we can get to know the characteristics of the pigments we use and exploit their potentialities to the full. These characteristics can only be fully realized by experience, but it will be well to say something about them now, so that we will be forearmed with the knowledge of what we are to expect.

We are all aware that different coloured surfaces have different qualities of colour, quite apart from their differences of hue. Thus, to take extreme examples, we know that a red brick has a different

kind of colour from a piece of red glass, and we sense instinctively that this difference has to do with the character of the material which carries the colour and with the behaviour of light with regard to it. A brick's colour is, as it were, 'solid' and all on the surface, because the material is opaque and the light does not penetrate it at all; whereas glass is transparent and its colour does not show itself unless the light which penetrates it is reflected from a white ground underneath, and this gives to the colour a quality of depth.

Great as these colour differences are, they are not greater than those which exist among pigments. An example will help to make this clear. If we take some rose madder, in oils or water-colour, and paint it out strongly over white paper or canvas, we will find that the ground is not hidden but can easily be seen through the layer of paint. In other words the pigment is transparent, the light simply passing through it to the surface below. If now we take the pigment Indian red and treat it in the same way we shall find that its behaviour is very different, for at once it begins to hide the ground and, if used in any thickness, will obscure it completely. In other words the pigment is opaque, and its capacity to obscure the ground is called 'hiding power'.*

Now some pigments are naturally transparent and a film of the paint behaves like a piece of coloured glass; it lets the light penetrate it and the ground show through. Thus transparent pigments have a luminous look (this is particularly apparent in oils), because they are lit by a light which glows through them, reflected from the ground underneath. Indeed light reflected from the ground is essential for their colour, so that if they are painted on dark grounds they practically lose their colour altogether; and in thick layers, where the light is not strong enough to reach the ground and be reflected back, they look blackish. This is particularly apparent in the case of the dark greens, blues, and violets, which will hide a ground with a blackish layer if applied thickly enough. For this reason transparent pigments exhibit a quality which might be confused with hiding power, but in reality it is quite different. True hiding power is a quality of pigments which reflect the light and which when applied thickly retain their colour.

* Hiding power is sometimes loosely referred to as 'covering power', but the latter is a technical term which strictly speaking has a different meaning: it refers to the power of a paint to form a satisfactory film over a given area. Hiding power is therefore the better term.

Opaque pigments have none of the luminous quality of the transparent ones. Their colour lacks 'depth', because it comes by direct reflection of the light from the surface of the pigment. Hiding power is of course related to the way a pigment is used; if very thinly applied, as in water-colour washes, no pigment will obscure the ground under it, but in the case of opaque pigments this is merely the mechanical effect of dilution, and they show their true character as soon as they are applied in any strength.

The quality of transparency and opacity enables us to distinguish two methods of applying paint to a surface. The one relies on the effect of transparent colour placed thinly over a white ground, which then becomes the sole source of 'whiteness' in the painting. If white itself is needed the surface is simply left blank, and the colours are paled to any desired extent by varying their thinness over the ground. This is the technique of the traditional water-colour. The other is an opaque technique, in which solid opaque colour is used on grounds which need not be white, and 'whiteness' is supplied by the use of white paint, which is freely mixed with the pigments when it is necessary to pale them. Hence the transparent pigments are especially valued in water-colour, and are not so valuable in oils, which as used to-day is typically an opaque medium; but it is unlikely that we will restrict our palette to one or the other, for there are not enough of either to go round. In oils, however, transparent pigments are freely mixed with opaque ones, especially with white, and are thus rendered opaque in mixture. Actually the two techniques are often combined; in an opaque technique, for instance, colours are often used thinly so that part at least of the ground shows through. Transparency and opacity are therefore somewhat relative terms, and this is emphasized by the fact that no rigid dividing line exists between pigments which are transparent or opaque; some are more opaque than others, some more transparent than others; some could be described as semi-opaque, others as semi-transparent. The distinction between the two is, however, an important one and makes itself apparent as soon as we start handling paints, and for practical purposes it is generally possible to classify a pigment in one or the other category.

Staining power. We shall find that pigments differ a good deal in their strength or intensity, as revealed by their ability to impart their colour to other pigments with which they are mixed.

For comparative purposes this is shown most clearly by their behaviour when white is added to them. Then it will be found that some pigments, such as terre verte and rose madder, are rapidly paled to the lightest tints, while others, such as Prussian blue and Indian red, are paled more gradually. This power of pigments to impart their colour to white (and so also to other pigments) is referred to as staining or tinting power. In practice it has great importance, because to a great extent it determines what use can be made of a pigment. A pigment which has very low tinting power, like rose madder, has little use by itself, and is mainly employed for introducing slight modifications into other colours.

Permanence. Another aspect of pigments to which we must turn is their permanence, that is their ability to retain the quality and brightness they possess when first painted out. We have already mentioned the matter of fading, and we shall find that there are other factors to be taken into account.

The reader may, however, feel some impatience at this talk of permanence, and may feel inclined to say that as he only wishes to paint for his own pleasure he does not see how the matter vitally concerns him. But the question is really whether, in the long run, painting can give pleasure if the continuity of the physical product of the activity is ignored. In point of fact, to go on painting pictures which are destined to crumble into ruins will only invite a feeling of futility, and will lead to a loss of interest in the work done. It will not draw out our fullest powers of concentration, or give us the conviction that what we are doing has any importance. Not that work which is permanent is more important for that reason, but unless it has the elements of permanence it forfeits our confidence. In the end we will only toy with a medium which we know at heart to be untrustworthy. It is after all the nature of painting to create a permanent, tangible, visible object; it is not like projecting a picture upon a screen, which is there for a moment and then disappears into the darkness, or like drinking wine, whose flavour is relished and then quickly becomes a memory: it is meant to have continuity, to have relevance for the future.

It so happens that nature has limited the painter by providing him with only a certain number of reliable pigments, and he keeps within these limits. We may as well do the same, because to go outside them will not be an advantage, and in the end will only spell disaster.

First then to consider more closely the question of the permanence of pigments in the light. What do we mean by saying that a pigment is 'permanent'? The word needs some qualification, because as applied to artists' pigments it is not always used in any absolute sense. There are, indeed, pigments which are absolutely permanent, that is to say even in the thinnest layers they will not fade at all, but the number available in this class is not usually found to be sufficient to provide a wide enough range of colours in a palette. Hence we have to go outside this completely safe class and draw upon others. Of these, a fair range of pigments exists which are usually referred to as permanent, by which is meant that they are considered to be permanent enough for nearly all purposes. But even so they do not all have the same degree of permanence and there are some which occupy a border-line position, there being some doubts about their acceptability. An example is Prussian blue. And here another factor comes into play, because the fading of a colour will to some extent depend on how it is used. A thin, much diluted layer of pigment will fade more quickly than a thick layer, and thus a pigment which is safe enough in the thick layers of an oil painting may be impermanent in the thin washes of a water-colour. But even in oils it must be borne in mind that when a colour is mixed with white and made pale, it is diluted in the same sort of way as in a thin wash, and so again its liability to fade is increased. Another factor which comes into the choice of pigments is the question of cost, because some of the permanent ones are expensive and, if they are going to be used extensively, may be outside our range. And a purely personal factor also arises, because we cannot always be ruled by physics and chemistry and we may find ourselves attracted to a pigment which raises some doubts on the physical side. Nevertheless if we find that it 'works' well with us we may prefer to take certain risks for the sake of what we can do with it. Really, only we ourselves can decide these matters when once we know what the situation is.

But fading is not the only cause of a pigment's losing its colour. When pigments are mixed together they are brought into intimate association, and in certain instances a chemical reaction can take place between them which results in their actual decomposition. Hence it is possible for two pigments to be permanent when used alone or mixed separately with certain other pigments, but to destroy each other when mixed together. An outstanding example

of this concerns the pigment emerald green, which turns black if mixed with cadmium yellow or vermilion. It is a startling change, insidious because it only occurs after a few weeks, and it is one which might easily be brought about by the unwary, especially since cadmium yellow is quite likely to be mixed with emerald green. The remedy here is, I think, to exclude emerald green from the palette, since cadmium yellow is a much more essential pigment. As it happens there is another reason for doing so, because emerald green is extremely poisonous.

Among the pigments likely to be met with this is fortunately an exceptional case, and it is the only one which is at the same time probable and completely disastrous. There are other mixtures which raise some doubts — doubts because they are not straightforward cases of deterioration and there is not always complete agreement about their undesirability — and these are mentioned in a note below.* For complete safety it is of course desirable to select a palette of colours which may all be mixed together without fear of chemical reaction, and such a palette is suggested in Chapter Eight.

Closely allied to this direct reaction between pigments is another possible source of chemical action. The atmosphere of industrial towns and even of living rooms with a coal fire may possibly contain sulphurous gases which have a destructive effect on certain pigments,† notably those containing lead. But the danger is minimized in the case of water-colours by the protective glass of the frame, and in the case of oil paintings by a covering of varnish. In connexion with oil paintings special factors arise which may lead to changes in the colour of pigments, but this question is treated separately in the next chapter.

We are now in a position to turn to a description of the pigments. The salient characteristics of each will be mentioned, together with any special points that arise in individual cases. It is not an exhaus-

* The dyestuff colours are liable to be affected by certain pigments, among which are aureolin, chrome yellow, and Mars yellow (an artificially made yellow ochre). Aureolin, alizarin colours, and flake white are not entirely safe in mixture with ultramarine. Prussian blue is best kept apart from cadmium colours and vermilion.

† Ultramarine is liable to be affected by sulphurous acid formed from sulphur dioxide. Flake white, chrome yellow (and this means also chrome green and cinnabar green), and emerald green are blackened by sulphuretted hydrogen, which is not however likely to be present in the atmosphere to any great extent.

tive list (for instance only a few dyestuff colours are mentioned), but it is meant to indicate a wide enough rage of important pigments from which a selection may be made. It will be convenient to start with the 'earth colours', which form a fairly well-defined group of their own, and then go on to deal with the pigments available in the principal colours.

Earth pigments. The earth pigments are found in the free state in nature, but in some cases the 'natural' product is now more easily made artificially. Their colour is due mainly to the presence of iron. They are all completely permanent pigments, and form a most useful series of characteristically earthy, relatively subdued colours, which are all inexpensive. As might be expected, their use goes back to the beginnings of painting.

YELLOW OCHRE. An opaque earthy yellow, obtainable in different varieties which exhibit some slight difference in colour, e.g. Oxford ochre, Roman ochre, golden ochre. A transparent variety is available as transparent golden ochre.

LIGHT RED, VENETIAN RED, INDIAN RED. These are all red ochres, which may be regarded as derived from yellow ochre. When the latter is heated it turns red, and the stronger the heat treatment the deeper the red obtained. Light red is yellowish, Indian red purplish; Venetian red stands between the two. They are all oxides of iron, which to-day are often made artificially. They are strongly opaque pigments, with good tinting power.

RAW SIENNA, BURNT SIENNA. Raw sienna is really a transparent yellow ochre, but a somewhat duller yellow. When heated it yields burnt sienna, a fiery brown, which is also transparent. In oils they suffer from the disadvantage of having exceptionally high oil absorptions.*

RAW UMBER, BURNT UMBER. Raw umber is a dark brown, inclined to be greenish, which on heating yields burnt umber, a rich warm brown. They are semi-opaque.

TERRE VERTE. This is a subdued earthy green, semi-opaque, and very weak in tinting strength.

* The significance of this will be dealt with in the next chapter.

Yellow pigments.

CADMIUM YELLOW (Cadmium Sulphide). Several varieties of cadmium yellow can be obtained, ranging from pale to deep, and finally passing to *cadmium orange*. They are brilliant opaque colours and are permanent, except in the case of the pale varieties, which are liable to fade.

CHROME YELLOW (Lead Chromate). The chromes form a series ranging from pale chrome lemon to chrome yellow deep and *chrome orange*. They are intense, opaque colours which offer an attraction in that they are a good deal less expensive than the cadmiums. Unfortunately some doubts exist as to their permanence, which depends to some extent on their care of preparation. The best chromes are reasonably permanent in oils but are not safe in water-colours, where the cadmiums are to be preferred. An objection to the chromes is their somewhat strident character, and if care is not used they are inclined to confer on a picture an overbearing yellowness, which once introduced is not easily remedied.

LEMON YELLOW (Barium Chromate). This is a valuable pigment, as it is a pale, unobtrusive yellow, with none of the stridence of the chromes. It is permanent and fairly opaque, but without much tinting power.

AUREOLIN (Potassium Cobaltinitrite). This is a permanent bright yellow, but it is somewhat unsafe in mixture with dyestuff colours and with ultramarine. It is transparent and therefore more valuable in water-colours than in oils; it is in fact the only satisfactory bright yellow which is transparent. Also known as cobalt yellow.

NAPLES YELLOW. This is a pale, opaque, stone-coloured yellow. At one time it was a specific pigment of lead and antimony, but as purchased to-day it consists of a mixture of ochres, cadmium yellow, and flake white. Although it is a popular pigment, and is permanent, it is quite unnecessary as it can easily be mixed on the palette.

Red pigments.

VERMILION (Mercuric Sulphide). This is one of the oldest of pigments and was used by the old masters. It is a brilliant opaque red, and can be obtained in different hues, ranging from orange to deep scarlet. Unfortunately, it has a tendency to blacken on

exposure to sunlight, and it is therefore to-day best replaced by the more modern cadmium reds.

CADMIUM RED (Cadmium Sulphide and Selenide). This is a permanent, opaque, brilliant red, obtainable in several varieties ranging from scarlet to deep red. These are recognized as the best opaque bright reds now available.

ALIZARIN CRIMSON. This is a lake prepared from the dye colour alizarin. It is regarded as a permanent pigment, but is liable to fade if used very thinly, as in water-colour washes. It is probably the best crimson to use, as an absolutely permanent crimson is not available. It has good tinting power and is transparent. Also known as permanent crimson.

ROSE MADDER. This is a lake prepared from the natural dye extracted from the root of the madder plant. Its colouring principle is alizarin, which is made artificially in the case of alizarin crimson. It is, however, much weaker in colour than the latter and is mainly useful for 'tinting' other colours.

Blue pigments.

ULTRAMARINE. Originally this pigment was obtained from the stone lapis lazuli, but prepared from this source to-day it is extremely expensive. It is now made artificially, and is a most valuable inexpensive pigment, being the 'purest' blue of all the blue pigments. It is permanent, semi-transparent, and may be obtained in light and deep varieties. It is worth noting that the colour is destroyed by weak acids, such as vinegar.

Certain varieties are given the names of new blue, permanent blue, French blue.

COBALT BLUE (Cobalt Oxide and Aluminium Oxide). In hue this blue is rather like a pale ultramarine, but it is very transparent and without much tinting power. It is absolutely permanent in the light.

PRUSSIAN BLUE (Iron Ferrocyanide). This is a very intense greenish blue. It is transparent, but as it has great staining power it makes strong opaque blues with white. Care should be taken in its use, as it is apt to make a picture heavy and dark. It has a fair degree of permanence; in water-colour it has the curious property of fading in the light and recovering its strength in the dark.

Prussian blue is also known as Paris blue and Berlin blue, and weaker varieties are sold as Antwerp blue and Chinese blue.

MONASTRAL BLUE (Phthalocyanine dye). This is a recent addition to the artist's palette. Monastral blue is a dye colour introduced in 1935 by the British Dyestuff Corporation. It is one of the most valuable of dyestuff pigments for the painter, and has more the character of a true pigment. It closely resembles Prussian blue: it is much the same in hue (though it is not quite so greenish), it is transparent and has great staining power. It makes good opaque blues when mixed with white. As, however, it has a high degree of permanence it is considered a more satisfactory pigment than Prussian blue, but it is more expensive.

CERULEAN BLUE (Oxides of Cobalt and Tin). This is a pale, somewhat greenish blue, and is strongly opaque. It is absolutely permanent, the only opaque blue about which this can be said.

Green pigments.

VIRIDIAN (Hydrated Oxide of Chromium). This is a very reliable deep bluish green, transparent, and absolutely permanent. It is in many respects the most useful of the green pigments, but unfortunately it is expensive. Viridian is also known by the names of emerald oxide of chromium and verte emeraude — names which should not be confused with emerald green.

OXIDE OF CHROMIUM. Chemically this is very similar to viridian, being oxide of chromium without the hydrate or water of combination. It is, however, a very different pigment, being a subdued earthy green, and strongly opaque. Like viridian it is absolutely permanent. Oxide of chromium green should not be confused with the mixtures sold as chrome green described below.

CADMIUM GREEN. This is a mixture of viridian and cadmium yellow and hence is a permanent green, which can however easily be mixed on the palette.

EMERALD GREEN (Copper Aceto-Arsenite). This is an example of a pigment which, excellent in itself, is undesirable for technical reasons. In the first place it is extremely poisonous, and secondly it turns black if mixed with cadmium yellow or vermilion. It is best avoided. It is sometimes called Veronese green.

COBALT GREEN (Oxides of Cobalt and Zinc). This is a subdued bluish green, opaque, and absolutely permanent. It is, however, expensive, and is without much tinting power.

CHROME GREENS. These greens, available as light, middle, and deep, consist of mixtures of Prussian blue and chrome yellow.

When of the best quality they have a fair degree of permanence in oils, but should be avoided in water-colour. They are inexpensive, but they are not very good greens in themselves, being rather heavy earthy colours. More earthy still are the *cinnabar greens*, which are similar in composition except that a deeper chrome yellow is used.

Violet pigments.

ULTRAMARINE VIOLET. This is a violet form of ultramarine. It is a transparent, bluish violet.

MINERAL VIOLET (Phosphates of Manganese). A permanent pigment which may be obtained in red and blue 'shades'. It is also known as permanent violet.

COBALT VIOLET (Cobalt Phosphates or Arsenates). The composition of this pigment varies, and the colour varies accordingly. Several 'shades' are obtainable. Those made from arsenates of cobalt are highly poisonous. They are all permanent pigments.

ALIZARIN VIOLET OR PURPLE, SPECTRUM VIOLET, AZO VIOLET. These are dyestuff pigments which far exceed in depth of colour the pigments mentioned above. They are considered permanent but they have the staining quality of dyestuff pigments generally.

White pigments.

FLAKE WHITE (Basic Carbonate of Lead). This is the white of the old masters, and is still probably the most popular white for oil painting. It is not used in water-colours. It has great opacity, and it is a pigment with particularly good working qualities. It is made up in two consistencies, one of which contains less oil and hence is more stiff than the other. It is highly poisonous.

The popular name for basic lead carbonate is white lead; other names for it are silver white and Cremnitz white.

ZINC WHITE (Zinc Oxide). This white is not so strongly opaque as flake white, but for this reason it is sometimes preferred. Unfortunately it has a tendency to crack in oils. It is practically non-poisonous. It is also known as permanent white, and is used in water-colour painting under the name of Chinese white.

TITANIUM WHITE (Basically Titanium Oxide). This is a modern pigment which has gained great popularity. It is very strongly opaque and is non-poisonous. In certain respects it is superior to flake white, but the latter still holds its own on account of its

superior working qualities — not to speak of the centuries of tradition behind it.

Black pigments. All these pigments owe their blackness to the presence of carbon; they are all permanent, though they differ somewhat in texture and in intensity.

IVORY BLACK (Charred Ivory). This is the deepest black of all, and is the one most commonly used.

LAMP BLACK (Soot of Burning Oil). This has not quite the depth of ivory black. In oils it has the disadvantage of drying very slowly.

CHARCOAL BLACK. Often sold as charcoal grey, it is a 'greyer' black than the others, but it has more opacity.

Grades of quality. These colours, in both oils and water-colours, may be obtained in two qualities, which are called respectively 'Artists' and 'Students'. The latter are a cheaper range, and it will be as well to know how they differ from the 'Artists'.

'Artists' colours are made from the pure pigment, and vary considerably in price according to the cost of the material. This is a matter of economics, and is not in itself a criterion of permanence. Thus we should not be misled into the belief that because a pigment is relatively inexpensive it is therefore not permanent. Yellow ochre, for instance, because it comes direct from the earth and is in plentiful supply, is in the cheapest range, while viridian, a compound of the metal chromium and expensive to manufacture, costs considerably more. Yet both are in the same group of absolutely permanent pigments.

'Students' colours are not only a cheaper product, but they usually do not vary in price. In the case of pigments which are in plentiful supply, like yellow ochre, they are only slightly cheaper than their counterparts in 'Artists' quality. They consist of the same material, but rather less carefully prepared. From the point of view of handling there may be a little difference between them. In the case of the expensive pigments, however, the matter is different. These in 'Students' are given a special designation such as 'tint' or 'hue' and are therefore not claimed to have the genuineness of the 'Artists' quality. As an example, one can buy 'Yellow Ochre' in 'Students', but only say 'Viridian Tint' in the same quality. The 'tints' or 'hues', although they approximate to the 'Artists' pigments in handling, are often markedly inferior in colour strength

and quality. Nevertheless they represent a substantial economy, and they do give a very fair idea of the workings of a pigment, and so in using them we can gain a useful experience which we can carry with us if we transfer from 'Students' to 'Artists' quality. A practical issue is raised here which is often overlooked. It is important not to feel restricted in the use of colours, and if on account of using expensive 'Artists' materials one is obliged to feel the necessity of husbanding one's resources, a psychological factor is introduced which is definitely harmful to freedom in technique. Plenty of colour should be set out on the palette. 'Students' colours are much to be preferred if by their use we are enabled not to worry about the 'waste' of paint. It is not unusual to see beginners squeezing out minute quantities of paint on their palettes, and then taking up such small amounts on their brushes that only tentative marks can be made on the canvas. This alone is enough to kill any enjoyment in painting. If one is not afraid to waste paint one is more likely to find in the end that it is not wasted; and the converse is also true. For this reason it is best, where possible, to use large rather than small tubes; and in oils it will be found that white is used more than any other single pigment, and it is simple economy to buy it in large tubes.

6 □ oil painting

Technique: ends and means. The technique of oil painting is a logical consequence of the nature of oil paint, which has already been described. It has to be realized that there is not just one technique, but many; that is to say the nature of oil paint is such that there are many different ways in which it can be used. On the other hand, it can be used in ways to which its nature does not lend itself, and which therefore invite disaster. Once we understand what we are doing when we paint in oils, we can develop the technique best suited to our needs, so long as we remember that we are subject to the limitations of a material medium which, whether we like it or not, obeys certain physical laws. A bad technique is one which stretches it beyond the point at which we can be said to control it — like stretching a piece of elastic beyond its normal tensile strength: the result is simply that it breaks down. Whatever our aim in painting may be, we have to work within the limits set by the physical character of the medium.

Technique is usually understood to be the way in which the materials are handled, and in particular the manner in which the paint is applied; it is therefore not distinct from 'expression'. Often people speak about technique as if it were something to be acquired first, before painting in any serious sense can be undertaken. But this is to make a fatal distinction between painting and the means by which painting is carried out. It is rather like learning to swim before going into the water. Every time we paint — every time we make a brush stroke — we will employ a certain technique, in terms of which we will create certain effects. The latter can never be conceived independently; at every stage they will be a product of the actual materials we use and of our particular ways of handling them. Technique therefore is not only a means, it is a vital part of creation. It is not a static thing, to be developed in its entirety before we can begin to think of making it a vehicle of expression;

79

every picture which embodies some fresh experience will call upon some fresh aspect of technique. We are never done with technique — unless indeed we are done with painting as a living thing, and are prepared to go on repeating ourselves endlessly. This is so often the fate of people who have acquired, at some time or other, a technique considered as a counsel of perfection; they strive always to clothe their expression in the 'right' (which is always the same) technique. The result is that they are no longer capable of making any fresh discoveries for themselves. But when we can see technique in the light of a developing process which is part of our expression, it becomes meaningless to speak of technique as distinct from the ends to which it is adapted. We cannot speak of a picture having a 'good' technique when the picture itself, considered as a mode of expression, is bad.

It is important that we should see this relationship between technique and expression; between the material and the aesthetic. Many of our difficulties are the result of thinking of painting in the abstract, and associating it with qualities like 'beauty', 'inspiration', and emotions of various kinds, quite divorced from materials, as if the latter belonged to a lower order of things. Such a rarefied view of painting will not carry us very far. It is like thinking of a meal without introducing the notion of food. If painting is to retain its interest for us, we must come to terms with the medium itself.

It is obvious that there is an entirely personal element in technique which cannot be taught, and which we must develop for ourselves. In order to do this, however, we must know how our materials work, what they can be made to do and — what should not be overlooked — what they can't. We need to know the principles which govern their use, not one particular way in which they can be used.

Rôle of linseed oil. The key to the use of oil colours resides in the nature and properties of the drying oil. It has to be realized that oil paint is not a static medium; it does not just 'stay put' as we paint it out, but both when it is drying and after it has dried it undergoes changes which may seriously affect the appearance of the painting. This is naturally most disconcerting and is often a source of trouble. In water-colour a picture will not change once it has dried — not, at any rate, on account of any changes in the medium itself — provided it is protected from moisture and damage. Not so in oils. The reason is, of course, that when water

dries it evaporates into the atmosphere and disappears altogether, whereas when linseed oil 'dries', so far from disappearing it actually increases in weight by absorbing oxygen from the air, and changes into a solid. If this solid were something fixed and stable, like — if we can imagine it — a piece of non-brittle glass, all would be well; but it is more in the nature of a piece of stretched rubber sheeting which is gradually shrinking in size. Moreover with age it undergoes changes which render the enclosed pigments themselves more translucent, and at the same time it slowly changes colour and turns more yellow.

These changes which take place in the dried oil layer can undoubtedly give rise to great complications if we paint in certain ways. But there is no need for us to employ methods which lead to complications, and certainly there is no need to be frightened away from oil painting because of its seeming difficulties. I once knew a student who had been painting for about a year in poster colours, and thought she would like to try her hand in oils. She read a book on the technique of oil painting — a highly technical book — and the result was to drive her to despair. It seemed there was so much she had to remember, and there were so many disastrous things that threatened to happen if she did not remember them, that she concluded that oils were altogether beyond her.

But this was simply due to the fact that the book, an excellent one of its kind, advocated a rather elaborate technique of painting in stages, the principle of which is that one begins with an underpainting in which certain pigments only can appropriately be used, and when this first painting is dry other colours are superimposed on it, and others again on top of these, so that the painting only gradually reaches its finished state and each stage is carefully planned with reference to the final effect. But oil paints can be used in a much freer and more direct way than this; and most of us will probably want to start and finish a painting in one sitting — a mode of working which simplifies technical questions considerably. Even if we do not have time to finish a painting in one session, we will go on with it merely from the point at which we left off; we will not aim to paint deliberately in successive stages.

We must not however gloss over the fact that oil painting presents a distinct problem which does not arise in water-colours — the possibility of physical deterioration resulting from gradual changes within the medium itself. When we spread out our different pig-

ments in oils we set up an unstable system on the surface of the canvas, and many disasters seem to threaten. But this problem can easily be over-stressed. The fact is that the oil medium is altogether more amenable and kindly than theoretical considerations might lead us to suppose, and the surprising thing really is, not that there is a possibility of cracking and deterioration, but that oil paintings survive at all. Yet they do, and they often stand up surprisingly well to rather rule-of-thumb methods of construction.

This should not be interpreted as a plea for disregarding basic principles, but it is important to see the relevance of these principles in the practical field. Often they are regarded in the light of 'rules', as if their primary purpose were negative — to avoid undesirable consequences. But their real value lies in the fact that they enable us to use oil paint with a sense of exploring its true potentialities, and this can only be done if we have a proper regard for its nature and qualities. If we have this regard, then it follows that we will also avoid the physical troubles that arise from misuse. Oil paintings that are made without any feeling for the nature of the medium look like anything else which is not cared for — unpleasing and unhappy. And so the first thing in connexion with this enigmatic medium is simply that we should care for it; then we will have no difficulty in acquiring the knowledge which fortifies instinct. As a result, we will secure freedom in its use, and this is surely the vital point, for it is essential that technique be our servant and not our master. If we are obsessed with technical questions and have to think, before we do anything, whether we are breaking the rules, our painting will rapidly reach a stalemate and lose all its freshness. But this is to go in fear of the medium. When we know how oil paint behaves it will no longer be a mystery to us, and we can approach it with some confidence; and if we do take risks in its use, we will know the risks we are taking and can measure them accordingly.

We all know linseed oil as a yellowish, rather viscous liquid which, when it comes out of the bottle, does not differ very much from other oils we know, such as salad oil. It is only when it makes contact with the air that the changes begin to take place. In a corked bottle it is protected from the atmosphere and so remains a liquid, for the small amount of air inside the bottle is not usually enough to bring about any serious changes. When in the form of paint we spread the oil over canvas we are of course extending its surface and exposing it to the air to the fullest extent. It remains oily for a day or two, and

then begins to get tacky; a skin is formed on the surface and finally the whole film solidifies. The time taken for the completion of this process depends to some extent on the temperature, so that in the summer it happens quicker than in the winter; it depends on the amount of 'air' we give the canvas — the oil will dry quicker, for instance, before an open window than in the still air of a room; and it also depends on the pigment itself, because some pigments have the property of being able to accelerate the drying of the oil.

Contraction. During the drying process the oil film absorbs oxygen from the air and expands; after it has dried contraction sets in, and this contraction, which is relatively rapid at first, continues slowly for an indefinite time. It never reaches a stage of complete stability. It is this contraction of the film which is a major factor in bringing about the cracking of oil paintings. Why this happens can be easily understood. Suppose we were to stretch a piece of rubber sheeting and paint some gum on the top of it. When the gum has dried into a hard film we release the rubber and let it regain its normal size. On our doing so the gum will crack, because it has been compressed from underneath and cannot itself contract to the same extent; it is subjected to a strain which it cannot withstand and breaks down.

An oil painting usually consists of paint put on top of paint. If the under layers contract a great deal more than the layers on top, the latter will eventually crack. Now the amount of contraction in the film of paint will depend on the amount of oil in it. The particles of pigment themselves do not contract. We have already seen that the amount of oil to pigment can be varied according to the relative amounts of oil and pigment mixed together, and as purchased in tubes oil colours are all made up to the same buttery consistency. We shall see that in painting we can increase or reduce, at will, this original quantity of oil. In order to have our system of stresses and strains as stable as possible, it is obvious that we should aim to have more movement in the top layers than in those underneath, so that in proceeding upwards from the surface of the canvas we come progressively to layers whose contraction is more than those underneath. In this way the upper layers are not subjected to a compressive strain from below, because they are themselves contracting rather more than the surface underneath. This, interpreted in terms of oil paint, means simply that we should aim to have rather more

oil in the upper layers than in the lower ones or, expressed as it is in the old formula, we should paint 'fat over lean'.

House painters are well aware of this, and that is why the 'undercoat' paints they use always contain less oil than the top coats with which they finish off. The undercoats dry 'flat', with a matt surface, because as they contain no more oil than is necessary to bind the pigment there is none in excess to cause a shiny surface.

Oil absorption. One further point should be mentioned. As oil paints in tubes are all made up to the same consistency it might be thought that they all contain the same amount of oil; that, whatever we may subsequently do with them, as expressed from the tubes they all start from scratch. This unfortunately is not so. The reason is that the different powdered pigments all soak up different amounts of oil in reaching the same consistency, much in the same way that a heavy clay soil will soak up more water than a light sandy soil. This is expressed by saying that the pigments have different 'oil absorptions'. Hence if pigments are painted out in layers, straight from the tubes, the layers will not — contrary to what we might have expected — contain the same amounts of oil. This of course is an additional complication,* but it is not so formidable as it might seem to be. For one thing, most of the pigments do not contain excessive amounts of oil; but more important still, painting a picture is very different from laying out colours direct from a tube. When we paint, a great deal of mixing of pig-

* It is only the pigments with high oil absorptions which are likely to give trouble. These can scarcely be said to form a well-defined class, because the oil absorption of a pigment is not constant but depends on various factors concerned in its manufacture. Hence there is often considerable variation in oil absorption figures given for the same pigments made under different conditions. In general it may be said that the majority of opaque pigments have moderate or low absorptions. The following are pigments with admittedly high absorptions: burnt and raw sienna, cobalt blue, burnt and raw umber, ivory and lamp black, terra verte, cadmium red. Pigments with moderate or low absorption, if painted on top of these pigments, will be liable to crack. But this presupposes that the pigments are used 'pure', without admixture; in practice this is not very likely to occur, since nearly always there will be some admixture with white (or other low absorption pigments), and this considerably reduces the likelihood of cracking. Again, the greater part of the oil film's contraction occurs in the early stages of drying, and therefore if the underpainting is left long enough for this stage to be completed before overpainting is undertaken, the danger of cracking is reduced. Preferably therefore the underpainting should be left for some weeks after it has first hardened.

ments goes on, and in particular we shall find that white (which has a low oil absorption, whatever its variety) is constantly mixed in with the other colours we use, and this leads to a general levelling out of oil contents and so to the establishment of a much more stable system than would otherwise occur. Again, if we start and finish a picture in one session our layers are all painted 'wet in wet', as the saying goes, and they will be a good deal intermingled by the movement of the brush, and finally the whole mass dries out together. This is not the same thing at all as painting in successive layers on top of dry paint. We may, however, want to go on with a painting after it has dried, and then it will be a useful precaution to add a little oil to the paints, in a way that will be clear later on.

Yellowing. Another change which takes place very gradually in the dried oil is that it turns more yellow. We are all acquainted with the 'gallery tone' which, before the cleaning of pictures was undertaken in recent years, was always associated with the old masters. Indeed at one time this 'brown sauce', as it has been called, was so admired that painters actually set about painting brown pictures so as to be in line with what was imagined to be the tradition of oil painting. But there was nothing very admirable about this tradition; it was simply the result of the yellowing of the heavy varnish with which oil paintings were treated as a matter of course. It had nothing to do with the intentions of the old masters, which indeed it only served to obscure.

The effect of this yellowing (more pronounced in the older type of picture varnish than in linseed oil itself) is a general darkening of the tone of the picture, but more important still is the effect on the colours themselves. This will be unequal; the greens, blues, and violets will be most affected, while the warmer colours will not be changed so much. The extent of yellowing depends on the amount of oil present; the more oil, the more yellowing, and the inference for oil painting is obvious — the less oil, the better.*

* The yellowing of linseed oil is not so serious a matter as is sometimes imagined. The 'gallery tone' is due far more to dirt and to the yellowing of the varnish than to any changes in the oil underneath. Yellowing is hastened by dampness and absence of light. It begins to occur with the initial drying of the oil, and freshly painted pictures may yellow if allowed to dry in the dark, especially if stored in a damp atmosphere. They should therefore always be allowed to dry in the daylight of a room. The special point to remember is that it is *excessive* oil which is most likely to yellow, especially if a free film of oil is formed on the surface of the painting.

Translucency. The third change which takes place gradually in the dried oil is a rather curious one: it affects the translucency, and hence the hiding power, of the enclosed pigments themselves. As time goes on, the oil film acquires the property of letting more light penetrate the layer of paint — less being returned by reflection from the surface. To see how this affects a painting we must understand how the presence of oil can change the degree of penetration of light into a pigment. When a powdered pigment is taken up in oil it is always, to begin with, rendered more translucent. This can easily be seen by a simple experiment. If some black lines are made on canvas with indian ink, it is possible to obliterate them by covering them over with a thick layer of pastel or chalk. This is the result of using the pigment in powdered form in air. If now some linseed oil is dropped over part of the pigment the black lines will be rendered visible, in other words the light is able to penetrate further into the pigment, which in fact is rendered translucent. The pigment itself has not been dispersed or changed by this process; it has simply been enclosed in a medium different from air. The same thing happens with water, but not to the same extent. Thus if some chalk is mixed up into a paste with water and gum, it is made into a water-colour paint which, however, becomes more opaque when it dries — that is, when it loses its enclosing film of water by evaporation. Everyone knows that this principle is made use of in marking out a cricket pitch or tennis court. But if the chalk is made into a paste with linseed oil it will scarcely show any whiteness at all, and if used as a paint it will have no hiding power, which will not be improved by the 'drying' of the oil because in this process the film does not disappear, but merely hardens. Not every pigment treated with linseed oil is rendered actually translucent; the very strongly opaque pigments (such as white lead) are able to retain their opacity in oils despite the fact that the amount of light which penetrates them is increased.

Now this capacity of the oil to produce translucency gradually increases after the film has dried, and in practice this means that we are able to see more 'into' an oil painting as time goes on. A layer of paint which is just sufficient to cover something under it may eventually allow the undercoat to show through. This can happen in quite a short time, say a year or even six months, depending on the thickness of the paint and on the amount of oil present. The more oil, the more marked is the effect. This increasing trans-

parency is, to say the least of it, rather alarming, and oil paintings sometimes have a devastating way of revealing their secrets. There is the famous case of the painting in the National Gallery in London by Pieter de Hooch, of an interior of a Dutch house in which a woman is standing on a chequer-board floor. The lower part of her skirt is superimposed on the floor and was evidently painted on top of it, because now the chequer-board pattern can easily be seen showing through.

From the point of view of technique this gives us yet another reason for not using any excessive amounts of oil. And we must remember that if we want to paint one colour over another we must make the top layer fairly thick if it is essential that the undercoat should not show through. Almost certainly there will be times when we will want to bring up lighter colours over darker ones, and here again we must see that the lighter colours are not painted too thinly, otherwise they will darken with age. Colours which we paint directly on to a white surface, such as prepared canvas, we can allow to remain thin if we like, because as they get more transparent they will only reveal the white surface underneath and so will not lose their clarity and brilliance.

Oil as 'the enemy'. Let us now sum up the properties of the drying oil and see where they lead us. From the point of view of the painter in oils they all seem to point in the same direction. They seem to reveal the oil in a very dubious light. While with one hand it confers great benefits, with the other it seems almost to take them away. Rubens, whose pictures always show such facility, must have felt strongly about this, for from him comes the famous statement that 'oil is the enemy'. It is indeed. It yellows, it contracts, it gives away secrets. And this is the important thing from a technical point of view: the more oil we use, the more we are helping on these undesirable characteristics, and the natural inference is that we should use no more than is necessary. There is of course a lower limit: we must have enough to bind the pigment, and for appearance's sake we may want more than will give us a dry matt surface; but to use excessive amounts of oil is simply asking for trouble. The relevance of this in the practical field will be apparent shortly.

Using undiluted paint. Knowing something of the sort of behaviour we are to expect from oil colours, we can now turn

our attention to the question of how we are ourselves to handle them. We squeeze out the paints on to the palette, and there they remain as bright shining blobs of colour. We can if we like paint straight away with these colours without any further treatment. With a stiff bristle brush we make any desired mixings on the palette, and then apply the paint directly to the canvas. Used in this way the paint will not be fluid and will not flow from the brush; we will not be able to use the colours thinly and it will not be easy to cover a large area of the canvas at once. The paint will have to be worked by the brush in its buttery state. Nevertheless this is a perfectly sound technique for those who like it. It has its limitations, but then so do all other techniques, and it has its compensations in its simplicity and directness. By taking the colours as they come from the tube we are not adding any other ingredients or introducing further complications which may give rise to trouble later on.

Of course we have to remember that oil paint will not harden while we work, and this means that it will have no rigidity on the surface of the canvas and will tend to be disturbed when one colour is put on top of another. We have to adapt our application of paint accordingly and only experience can help us here. A soft brush will cause less disturbance than will a stiff one. It is one advantage of using canvas that its grain provides a tooth which holds the paint to some extent and prevents it 'slipping' over the surface. It is best to do overpainting as directly and decisively as possible, without 'worrying' the paint with the brush, for paint that is too much manipulated goes dead and loses its brilliance. The whole question of overpainting is as much one of approach as it is one of practice. It is foolish to think of perpetually blotting out mistakes by piling up thick pigment; in the end everything will be reduced to a muddy greyness. If we build up our paintings on the principle of development which has already been discussed, we will regard successive applications of paint as adding to and arising out of what has already been put down, not as a means of reconstructing our picture. With this in mind we can merge one layer with another, or paint 'wet in wet' on the canvas, or for strong emphasis take up thick pigment and completely cover what is painted over. On the other hand it may be — and this has much to commend it from the technical point of view — that we will not want to do much overpainting but will be content to take things as they come, finally making only a few additions here and there. If we do have to make any radical

changes it is best to scrape the surplus paint off with a palette knife and wipe the canvas down with a rag dipped in turpentine. The paint may be applied as thickly as we wish and indeed painters have been known to squeeze it directly from the tube on to the canvas. The name 'impasto' is often given to paint used in such thick, solid layers.* We have probably seen paintings in which the paint has been applied so thickly that it has been moulded and shaped almost like a work in relief. Many paintings by Van Gogh are like this.

Palette knife painting. Paint applied thickly in this manner, in which the brush is used more as a tool for moulding than for spreading it, leads naturally to a way of painting which eliminates the brush altogether and substitutes the flexible steel blade of a palette knife. For this reason the method is usually called palette knife painting, but special 'painting knives' are made for this purpose, in various shapes and sizes, of thinner and more flexible steel, which enable more control to be exercised. The paint is taken up by the knife and applied rather as butter is spread on bread, and it does not take much ingenuity to handle the knife in a great variety of ways which call forth particular effects. The paint can be spread with the flat of the blade or with its edge, thinly if desired (by increasing the pressure), though the method lends itself to the use of thick paint, which can be moulded by the pointed end of the blade. The edge, because of its length, readily imposes a pattern of straight lines which, the equivalent of brush strokes, are often to be seen as a characteristic feature of palette knife paintings. By scraping hard on the canvas with the knife edge we can expose its white grain against darker colours which sink into the grooves, and this gives its own effect of texture; and in the same way by using the point of the blade we can cause white lines (the exposed canvas) to be 'cut out' of the paint. The surface in the end is usually very uneven on account of the different levels of paint.

There is undoubtedly a certain fascination about a method so direct and dispensing with so much of the impedimenta of oil painting; but the manipulation of a full impasto, though it has an immediate appeal, is inclined to make for a lushness of effect, all too superficial, which loses its interest before long. In general the

* It should be noted that the use of very heavy impastos increases the liability to crack.

knife allows for great freedom in handling paint and for a variety of trick effects, which will arise more or less accidentally and which in a sense are come by in rather too facile a manner. As a method of painting it also has great limitations, and for these reasons it is not recommended as a method of starting, although at some time or other most of us will want to try our hand at it and see how it goes with us.

What is useful to bear in mind in speaking about this method is that oil paint lends itself to many forms of treatment, and may be spread or worked by any device we care to choose. We tend to think of painting in terms of a brush only; but the brush is simply a tool of convenience and there is nothing sacrosanct about it. Oil paint may be spread, scraped, rubbed, fingered, and modelled, and instruments such as razor blades, knives, match sticks, and even the ends of the tubes and brushes themselves have all at times been pressed into service. Not everyone will want to call upon these expedients, but they are technically serviceable means if we feel disposed to adopt them. We need not limit them to pictures in which no brush is used at all; on the contrary perhaps their most effective use, as with the palette knife itself, is in association with the more usual methods of painting — as additional means to certain ends.

Thinning the paint: mediums and diluents. But to come back to the brush. To be able to spread the paint freely it is necessary to have it in a thinner condition than that in which it comes out of the tube. For this purpose use is made of an oil — called a 'medium' — which mixes in with the paint and so renders it more liquid. If it is a volatile oil, which simply thins down the paint and then evaporates, it serves the function of a 'diluent', much as water is a diluent with water-colour paints. But properly speaking a medium has binding qualities of its own, and various ingredients, some of them most complicated, are sometimes introduced. Indeed, many recipes for media exist, and many different kinds can be purchased ready-made. It is best, however, to use our own and not rely on the ready-made article, the formula for which may not be divulged. The guiding principle is clear enough. Any new ingredient introduced into our original oil is liable to bring additional complications; we want therefore to keep the medium as simple as possible. There is in fact no need to go beyond the use of linseed oil and turpentine.

It will be found most convenient to keep the medium in a 'dipper', a small metal container which clips on to the side of the palette. The brush is first dipped in the medium so that the bristles absorb the liquid, which is then worked into the paint on the palette; the colours are mixed as desired and applied to the canvas.

Turpentine is a volatile oil and dries, as water dries, by evaporation. Hence as a medium it plays no part in binding the pigment, but merely 'extends' the oil already present in the paint. Its effect, therefore, is to reduce the quantity of oil to pigment. Now the colours as they come from the tubes contain plenty of oil, more than enough to bind them, and as we have already seen that 'oil is the enemy', a good and convenient technique consists in using turpentine only as a medium. It enables the paint to be spread easily, and indeed with excess of turpentine oil paint will take on the character of water-colour. This of course is not the effect we want, and we must be careful not to dilute the colours too freely, otherwise there will not be enough oil present to form a satisfactory film of paint. But the very diluted paint may be used as a means of freely putting down our preliminary ideas, and at this initial stage it is best if we reduce the amount of white to a minimum, relying on a thinned water-colour effect. In a few minutes the turpentine will evaporate from the canvas, leaving the particles of pigment relatively firmly enmeshed in the grained surface. (It is rather the equivalent of making any preliminary marks in pencil or charcoal.) We then continue in thicker colours, lightened freely with white as desired, and so build up the characteristic effect of an opaque medium. We can go on to use the paint as thickly as may be needed, taking it finally as it comes from the tube if we wish.

It will be clear that the use of turpentine only as a medium makes for great ease and convenience, and has the advantage of extreme simplicity. But, as so often with simple methods, it is also technically very sound, and indeed for direct painting can scarcely be improved on. It avoids all the pitfalls that arise through adding oil and other ingredients to the original paints.

Paintings made with turpentine only will dry out relatively matt, and can be treated with a wax varnish in the manner to be described later on.

If we prefer a rather more oily surface to the painting when it is dry, giving greater depth to the colours, or if we find that turpentine alone is too 'loose' a medium, we can add a little linseed oil to the

turpentine. Linseed oil undiluted would be quite excessive and the painting would dry with a very unpleasant shiny surface. Furthermore, any free dilution of the colours at the start would mean laying out a very oily surface on the canvas which would be difficult to paint over; and indeed overpainting in general is difficult on colours rendered 'slippery' with added oil. There is therefore every reason why the oil should be well diluted with turpentine. A few drops of linseed oil in the quantity of turpentine in the dipper may be found sufficient for our needs, but in any case it will be well not to have more than one part of oil to three parts of turpentine.

The advantage of using a medium is not only that it allows for a freer manipulation of the paint, but it enables the opacity of the paint to be varied by dilution. The paint can if desired be applied in a thinned translucent state so that it only partially covers the underpainting. In all overpainting we must bear in mind the fact that oil paint tends to get more transparent with age, and if the underpainting is intended to be obliterated the top coat must be thickly applied; but if the underpainting is meant to contribute its effect to the final result, then we must remember that this effect will tend to become stronger as time goes on. Thus if we paint a thin green over a yellow, we must reckon with the green's becoming more yellowish in time; but if we paint the green over red, it will tend to become brown. If we bear in mind this tendency of the paint to become more transparent we can adapt our overpainting accordingly, and it will not cause great difficulty; on the contrary it will assist a logical development of the painting, and this will be reflected in the result. As we have already said, oil paintings that are made without any feeling for the medium look incoherent and unpleasing.

If it is not possible to finish a painting in one session then we must leave it to dry out thoroughly before going on with it, because painting on top of half-dry paint is a cause of cracking. The longer we leave it the better, but we should make sure that the surface is properly hard and has no areas which are still tacky. To work on top of firm dry paint is of course very different from painting on it when it is soft, and we may find that there are certain passages which must be left to harden before we can add the finishing touches. When continuing on dry paint we should aim to have more oil in the top layer; hence if we began with turpentine only, it will be advisable to add a small quantity of linseed oil to the medium before carrying on.

Glazing and scumbling. It will be as well to mention briefly here the specialized technical device known as glazing, so that at least we will know what it is, although we may have no occasion to make use of it ourselves. A glaze is a very thin transparent film of colour applied over a light ground, so that the latter shines through and gives the colour luminosity. Thus any water-colour wash is essentially a glaze of colour over a light paper. The principle may be illustrated by reference to coloured glass, which indeed the word 'glaze' suggests. A stained glass window can be regarded as a glaze of colour over the light coming from the sky. If a piece of red glass is placed over white paper, it is illuminated by the reflection of light from the white surface, and the colour of the glass is shown up strongly. If, however, the glass is placed over dark blue or black, its colour will practically vanish. Hence the principle of glazing — that the glaze should be superimposed on a light ground. If the light ground is coloured, it will change the colour of the glaze by mixture; if for instance the red glass were placed over a light yellow ground, the red would be changed in the direction of orange. Hence there are two factors concerned in the final colour of a glaze: the glazing colour itself, and the colour of the ground. It can readily be imagined that an infinite variety of effects is possible, and that the method is susceptible of the greatest subtlety. A pigment to be used for glazing should be transparent, and it should only be applied over paint which has been allowed to dry hard. The glazing colour may be thinned with linseed oil and painted over the ground with a soft brush or — and this is said to have been a method of some old masters — rubbed on with the fingers. An advantage of the glazing technique is that the light, shining up through the glaze, gives a lustre and brilliance to the colour which is lost when reliance is placed solely on reflection from the surface of thick paint. It is for this reason that paintings by the old masters have a depth and luminosity which is lacking in modern paintings, for to-day the deliberate glazing technique is not much used. And the old masters were not content to rely on single glazes, but often several layers of glazing colours were used, which added depth to the result. In the cleaning of old master paintings, one of the difficulties is to remove the layers of heavy varnish without disturbing any of these delicate glazes.

Another technical device is that known as scumbling, which consists in the application of opaque or semi-opaque paint over a darker

ground in such a way that the latter is not completely hidden. A useful type of scumble is produced when a brush loaded with stiff paint, light in tone, is dragged over an area of darker paint so that some of the paint from the brush adheres to the upper parts of the grained or uneven surface of the under paint, which is thereby lightened without being obliterated. The amount of pigment which adheres will depend on the roughness of the surface and on the pressure applied to the brush, and useful variegated effects can thus be obtained. This will be found to be a helpful device which is straightforward in practice.

Both glazes and scumbles are means of modifying the appearance of the under paint, but the essential difference between them is that glazes consist of transparent paint, while in scumbles opaque pigments are used. Thus any application of opaque paint thin enough to allow the ground to show through constitutes a scumble, which will often be produced, whether deliberately or not, when diluted paint is freely superimposed on under layers. (Scumbles are, of course, readily produced with gouache water-colours, to be described in the next chapter.)

Varnishes. Oil paintings are often treated with a varnish. The word is used to include any transparent film which is applied over the surface of the finished painting, after the latter has dried. We probably associate 'varnish' with the clear golden liquid which is painted over woodwork and bestows upon it a characteristic shine and brilliance. Picture varnish does not differ from this in principle. Its function is twofold: it serves to isolate the paint from the atmosphere and so protects it from dirt and from chemical action, which is particularly likely to occur in the smoky sulphurous atmospheres of towns; and secondly it adds lustre to the paint, especially if it has dried out matt, by allowing for more penetration of light, so giving greater depth of colour to the painting. Too much varnish, however, is undesirable, as it gives a very shiny surface which is unpleasant in itself, and is so highly reflective that it is only with difficulty that the picture can be seen at all.

The best-known picture varnishes are made from resins — substances exuded from trees, some (like amber) being found in the fossil state. They fall into two groups depending on their degree of hardness, and are known in consequence as hard and soft resins. The varnishes consist of solutions of resins in suitable solvents, and

hence have the effect of spreading a film of resin over the surface of the painting. The hard resins are dissolved in linseed oil and are therefore known as 'oil varnishes'; the soft resins dissolve directly in turpentine or alcohol and form the class known as 'spirit varnishes'. The varnishes most likely to be met with are copal oil varnish and mastic varnish. The latter is a spirit varnish and consists of a solution of mastic resin in turpentine. The disadvantage of using either copal or mastic varnish is that they both yellow with age and are liable to crack. The picture should be allowed to dry out hard, and preferably left for as long as possible, before the varnish is applied. A year is often given as a minimum period, the idea being to allow the contraction of the paint to proceed as far as possible before another film is put on top.

To-day many trade products are offered as picture varnishes, in which the natural resins are discarded in favour of synthetic varieties; and though high claims are made for them, their actual composition is usually withheld.

Varnishing is the subject *par excellence* of mystery and cookery in the history of oil painting, and innumerable recipes exist for the best, and indeed the only safe varnish to use. Almost every book tells us something different, and I have no intention of adding to the mystery. There is, however, general agreement that varnishing with either copal or mastic is a somewhat hazardous undertaking and at the best of times leaves much to be desired. Fortunately they are not necessary. In any case the vogue of the highly varnished picture has had its day, and something much less scintillating is preferred. An excellent alternative exists, and one about which there is good agreement that it is both safe in itself and straightforward in its method of application. It consists in treating the painting with a coating of wax, much as furniture polish is applied to woodwork. The advantage of the method is first its ease of application; and then since the wax is a soft covering it will not crack and may be applied as soon as the painting is completely dry. Moreover it does not turn yellow with age; and finally it can easily be removed if necessary. Either paraffin wax or purified beeswax will answer the purpose, and the preparation of the 'polish' can easily be undertaken oneself (though commercial preparations are available). The wax is cut into small shavings and dissolved in turpentine, so as to produce a solution of the consistency of a thin paste. The wax dissolves more readily if the turpentine is warmed, and this is best

done by placing the container in warm water — not heating it over a naked flame. When the solution is cool it is ready for use. It is painted over the surface and left for a day or two in order to allow the turpentine to evaporate. The waxed surface is then polished with a silk rag. This does not result in the high gloss of varnish, but it does add depth and lustre to the colours in a very pleasing way. Of course no soft varnish will last for ever and it may eventually need renewing, but this is certainly better than applying a more durable varnish which may seriously damage the painting.

It will often be found that an oil painting dries out unequally and that in certain parts of the canvas the paint has 'sunk in' — that is, dried very matt and 'dead' compared with the rest. Such passages are corrected by a varnish, which has the useful effect of making the entire surface uniform.

Prepared canvas and substitutes. So far we have taken the canvas for granted. Canvas prepared with a white 'ground' ready to receive the paint can be purchased in various qualities depending on the type of canvas itself, and in various grains depending on its texture. The grain or tooth makes an attractive surface to paint on, as it not only provides a 'bite' which takes up the paint easily, but also gives a pleasant effect to the result. A coarse grain lends itself to broader treatment than does a fine one. Prepared canvas can be bought by the yard or in six-yard rolls; it may also be obtained ready attached to stretchers. A stretcher is simply a wooden frame over which the canvas is stretched tightly in a drum-like manner. Any slack can be corrected by slightly widening the stretcher itself since it is made with expanding corners which are held in position by wooden pegs or 'keys'. If these keys are tapped with a hammer the corners are spread apart and the tension on the canvas is increased.

The drum-like tautness of a stretched canvas is very convenient as it leaves a slight amount of spring which renders the surface some-how sympathetic to the brush. Prepared canvas, however, is expensive and buying it on stretchers is likely to be impossibly so for people who paint at all frequently. Fortunately, cheaper materials are available. Instead of buying canvas on stretchers one can buy canvas boards — boards with a canvas surface or a surface prepared to resemble that of canvas. But cheaper still, and probably the most practicable for our purpose, is what is called 'oil sketching paper'.

This is paper treated with a surface suitable for oil painting and provided with a canvas-like grain; it may be obtained in small blocks containing about a dozen sheets, or in single sheets of larger size. Some of this sketching paper will be found to have a very greasy surface and no very effective grain, and it is then almost worse than useless; but some varieties can be obtained in coarse or fine grain surfaces which are reasonable substitutes for canvas. When in use the paper will have to be pinned to a board in order to give it the necessary rigidity.

Preparation of supports. However, apart from the materials which can be purchased ready-made it is not difficult to prepare our own; this for many people will have a definite attraction, as it gives an added independence to our activities and at the same time we can prepare for ourselves the type of painting surface which is best suited to our needs. In using our own materials we can press into service odd things that lie to hand in the home, and we can adapt our paintings to the exigencies of the situation. For instance, an odd bit of cardboard may give us the idea for getting to work on a picture which we had only vaguely thought about before. Almost any flat surface, such as cardboard, hardboard, wood, or paper, can be used if it is suitably treated.

A material like cardboard or paper, used by itself, will absorb the oil and drain it away from the pigment, and the resulting paint will be dry and matt, resembling poster colour more than oils. If too much oil is drained off, there will not be enough left to bind the pigment, which may eventually crumble. Again, the oil by soaking into the ground will darken it, so that little light will come from that direction in the painting. Apart from these disadvantages it will not be found easy to paint on a very absorbent ground. The paint will 'dry' as we put it on and will not easily spread — the going will be rather heavy. Nevertheless paintings are sometimes done directly on to paper and cardboard and they seem to last reasonably well, and it is of course a simple way of settling the matter of a prepared surface. One advantage of working on absorbent grounds is that as the oil soaks away from the pigment the paint is left relatively hard and may be overpainted without difficulty, and for this reason some people prefer grounds of this kind. The paint should be used thickly, so as to provide plenty of oil and so that the ground may be well covered.

It is usual to prevent the oil soaking in by treating the surface with a substance which oil will not penetrate. Two aspects of the prepared material are then distinguished: the 'support', the canvas or cardboard for example, which is covered with the 'ground', the surface which will isolate the layer of paint from the support. The simplest non-absorbent material to use is size, which can be purchased at any hardware store. Size is a form of protein; it may be regarded as a crude gelatine. Its quality varies a good deal and some is decidedly poor. It is better therefore to use powdered gelatine, which is more uniform in quality and much more efficient. It is easily prepared. About four to six heaped teaspoons of the powder are added to half a pint of cold water and well stirred. It is left for about half an hour, when the gelatine swells up by absorption of the water. The mixture is now warmed, not directly over a naked flame but by placing the container in a saucepan of hot water, which may be kept hot over a low gas jet. The gelatine is stirred, when it goes into a clear viscous solution. If this solution is painted on to any absorbent surface, such as paper or cardboard, it forms a protective layer against oil. As soon as it is dry it is ready for use. (It is necessary to apply the solution while it is still hot, because as it cools it gets more viscous and finally sets to a jelly.) By itself, however, gelatine dries into a very smooth shiny layer which is not easy to work on as it lacks any grip on the paint, which is more likely to slide over the surface than adhere to it; and since gelatine is colourless it does not add any whiteness to the ground. These difficulties can be overcome by mixing into the solution, while it is still hot, some powdered chalk or 'whiting'. The whole should form a thin creamy solution. On being painted out, the chalk is stuck to the surface and dries out white; and having a rough-cast effect it takes away the extreme smoothness of the gelatine and gives a surface which will take the paint reasonably well.

Cardboard, paper, and wood may all be treated in this way and serve very well as supports. Different grades of paper give different surfaces from rough to smooth, and one need not be restricted to white paper — any stiff wrapping paper will do. The rougher, in some respects, the better; and the same goes for cardboard. Quite a good grained surface can be made from linen-backed lining paper. This is lining paper which is strengthened by having a covering of thin linen on one side, and when this side is treated with the ground the paper backing prevents the liquid soaking through the pores of the linen.

Another useful material which has become very popular with painters is hardboard, which is sold at many hardware stores and builders' merchants. It may be obtained in large sheets which can be cut down to size, and smaller 'off-cuts' are usually available also. This material is particularly useful because it is very durable and rigid, and the two sides have different textures, one being smooth and the other rough. The latter often has a canvas-like grain impressed upon it so that if this surface is treated with a white ground it comes to resemble a coarse canvas and provides a good 'bite' for the paint. This type of surface is, however, best treated with an oil ground as described below for canvas, but the smooth side of hardboard responds well to treatment with the chalk ground.*

In the preparation of chalk grounds the quantity of gelatine should be reduced to the minimum needed, because if too much is used it is likely to cause the layer to crack. The more gelatine, the less absorbent will the surface be, and the more chalk, the more absorbent it will be. It is certainly undesirable to paint on surfaces which are too stone-like in their hardness and which are completely non-absorbent. A certain degree of absorbency is to be looked for, because this makes a much more satisfactory surface to paint on; but really only we ourselves can decide the degree of absorbency which suits our needs. It is worth while paying some attention to this point, because I have known amateurs who have attempted to make their own grounds according to some rigid formula as to the quantity of materials to be used, and have found them unsatisfactory; whereas it should be realized that the method must be adapted to individual needs. A little experience will soon enable us to judge the quantities that make a ground which suits us best.

To render a dark surface white it will be necessary to apply more than one coat of the chalk solution, but it is better to apply several coats of the thin cream rather than rely on one thick layer, which will be liable to crack. Naturally a material like paper, which is easily bent, will not carry as heavy grounds as will stiff boards, without the possibility of cracking. If, however, intense whiteness is required, the opacity of the chalk can be considerably increased by adding zinc white (zinc oxide) to it, and this enables hiding power

* It is perhaps worth mentioning that it is possible to buy at the artists' shop a white priming paint, often sold in tins as 'hardboard primer', which is intended to provide a ground by being painted out directly on to hardboard and similar materials, and is ready for use after twenty-four hours' drying.

to be obtained without resorting to great thickness in the layer of ground.

We need not, however, think only of painting on surfaces of glistening whiteness. It is often helpful to paint on darker grounds and bring up thickly the lighter colours against them. It is necessary to say 'thickly', because the increasing translucency of the paint will tend to make the picture darker with age. Some people prefer to paint on dark grounds, which do not have quite the hard vacancy of unused whiteness, and they find that such surfaces are more stimulating. To make darkened or coloured grounds one can add suitable powder colours to the original chalk.

Again, there are people who find it helpful to paint on top of a discarded painting, which is often turned upside down so that the picture itself does not obtrude. It naturally offers a variegated surface which often suggests ideas and patterns of colour which can be worked into the top picture. Perhaps from a technical point of view the practice may be open to question (it is certainly useless to think of painting on top of an old varnished painting), but of course it depends on the condition of the underpaint and on the precautions taken to minimize the dangers of deterioration. Our technical knowledge will help us here.

Canvas cannot easily be prepared by the above method, because the chalk layer would have to be made so thick that it would certainly crack when the canvas is rolled. It is much better to use the 'oil ground' under these conditions. The canvas is first treated with a coat of size or gelatine and allowed to dry. On top of this is now painted a coat of white paint (preferably white lead) in which the oil content is reduced to a minimum. The ordinary white undercoats sold in paint shops serve quite well for this purpose. They should be painted out liberally on the canvas so that the pores of the grain are filled up. Two coats will probably be necessary, because if the teeth are not properly filled with undercoat a great deal of paint will be taken up in covering them in the actual painting.

Of course the oil ground can, if desired, be used on paper and cardboard, which are then treated in the same way as canvas, but it must be remembered that the oil ground does not provide the desirable roughness of the chalk ground when applied to smooth surfaces.

The preparation of chalk or oil grounds is of course time-consuming, and the introduction of new materials has now made it

possible to prepare supports for oil painting by a quicker, though decidedly more costly, process. This consists in the direct application of a priming paint of the plastic emulsion type (often called an acrylic primer) to the surface to be prepared; no preliminary sizing is necessary and the thick white paint, supplied in tins or jars, can be brushed out directly on to almost any type of support, such as cardboard, hardboard, wood, canvas, and fabrics generally. In a matter of a few hours the surface is dry and ready to receive oil paint. The priming coat is said to remain flexible indefinitely so that canvases can be rolled without fear of cracking.

The difficulty with canvas prepared by ourselves or purchased in bulk is the question of stretchers, which are relatively expensive and anyhow occupy a good deal of space. One can keep two or three stretchers going, so that the canvas is stretched, used, and then removed from the stretcher and rolled up. But stretching canvas is rather a tricky affair* and canvases of moderate size can be used simply pinned to boards. If a finished painting is going to be framed it can be given a backing by being glued to a panel of hardboard or wood. Sometimes it can be simply tacked and stretched across the back of the frame itself. These methods may be rather makeshift, but at the least they can meet an emergency; and in any case it is unlikely that we will restrict ourselves to painting on canvas attached to stretchers.

* In stretching a canvas, one's first requirement is to have its grain correctly aligned with the sides of the stretcher frame, otherwise it will be pulled out of shape. The canvas should be of a size which allows for an overlap of about 2 inches all round the stretcher. The canvas is placed face downwards and the frame placed over it. The canvas is then fixed with one tack inserted in the middle of one side of the frame; it is then pulled tightly across to the opposite side and tacked there. This is repeated for the other two sides. Tacks are then inserted at regular intervals of about 2 inches on each side of the first tack, so that the tacking proceeds outwards towards the corners. As each tack is inserted, the canvas is stretched across to the opposite side and tacked there. This is repeated in rotation for the other two sides, so that the tacking proceeds from the middle of each side towards the corners. When the corners are reached the overlap of canvas is folded inwards and tacked down. By following this procedure the canvas is stretched outwards towards the sides, whereas if the tacking is begun at the corners the canvas is likely to sag in the middle. In this way it is possible, without any special instruments, to stretch a canvas reasonably tightly, and any slack can be made up by gently tapping the keys. These, however, are not really meant for the purpose of creating tension in the canvas, but only to make up any slackness which occurs through wear and tear.

Other equipment. It will be seen that the oil painter will find a good deal of scope for his activities if he is something of a handyman. He can of course purchase everything ready-made if he likes and if he can afford to, but to do this is to miss a great deal of the interest which goes with making one's own materials. These will call for some resource and improvisation, but this is not likely to act as a deterrent. Many amateurs rely entirely on the products of the art shop because they do not know how much lies within their power to make for themselves.

It will be well now to say something about the other materials of the oil painter. With regard to the paints themselves, these have already been dealt with in Chapter Five, and most people will be content to buy them in the tubes in which they are sold by the colourman. The pigments can, however, be obtained in powdered form ready for mixing with oil, but this is a somewhat specialized procedure.

Palettes can easily be made out of three-ply wood or hardboard. The surface should be treated with a strong coat of size. The shape is usually either oval or rectangular, and a small hole is cut out near one edge to allow for the insertion of the thumb. But the palette is not necessarily held in the hand; especially if we prefer to work standing up, it may be found desirable to keep the palette flat on a table, and so have the left hand free while we work. Under these conditions any non-absorbent material of suitable shape will serve as a palette, such as a glazed tile or a sheet of glass. The traditional palettes of oil painting are brown, and some difficulty may be experienced with these at first, because the colours naturally tend to look rather different in brown surroundings from their appearance on the canvas; but a little experience soon overcomes this difficulty. We can if we like paint our palettes with white paint first, leaving the paint to harden well before use; but a subdued palette will be found to have certain definite advantages.

Palettes should be cleaned after use; if this is not done they are inclined to become piled thick with paint as successive layers are added and allowed to harden. They can then become very heavy to handle, and the accumulated paint will have to be burnt off. To overcome this difficulty the 'tear-off' palette has been introduced, consisting of a stiff-backed pad containing numerous sheets of oil-proof papers. After each painting session the top sheet is torn off, leaving a fresh sheet to be used next time. But a palette is a perma-

nent part of a painter's equipment and many people will prefer to use the same palette over and over again rather than rely on a disposable article.

Palette knives have already been mentioned. They are obtainable in various sizes. They are useful mainly for scraping unused paint off the palette, and for any considerable mixings of paint which cannot conveniently be done with the brush. Painting knives are more delicate instruments, consisting of very flexible high-grade steel. In shape they are essentially trowel-like, with many modifications; only by trial can we discover the kind that suits us best.

Brushes are to be had in so many varieties that it is best to have a look for oneself in a dealer's shop. Broadly speaking they are of two kinds, depending on whether they are made from stiff bristles or soft hairs, and both kinds can be obtained round or flat. The latter show the greatest variations; they differ in the length of the hairs and as to whether the hairs are brought to a sharp, straight edge or are rounded off at the ends ('filbert' shaped). The stiff brushes made from hog bristles are the ones usually used for oil painting, and the flat, straight-ended type will probably be found best for most purposes. Of soft brushes the best are made from sable hair, but their cost is considerable. Cheaper kinds made from other hair can be used in their place, but these usually do not have the 'spring' and resilience of sable. A flat, soft brush may be found useful where it is necessary to lay the paint without disturbing the under layers to any great extent. On the whole, however, soft brushes make more precise strokes, and if used too much tend to a concentration on detail which is likely to result in a fussy and 'bitty' treatment generally.

One thing can scarcely be over-emphasized, and that is that the kind of brush used will make a great difference to the kind of picture that comes from it; and some brushes will give much better results than others. It is useless to try to force a brush into creating effects which it is not suited to make. It is therefore well worth some experiment to find out one's preference. There is something entirely personal about brushes and, as with our favourite pen nibs, only we ourselves can make the choice. Of course they are to be had in different qualities, and the price varies accordingly. An expensive brush has carefully selected bristles which behave in a more predictable manner than those of a cheaper one; nevertheless it is a great mistake to suppose that expensive equipment will necessarily lead

to better results. It is often said that only the best (that is, the most expensive) brushes should be used; but a cheaper brush will not necessarily produce an inferior painting — only a different one. It is sometimes overlooked that brushes are not static things; they begin to wear away as soon as we use them and this wear will probably be uneven, so that the bristles become moulded by our manner of applying the paint. In this way brushes become unmistakably 'ours'. Unfortunately their useful life is over when the bristles become too short; no sooner, it seems, do we wear them in by use to suit our own brush strokes, than we have to discard them.

The sizes of brushes are given numbers, increasing in size from 1 to 12, and the maker usually stamps each type with a series number, so that a brush can be specified by stating the latter, and then quoting the size. The size number is only specific for particular types of brushes; thus a number 6 brush of one type may be larger or smaller than a number 6 brush of another type. We should not choose brushes which are too small, otherwise it will be sheer labour to cover the entire surface of the canvas. Nor is it necessary to have a great many brushes in use at once. One fair-size brush may be found sufficient, as it can be cleaned repeatedly; but three or four of different sizes may be preferred. There is a strong tendency among beginners to start holding a brush by the ferrule end, but it has already been pointed out that this is most restricting. It means that only the fingers and wrists are brought into operation, and moreover the hand itself covers the painting while we work. It is much better to hold the brush at the end of the handle so that our whole forearm is brought into action and we ourselves are at some distance from the canvas — not crouching over it — and can take in everything at a glance. At first it may seem difficult to control the brush at this distance, but this is because we tend to think of control in terms of the precise control we exercise over a pen or pencil when we are sitting at a table. But this is not called for in a painting. Actually it will be found altogether more natural to bring a painting into being if we resist any temptation to work like precision engineers or architectural draughtsmen, and keep our eye resolutely on the main thing — the entire effect we are creating on the canvas.

While painting is in progress, brushes can be cleaned in turpentine and wiped with a rag. For this purpose it is necessary to have a jar of turpentine at hand, so that the brushes can be dealt with before being dipped in the medium. If, however, brushes are repeatedly

swilled in turpentine, the latter will soon become very muddy; and then not only will any effective cleaning be impossible, but the medium itself will become clouded. This can be avoided by first dipping the brush rapidly in and out of the turpentine so that the paint is just loosened and can be wiped off with a rag. The process can be repeated if necessary. In this way the bulk of the paint is transferred to a rag and not to the turpentine, which is kept reasonably clean. After a painting session, brushes should be given a final cleaning with soap and warm water, and we should make sure that the soap is thoroughly washed away from the bristles afterwards. If however we paint frequently this routine will become irksome and at some slight risk to the brushes we may prefer to leave them inserted in a jar of turpentine. Naturally it is better if we can suspend them in the liquid, so that the bristles are not pushed out of shape.

We shall use a good deal of turpentine, and the distilled variety sold by the artists' dealers is at an inordinate price. It is cheaper even to buy medicinal turpentine from the chemist's. Better still however to get it from the hardware shop, where it is to be had by the pint at much smaller cost. It is sometimes combined with 'white spirit', but is still serviceable. And turpentine substitute is well known and easily obtainable; it dispenses with the smell of turpentine and with the annoying stickiness which it always develops where — as round the cork of the bottle — it is for any time in contact with the air. There is a simple test for the purity of all these diluents. It will be realized that what is required above all else is that they should evaporate without leaving a stain behind. If therefore we take a clean sheet of white paper and half cover it with the liquid, and then leave it out to dry, a comparison of the two halves will show at once if any deposit has been left.

With a little ingenuity an easel offers no difficulty. Three stiffish poles — broom handles for instance — can be roped together at one end and spreadeagled in the manner of a tripod. If the legs slip they can be pointed at the ends or fixed by connecting them with string. A series of holes drilled through the two forelegs, at distances of about three inches, can have 2-inch nails inserted in them to act as supports for the picture. For outside work small folding easels are more convenient. These are naturally difficult to make unless one has a flair for carpentry.

Oil paintings are not usually framed behind glass since, unlike water-colours, they can be cleaned if necessary. Although in practice

this is seldom done, there is no doubt they look better unglazed and this simplifies the question of framing. Frames can often be picked up at second-hand shops, where they are wont to lie amongst the accumulated rubbish of years' standing. With a coat or two of emulsion paint even the dirtiest frame can be made quite present-able. Sometimes the old-fashioned gilt frames look particularly well when treated in this way. With a mitre board it is not difficult to cut frames down to any size and if, as is not at all unlikely, the corners do not fit very well together they can always be filled up with plastic wood. For such expedients the final emulsion paint covers all. Another method of dealing with old frames is to paint them with a paste consisting of cement mixed up with a household paint, say cream or grey. The rough-cast effect so produced looks very well with oil paintings. Sometimes one is lucky enough to pick up a frame complete with stretcher and crumbling oil painting, which can be removed or, if it is not too badly damaged, reversed on the stretcher and the surface treated with an oil priming.

7 □ water-colour and other media

Our approach to water-colour. There is a subtle difference between the popular estimate of oil and water-colour painting; the former is regarded as of more significance, whereas the latter is often associated with a rather flimsy and emasculated product — the legacy of a tradition which dies hard. The attainment of a certain skill in water-colours was at one time the proper accomplishment of the educated and refined young lady; and something of the same air of wistful charm still surrounds the popular conception of the medium as demanding a delicate touch and other-worldly sensibility. The water-colourist has somehow not come into his own as a full-blooded person.

Now this is unfortunate, not because this conception is either true or of much importance, but because it colours our approach to the subject. Certainly we need not approach it in any spirit of resignation.

For some reason water-colour is often considered less of an accomplishment than oils. 'He paints in *oils*' — the emphasis is deliberate, meaning that he does something much more impressive than any paper-and-water stuff out of a paint-box. There is no rhyme or reason in this idea at all. It is true the water-colourist sometimes works to a small scale and brings a somewhat 'miniature' attitude to bear on his endeavours; but there is nothing in the medium itself to suggest a diminutive or trivial product.

Light from the paper. In water-colour painting, since water is the medium used for spreading the pigment over the surface, the particles of pigment are left exposed on the paper as soon as the water has evaporated; they are not enclosed in a medium as in the case of oils, and we do not have to concern ourselves with the technical problems which arise through changes in the medium itself. But water-colour paints can be handled in two distinct ways, and this may give rise to confusion. In the first place there is the

107

traditional water-colour, which comes out of the familiar black boxes with their rows of solid paints. It is a peculiarly English medium, for it was in the England of the eighteenth and early nineteenth centuries that it was largely developed. Its particular feature is its transparency, the paint being used thinly so that the white paper shines through and gives light and brilliance to the colours. The paper therefore plays an important part in the painting and is not meant to be obliterated. White paint is seldom or never used, whiteness being supplied by the paper, which is simply left blank if white itself is required in the painting, and the colours are paled to any desired extent by varying their thinness over the ground. There can then be no question of lightening a painting by overpainting with pale colours; every colour put down brings more covering over the paper and so reduces more of its light, and it is not possible to build up a picture from dark to light or to paint out what is underneath. It therefore calls for its own kind of technique, the discussion of which will be taken up later in the chapter.

Poster colours. Whenever water-colour is mentioned it is this transparent kind that most people think of, and it is not always realized that water-colour paints can be handled in an exactly opposite way, so that they function, like oils, as an opaque medium. In this technique the paint is spread thickly over the paper, and white paint is freely mixed with the colours to pale them and to increase their opacity; one colour will obscure another when painted over it, and the ground in the end may be entirely obliterated. When water-colours are used in this opaque way they are known by the general name of *gouache* colours. Thus transparent water-colours become gouache colours if white is mixed with them to produce opacity, but for the purpose of this technique special paints are usually used, the best known of which are those called poster colours. These are water-colour paints which are all rendered more or less opaque by the addition of some filling material, such as chalk; and as a good deal of white light is reflected from the matt surface when they are dry, the colours tend to take on a somewhat chalky appearance. Poster colours in the form of a 'buttery' paste can be obtained in tubes or in pots; from the latter they may be transferred to the palette by means of a palette knife or penknife blade. They have the same consistency as oil paint and when first set out on the palette they look like oil colours almost exactly, but as the water

dries off they harden. In the course of painting they are constantly moistened, but left to themselves they eventually become very hard and are then not so easily taken up by the brush. It is best therefore to set out fresh paint each time we use them.*

The ordinary bristle brushes of oil painting serve well here and help to overcome the temptation to niggle at water paints with a small brush. The paint can be spread, as with oils, thickly or thinly according to the extent to which it is diluted by the medium, and a good deal of play can be had by varying the thickness and hence the opacity of the paint; in places, transparent or semi-transparent layers can be applied, so that part of the under paint or the ground shows through, and in others, strongly opaque paint can be used for its hiding power. But it should always be remembered that we are dealing here with an opaque medium which lends itself to a thick solid treatment. Used very thinly the paints resemble transparent water-colours, but this is not their characteristic effect. The tendency in beginners is to use them in too watery a condition and so lose their particular value as opaque colours. As with oils, the thinned paint can be used as a means of freely setting down our ideas, since in this condition the colours flow readily from the brush and may be spread quickly over the paper. Then thicker paint can be taken up, with as much added white as may be needed, and the picture developed to an opaque stage. We are not, as in oils, dealing with soft paint all the time; as soon as the water has evaporated the paint is hard and colours can be overpainted with ease. Overpainting is best done quickly, however, otherwise the underpaint softens and merges with the paint on top. It is another case of painting directly and not 'worrying' the pigment.

A marked difference from oils — and this will be distinctly annoying at first — is that the colours get considerably lighter as they dry out, a result of losing the enclosing film of water. This is especially noticeable with the dark colours when, as often happens, some white has been mixed in with them. It takes a little time to get used

* It is well known that poster colours can also be obtained in the form of solid circular cakes, which are often sold in boxes containing a variety of colours. The solid paints do not require preliminary setting out on a palette, but a disadvantage with them is that they do not lend themselves to effects of thick impasto since the paint film derived from a solid cake is always relatively thin. The more versatile 'buttery' paint which comes from tubes or pots will generally be found more satisfactory.

to this general lightening of tone, but one can soon allow for it and judge more or less what is to be expected.

With poster colours we do not have to concern ourselves with the technical problems that arise in oils, and the complete freedom they allow in handling makes them probably the best medium for the beginner. Moreover they serve as an excellent introduction to oils, to which they almost inevitably lead. They are inexpensive and call for a simple equipment. They can become garish and flamboyant, but there is no reason why they should do so if we are careful to choose the right sorts of pigments to start with (this question is dealt with in Chapter Eight). Poster colours are made up in many brilliant and even glaring colours mainly of dyestuff origin, but it is best to resist the more lurid of these, whose true place is in the field of commercial advertising, and stick to the recognized pigments. Poster colours are then susceptible of real refinement and can produce colour schemes which have nothing 'posterish' in their character. The word 'poster' is unfortunate as it suggests a slap-dash and not very serious medium for painting, but this is quite unjustified; and though we are unlikely to confine ourselves to these colours, they are so handy for the spare hour's painting that we will probably fall back on them again and again.

Powder colours. A variation of the poster colour obtained ready mixed in tubes or pots is what is called powder colour or tempera water-colour. This consists of the dry powdered pigments to which gum has been added; when mixed with water they form an opaque paint similar to poster colour. The most convenient way to use them is to set them out in the dry state in a cake tin — the kind provided with nine or a dozen separate pans — and place in each pan a separate powder. The brush is then dipped in the water and — not too wet — dipped in the powder, which, adhering to the brush, may be transferred to the palette for mixing or applied direct to the paper. When a mixture of colours is required the brush need not be cleaned between each application to the different powders; when one colour has been transferred to the palette the brush, still wet with paint, can be dipped in a different powder without any admixture taking place in the pan — the new powder simply adheres to the brush and may be mixed into the colour on the palette.

The advantage of powder colours is their convenience. The powders naturally remain ready for use at any time and do not, like

poster colours, have to be set out fresh each time, and they are very readily taken up and applied. They are, however, in general not so satisfactory. They are more granular and much more chalky in use and do not give so clear a colour. Also the pigment is not so easily obtained as a thick paste; it means constant transference of the powder to the palette to make a really thick paint, whereas poster colours can be taken up directly in any thickness.

Plastic emulsion paints. It is convenient at this point to mention the water paints popularly called 'plastic emulsion' paints, which bear a superficial resemblance to poster colours. They differ from the latter in that they are not gouache colours and they employ a 'plastic'-type binding agent in place of gum. This binder has the property that, when dry, it becomes impervious to water, and it is mainly this property which gives to these paints their unusual character. They are issued by manufacturers under various trade names and are sold in plastic tubes; when first set out on the palette they look very much like poster colours. There is, however, this great difference in use that once they dry and harden on the palette they become completely waterproof and can no longer be taken up by the brush and spread as paint. This is a disadvantage because on a warm day, and especially in the open air, the drying occurs rapidly and can only be delayed by keeping the colours moist. This can be done by means of a water spray which is sold especially for the purpose, but any means of damping the colours may be employed instead. It is advisable not to set the paints out on the palette until one is ready to start painting and one should then aim to work rapidly.

The paints can be manipulated in a variety of ways. For instance they can be freely diluted with water and spread in transparent films, and can then be treated in the manner of the traditional water-colour to be described below. On the other hand they can be taken up thickly and applied, if need be, in heavy impasto, and white paint can be freely mixed with the colours so as to render them opaque and give them the character of gouache colours. If this is done the general technique is similar to that previously described for poster colours and oil paints. The waterproof property has the advantage that any underpainting when dry is completely undisturbed by any application of paint on top. This means that many of the effects of oil colours which require that the under paint should first be given time to harden can with these paints be

carried out in one session. For example glazing techniques, which in oils are often not undertaken because they are so time-absorbing, can now be readily carried out with good effect. Palette knife painting can also be undertaken, so long as the paint is used fresh from the tube and is not allowed to become stiff through drying. Plastic emulsion paints can be used on almost any type of surface whether primed or not (a white priming paint is available) and it is claimed that the paint film, even in heavy impasto, remains flexible for an indefinite period and is not liable to crack. The final painting dries out matt and can be treated with a plastic-based varnish to give a gloss finish, or if desired a plastic medium can be used to thin the paint in place of water, in which case the paint dries with a gloss surface without further treatment.

It can be seen that these paints are certainly versatile and may even challenge comparison with oils. But the fact that in using plastic paints we may employ many of the techniques of oil painting does not mean that they are in any sense a substitute for oils; it must be remembered that they are essentially water paints and we shall find in handling them that there is a vast difference between a medium based on water and one based on oil. The plastic paints are especially valuable for purposes which call upon their quick-drying, water-resistant properties.

Transparent water-colours. We turn now to consider the traditional water-colour. As a transparent medium it presents different problems and it creates different effects from those encountered in a medium in which gouache colours are employed. It is commonly held to be a difficult medium and assuredly it is not easy to achieve the precision and detail that are displayed in paintings of a certain type. But there is no need to aim at virtuosity, and the more simply we use the medium the better. It holds so many attractions in itself that we should not be put off by stories of its intractability. Typically it lends itself to spontaneity, it makes no allowances for second thoughts, it is the very medium that can be carried about for the making of quick sketches; and it is a pity to see, so often, its sparkling lightness crushed under the weight of a dourness and deliberation which is quite foreign to its nature.

The difficulty is often held to be that it is impossible to cover up mistakes. But we have already had reason to see that this need be no disadvantage, and in water-colour particularly the process of

constantly correcting 'mistakes' is the very one that leads to despair. It destroys all happiness in the medium and leads to muddy colour and confusion. Water-colour calls for direct statements which we are prepared to keep to. It is rather like drawing with a pen: we are committed to whatever we put down. We should not hesitate to use it this way.

Much of the difficulty that is encountered with water-colour is the result of the way we approach it. Probably most of us have made our first — and perhaps our only — contact with painting by way of the children's colour box, which is supplied with small brushes, much too small to paint out the colours with any degree of freedom, and indeed we may have used them only for colouring illustrations in books or at best our own outlined drawings. This is not to be wondered at. The whole intention of these boxes would seem to be towards small scale and detailed work, and this induces an attitude of mind which conceives water-colour as a fussy medium, limited in scope and size. We will do well to break down this attitude by using large brushes and large sheets of paper. This in itself confers a new range and sense of adventure on the enterprise of using the paints. These can be had in tubes as well as in the familiar pans, and in many ways it is better to start with the tube colours and squeeze them out on to a palette, so that they can be used right away in a moist condition. Water-colour boxes themselves are often a cause of confusion, because they contain a great assortment of colours, bewildering in their variety, and many of them fugitive. It is best therefore to buy our own, starting with a few and gradually adding to these as we feel the need for more. It is often helpful, too, to start by using brushes not of the usual round type but of the flat type, which make broad or thin strokes according to the way they are handled, and whose shape seems to suggest much more the idea that one paints rather than niggles with them. One advantage of using a large brush is that, when fully charged, it holds plenty of water and does not quickly dry up on the paper, while the quantity of water it holds can always be reduced at will.

The technique of water-colour painting is essentially a glazing technique, and the principles involved are similar to those employed in the glazing of oil paintings; that is to say, we place transparent colour over a light ground. Just as the paper contributes white to the colours, so when one colour is superimposed on another the latter shines through and contributes its colour, as if by mixture, to the colour on top — or conversely the colour on top is modified as

if by mixture with the colour below. In all superimposing the under colour must be allowed to dry before another colour is added over it. The slightest changes can be brought about by washing one thin colour over another, and the stronger the colour on top the more marked is the effect of overpainting: but always there must be light from the ground shining through, since as we have seen transparent colours on dark grounds lose their colour altogether. Hence we have to bear in mind that every colour put down is going to darken the picture, adding to what is already there but not obscuring it; and we must be very conscious of the white paper as playing an essential rôle of its own, and see it as the source of whiteness and of the brilliance of our colours. It is the paper itself which gives the sparkle to a water-colour, and some of it may be left blank, or at least covered only with thin washes of colour. Hence we must know when to stop. Many water-colours are ruined because they are carried too far. When this happens, and the picture is seen to be getting too heavy and dark, the tendency is to try to lighten things by working the paints thickly so as to make them act as opaque colours, but the result then is nearly always disastrous. It is certainly a mistake to mix our media here. Once we start using the paint for its opacity we are out of the realm of ordinary water-colour and into that of gouache. We may as well then start with the opaque colour from the beginning. Especially is this so if we start introducing white to give hiding power to the colours themselves. Their transparency is then lost and they do not harmonize well with the colours that remain transparent.

Of course we have to take the pigments as they come and although we agree to make water-colours transparent, the paints themselves are not all transparent by nature. This will quickly make itself apparent. A pigment like Indian red is strongly opaque and will have to be diluted a good deal to be made transparent, whereas viridian, as a natural transparent pigment, will never be opaque. Opaque pigments should not be applied in thick solid layers; always some light from the ground should give them depth and brilliance. This does not mean that opaque pigments may not be used for their hiding power in places for the sake of emphasis, and there is no objection to the use of Chinese white here and there, but what we should avoid is introducing a technique appropriate to opaque colours into a transparent medium.

Water-colour, which in essence is so spontaneous and so simple,

has been made the subject of the most elaborate techniques which are quite exhausting in their precision and detail. There is no medium which can be made to offer greater scope for sheer dexterity and manipulative skill. But an art medium can become too elaborate, and in the process it often happens that the spirit goes out of it, and the sense of adventure. We shall do well to remember the essential character of water-colour — transparent colour on white paper— for this is the key to its technique, and if we grasp this point we have in our hands the means of developing it for ourselves.

In some ways we cannot do better than take up our colours in strength and put down direct final statements, with little intention of touching up afterwards. It is surprising how a few bold touches of colour can come together on the white paper and bring about a complete effect with extreme economy of forms and suppression of all detail. It is the paper itself which binds the forms together and makes them coherent. To go on further and cover all the paper may add nothing to the picture, but on the contrary destroy its unity. A few guiding lines in pencil may be found helpful, but these should be reduced to a minimum, to serve as guides to the placing of colour — lines we will paint over and not paint round.

It cannot, however, be denied that it is much easier said than done — to take up colours boldly and put down 'direct final statements'. Many people simply cannot do it at first, and can come only gradually to such a way of working. For them it is better to tackle water-colour in a different way and follow a building-up process starting from preliminary suggestions. Naturally this cannot follow a dark-to-light order of events, but it can go the opposite way. That is to say we start by putting down pale colours — perhaps very pale indeed — and work these up to completeness by overpainting with stronger colours. The painting then is developed in layers of transparent washes, and under these conditions the strongest accents are added last of all. This is a method which makes full use of the glazing effect of water-colours, and hence is in keeping with the character of the medium; but of course there is a limit to the amount of overpainting which can be done without losing clarity of colour. Crispness of edge and clear definition can only be preserved by painting on top of dry paint, but on the other hand it is at times desirable to paint 'wet into wet', and mix colours directly on the paper. A merging of colour naturally takes place under these conditions, and this for certain effects may be just what is called for.

Technical devices. The water-colourist has certain special ways of handling his materials so as to achieve particular effects. They can be called tricks if we like, but it rather depends on how they are used. Purely technical devices can easily develop into tricks indulged in for their own sake, having no connexion with individual creativeness and perhaps even stifling it. They can for instance be made to bolster up illusion or to display virtuosity, and then are almost grotesque in their banality. But water-colour is a give-and-take between paper and paint and no virtue resides in ignoring the manipulation of either in such a way that its inherent qualities are revealed. It may be well to say something about these technical devices — often applicable to gouache as well as the transparent medium — which in any case may stimulate our own resource and invention.

First, then, 'laying a wash' — that is, covering a fairly large expanse of paper with an even film of colour. This is a useful accomplishment, but can easily be overrated, as when it is made the first requirement of technique. In practice we may not want to lay a wash at all, or if we do we may not worry if it does not lie perfectly smooth. On the other hand it is often helpful to paint on a tinted ground, against which the other colours react and which can be an aid to unity by providing an over-all colour at the beginning. If we do want smooth washes they are not really difficult to make and with a little practice should give no trouble. The first requirement is to make up all the wash colour at once, because if it runs out before the end we are in a hopeless position. More than enough of the 'colour-solution' should be made up in a separate container, say a saucer. The brush (which should be a large one, holding plenty of water) is then well mixed in the solution and applied, firmly and at uniform speed, in one wide band horizontally across the top of the paper, which should be slightly tilted towards the base. The brush is again dipped in the solution and the process repeated immediately under the first band. This is repeated until the whole area is covered. It should all be done without a break so that no edges are allowed to dry off. With a little practice it is possible to lay satisfactory washes in this way, but if it is found difficult to make them uniform enough, the surface of the paper may be wetted first and the wash applied in the same way after the surplus water has dried off. A graded wash requires a slight alteration in the procedure. After the first band has been applied the brush, instead of being reloaded with wash

solution, is dipped once in clear water and then run in under the band as before. It is again dipped in water, and so on; in this way the wash gets gradually paler until if need be it merges with the white paper itself.

The paper will wrinkle and buckle if it is wetted to any considerable extent. This can be prevented by first stretching it on a board. The paper is soaked in water or at least damped on the upper side. This causes it to swell and expand slightly. It is now placed flat on the board, to which it is attached along its edges by overlapping gummed paper. When the paper dries out it is stretched tightly, because it cannot contract away from its edges, and it will retain its even surface when wetted again. To go to the lengths of stretching the paper every time will, however, be tedious and quite unnecessary.

A favourite device is 'sponging out,' which relies on the fact that a wet sponge can be made to remove paint from the paper. The extent of removal of course depends on the degree of sponging. The paint can be lightly brushed away, producing an effect of variegation, or swept off vigorously so that the white paper itself is revealed. Where one colour has been superimposed on another, it is possible by light sponging to remove the top colour without disturbing the one underneath. The removal of colour can also be effected with a wet brush, which is first made to loosen the paint and then, after being wiped dry, is made to soak it up. Blotting paper is also useful for soaking up colour from a wetted surface. A wet rag, depending on its texture, will produce various surface effects if it is lightly dragged across the paint.

The wet paint itself can be manipulated in various ways. Scratchings and rubbings will all produce their own effects. Turner — a pioneer in the water-colour technique — is said to have used his thumb! And stiff bristle brushes are useful here. It is not only the soft hair brushes that can be used in water-colour, though they are the most popular. As a matter of fact bristle brushes work well and naturally deal with the paint in a firmer sort of way. They can be made to scrape paint from the surface and work it about the paper. An old brush that has been worn down by use and has stunted hairs will serve well here as a tool for scratching and working the paint. All this applies to wet paint, but when it is dry, scraping ('lifting' it is sometimes called) can still go on. With a penknife the paper can be scraped away and so made to show up white against the paint. This is used for bringing up sharp lights against darks,

or less strong contrasts can be made by only partially scraping the paint away. Effects of texture can be produced by handling the pen-knife blade in different ways; the point, for instance, induces sharper and more incisive effects than those obtained with the flatter part of the blade, and the type of paper used will have an important bearing on the result. Thus on a grained paper scraping will remove paint from the tops of the grains only; a soft paper yields itself more readily to lifting than a hard one, while on thin paper only very limited scraping is possible at all. It is worth noting that lifting can also be carried out by gingerly treating the paper with very fine sandpaper, to remove just parts of an area of paint. A sense of surface and texture has come strongly into modern painting, and it is by devices such as these — very much up to the individual as to how they are used — that they can be brought about.

A grained or rough paper has a texture of its own and this can be emphasized in the course of painting. A brush, not too wet with paint, can be dragged over the surface so that the paint adheres only to the tops of the grains while the hollows are left untouched. This reveals the grained texture — dark against light. The reverse process is also effective; when the surface is painted so that the hollows as well as the tops are covered, a wiped brush or damped rag dragged over the paint will remove it from the tops, which are left pale against the dark paint in the grooves.

A picture may be painted entirely on damped paper. The paper is first treated with a wash of water, or entirely soaked, and the painting begun when the surplus moisture has dried off; and if the wet paper is put on to a slate it will retain its dampness for a longer time. Under these conditions the paper takes up the paint very readily and the colours run freely about, but of course there are no crisp edges and a 'softness' is given to the forms. Paintings done on damped paper have an air of indistinctness and take on an atmo-spheric quality.

It is sometimes useful to isolate, temporarily, an area of the paper from the effect of water-colour paint. This can be done by covering the area concerned with a clear rubber solution; any area so covered will be rendered waterproof by the film of rubber, which can be subsequently rubbed off, leaving the paper in its original state.

Paper, brushes, and palettes. We have had reason to see that the kind of paper used will have a considerable effect on

the work done. Apart from any influence of the surface texture, some papers take the paint easily and help the picture along, while others seem to retard it. It is worth giving some attention to this point because we may find that we make no headway with water-colours or at least that our style is hopelessly cramped, when really it is simply that we are using a paper that does not suit us. Broadly speaking paper is of two types; cartridge paper and the more expensive hand-made papers. They are sold according to weight, the heavier papers being thicker and more expensive. The standard size is the imperial sheet, 30 by 22 inches, which may be cut down to requirements.

In many ways cartridge paper answers best. It varies a good deal according to its quality, and one can only try out different kinds and find what one prefers. This is not by any means a question of cost. It may well be that a cheaper quality, which is perhaps somewhat absorbent, works better than a more expensive one. The disadvantage of the cheaper papers is that they tend to yellow with age. This is where the hand-made papers score; they are made to last. The famous Whatman paper is the best known. It is made in three distinct kinds of surface, called Hotpressed, Not, and Rough. Hotpressed is very smooth; Not means simply 'not hotpressed' and is slightly rough; Rough has a definite canvas-like grain impressed on it. The latter can be made to produce particular effects which have already been referred to, but apart from these the colour in ordinary use tends to collect in the deeper parts of the grain and so produce a mottled effect which automatically emphasizes the nature of the surface. In general, however, rough papers are not recommended at the beginning as they are somewhat tricky to handle, and do not lend themselves well to the spread of the paint. On the other hand a hotpressed surface is too smooth and glassy, and a 'not' is definitely best for most purposes. But when all is said and done (and hand-made papers are often spoken of as the only ones worth using) hand-made papers have a brilliant, hard, scintillating surface which is somehow unsympathetic — it has no give-and-take — and the beginner will be well advised to stick to cartridge paper and experiment with the more specialized papers later on.

One other paper should perhaps be mentioned. 'David Cox Paper' is specially made for water-colour painting and has a slightly absorbent surface. It is roughish, not grained, and has no brilliantly hard surface. It is a pleasant paper to use, but it is expensive.

Of course with gouache colours, papers which are not white can well be used and indeed are often preferred. The opaque colour shows up strongly against the darker ground, and one is not confronted with a glaring whiteness at the beginning. Sugar paper is useful here; it has a greyish or brownish surface and is inexpensive. But stiff wrapping paper can also be brought into use and it does not very much matter if it is marked or printed on; and we should not forget lining paper or the back of wall-paper, which can be bought by the roll, very conveniently 22 inches wide — the same width as the imperial sheet. Some people find it helpful to experiment with gouache colours on newspaper, a very absorbent and easily damaged material; but the newsprint is easily covered, and a page of type, columns and pictures presents a variegated surface which may stimulate ideas, and at least is not an 'empty blankness' at the start.

With regard to brushes, nothing in soft hair equals the spring and resilience of sable, and if we want the best we shall have to be prepared to pay for it. But very serviceable brushes are made of squirrel hair (sometimes called 'camel' hair), which are altogether cheaper. Most of the brushes sold for ordinary water-colour use are the round type; but the flat type, in sable and other hair, can be obtained as 'one-stroke' lettering brushes. The bristle brushes will be the same as those used in oil painting.

Palettes can easily be improvised. Flat glazed tiles serve quite well, and three-ply wood or hardboard is suitable if given a coat or two of white paint. Any sheet metal can be treated in the same way. It should be noted that water-colour boxes with lids that open out into palettes can be purchased empty of pans or tubes, and if bought in this way they can be filled only with the colours we really need.

Some people prefer to have the water-colour board inclined at only a slight angle, and if outside they rest it on their knees. For certain purposes the sharp angle of an easel is of course inconvenient, as very wet paint will run down the paper; nevertheless the general advantages of working at an easel remain and they should not be discarded just because at times the painting will have to be given a less vertical position.

Water-colour combined with other media. Water-colour, both transparent and opaque, can be made to work very well in association with other media. This for some people will

increase its scope and interest, especially where it is felt that water-colour is a limited medium. Instead of thinking in terms of water-colour only we can fix our awareness first on the paper and see it as open to treatment from many directions — indeed as offering a challenge to the resources we can bring to bear on it. A combination of media may help to increase these resources. Not that painting is mere ingenuity in juggling with media; but materials sometimes have the effect of drawing out a person's imaginative powers, and what is dead material to one will be stimulating to another.

For instance, a pencil can be used in association with water-colour. In the transparent kind any pencil lines put down first will show through, and washes of colour can be run over them with the intention that the lines should contribute their part to the total result. This is quite different from using pencil outlines and filling up the areas with colour. Again, pencil lines can be added on top of water-colour, to give linear emphasis in certain directions or to contribute their own patterning and shape. The two procedures can be combined, by starting with faint lines and strengthening these and perhaps adding to them after the colour has been put down. The strength of the lines will naturally depend on the grade of the pencil. Stronger emphasis is given by charcoal lines, which can be made with willow charcoal obtainable in packets containing a selection of twigs of different sizes. Charcoal, however, will merge with the water and may have to be 'fixed' on the paper first, in the manner that will be described under pastels.

Pen and ink lines can be used in the same way. Ordinary writing ink from a fountain pen can be used quite effectively over water-colour; the lines tone in well and do not make themselves prominent. Indian ink is much stronger and makes a definite pen-and-ink drawing. It not only does not fade in the light, but it is waterproof, and when dry will not run into wet paint put over the top of it.

It will be well if we can take the plunge and put down all lines, in pen and pencil, boldly and without thought of alteration — casting all, for better or worse, on decisive strokes. If some seem to go astray, they can be left as evidence of the search for direction and form. They tell the story of the drawing. This is better than trying to reconstruct an original line, for its cleanness and certainty go as soon as we try to remake it, whereas a new line adds to what is already there without destroying the evidence of its coming into being. In any case the process of trying to make it appear that a line

once put down never existed is seldom successful. It may help if we try an experiment as follows. Make any quick scribble without taking the pen or pencil off the paper, and run the line over the whole area of the paper. The result is a crisp pattern that could never come about by slow deliberation. Run some water-colour washes over these lines and when they are dry add touches of stronger colour in certain parts, perhaps to some extent following the natural shapes that the lines have made. Add some decorative features, effects of texture — by spotting, hatching, criss-crossing, or other characteristic marks of the brush or pen. Worked up in this way the scribble will become a decorative design which will give the cue for other variations on the theme. Simple devices of this kind can often be the means of starting us off on discoveries of the world of shape and colour, discoveries that would never be made if the original stimulus were not given.

A great deal of interest is to be found in working with the reed pen, which can easily be made for oneself. Reeds grow by the sides of rivers and ponds; they have hollow stems except at the points, about six inches apart, where the leaves are borne. The stems taper towards the ends, and so the different cuts will vary in thickness. If a piece of the stem is taken and, with a razor blade, shaped like a flat nib, it will be found that when dipped in ink it produces a line of great flexibility — broad if drawn down on the flat edge, and fine if drawn sideways. Other variations in the line can be made by varying the obliqueness of angle of the pen on the paper. Very fine lines can be made by drawing with the back of the pen. It lends itself very well to quick drawings which can be treated afterwards with water-colour, either when they are dry, or when wet — in which case the line can be effectively 'run into' the colour. Indian ink is rather too heavy, but fountain pen inks work very well, especially black and sepia. But the pen can also be charged with water-colour paint itself by filling it with a loaded brush; in this way the pen may be used with any colour and so its work may become more directly part of the painting.

Effects of a special kind can be obtained by the use of wax crayon with water-colour. Wax renders the surface of the paper impervious to water, so that wherever the wax is, the colour will not settle. For example, if some yellow lines are marked on paper with wax crayon, and a blue wash of water-colour run over the top of them, the blue will settle all round the yellow lines, which will be shown up

strongly by the background of contrasting colour. This behaviour of wax can be exploited in various ways. Perhaps most striking of all is the effect of white crayon or clear paraffin wax. When marks are made on white paper with these, practically no noticeable impression is made. If, however, a wash of any colour is now run over the paper, the marks of the wax will show up white against the coloured background. This provides a means of isolating white shapes from water-colour, while at the same time the latter can be applied with great freedom since the shapes will always remain intact. The procedure can be varied slightly. The clear wax can be applied over any area already treated with water-colour, and the colour is then 'fixed' and unaffected in any subsequent treatment of the painting. This can be carried a stage further with gouache colours which, if thick enough, can be made to 'take' to some extent over wax and so a painting can be built up on the use of wax and paint. If wax is applied lightly with the flat of the crayon, it will partially cover the paper but leave parts still exposed. This is accentuated with a rough paper where the wax will adhere to the tops of the grains only. When a wash is applied, the colour will take on the exposed parts only and will present a mottled effect — another effect of texture, which can be varied according to the amount of wax worked into the surface and to the darkness of the colour wash. Finally these treatments of water-colour and wax can well be combined with pen and ink work, in a way that is much more straightforward in practice than it may sound from description.

Wax crayons. Wax crayon itself, considered as a medium, deserves more attention than is generally given to it. It is often dismissed as a children's plaything, and it is true that crayons are not made up as a serious art material and are to be had in shops which do not specialize in artistic products. Of course they are rather greasy and shiny, but with a little care they can be made to give quite good results. They compel directness and spontaneity, because very little can be done in the way of alteration once a colour has been put down. They differ a good deal according to their make; some are softer and more easily applied than others, and there seems no way of judging this except by trying them out. A hard crayon is very difficult and unpleasant to use. The temperature plays an important part here, and in summer time they are more easily worked than in winter, when it is best to give them the

warmth of a fire before starting work. The mistake that is often made with crayons is that they are used too consistently pencil-wise, with the pointed end only, so that in effect they are made the instruments of drawing and not of painting. This in part is due to the fact that many crayons are very narrow, of more or less pencil thinness, but it is possible to buy much wider ones, of about half-inch diameter, which spread the colour more broadly and are much to be preferred for anything in the nature of large scale work. It is often a good plan to break the crayon, so that it is not more than about 2 inches long; it may then readily be used flat-wise, not necessarily along the whole length of the body, but the area in contact with the paper can be varied by adjusting the angle and the pressure. And in regard to the latter it may be said that a good deal of pressure will often be necessary, in order to make the crayon more malleable. To a limited extent mixing of colours can be carried out on the paper by working one transparent colour over another, but this will not be easy, on account of the greasy nature of the wax, and firm pressure may be needed; but it is straightforward enough if the first colour is put down only lightly. Mixing of this kind is like glazing, and is most effective when a darker colour is put over a lighter one. Mixing can also be carried out by criss-crossing with different colours, by varieties of hatching strokes, and by spotting colours side by side. Wax colours are mostly transparent and their effect is that of a glaze over white paper. They are in consequence extremely brilliant, and this is enhanced if the surface is finally polished with a rag, when the colours assume a luminosity and depth resembling a varnished oil painting. Incidentally this polish also evens out the surface, because as applied, some colours take on more shine than others, and the appearance is much improved when they are all brought to the same level. As the surface of a wax painting remains soft, the wax can be cut away with a penknife blade, and white lines and shapes can be brought into the painting by scratching down to the paper.

Pastels. Similar in shape to wax crayons but very different in use are pastels, which are a form of direct body colour. Pastels consist of the powdered pigment held rather loosely together by a thin adhesive substance, and when they are applied to paper the powder simply comes away like chalk on a blackboard. They can be made to produce brilliant colour; but the colour has no depth

and looks, as it actually is, powdery and chalky. A danger lurks in the insipid prettiness of many of the 'pastel shades', which only too readily give rise to a certain lushness of effect, artificial in the bad sense. However, it is up to each individual to resist such tendencies, for there is nothing in the nature of the medium itself to suggest a debased type of colour. Pastels allow for a great deal of freedom in handling, because they can be applied in any way we fancy. One colour can be applied over another, or rubbed over another so that to some extent the two merge and mix. A general merging of colour and of edges can be brought about by rubbing the powdered surface with the finger or brushing it lightly with a bristle brush, but this can easily be overdone, as it tends to make for too much softness and for vague and undefined forms. As with wax crayons, pastels can be used flat-wise or point-wise, and so can be spread broadly in flat areas of colour or applied in individual strokes which, by their varied size and direction, can create shape and structure in the painting. Pastels can be used on darkened papers, which indeed are preferable to white, since the great opacity of the dry powder makes it a simple matter to bring up light colours against a dark ground. Tinted and grained papers can be obtained ready-made for pastel work, but any paper not too smooth is suitable, and white paper can be treated with a water-colour wash first. It is often a good idea to start a painting by putting down preliminary suggestions in water-colour, either transparent or opaque, and working on top of these, when the water has dried, with pastels. This gives us something to work on, and the water-colour suggestions can be made very freely since they can eventually be covered over. Pastels can also be used in association with water-colour, usually as a means of touching up and heightening effects at the end. Their opacity naturally makes them harmonize best with gouache colours, with which indeed they can often be associated with good effect. They are too dusty to take water-colour paint on top of them unless they are previously fixed (see below), but non-greasy dustless crayons can be obtained, under different trade names, which can be intermingled with water-colour and which enable paintings to be built up on the use of the two media.

An interesting variation in the use of pastels, and one which is not often tried, is brought about by employing fine sand-paper as a ground. This naturally bites strongly into the crayon and takes it up very thickly, and the result can be made to resemble a matt oil

painting. It makes for an effect of great solidity, and sandpaper provides a useful 'warm' ground to paint on.

An objection to pastel paintings is their instability. The surface particles are very easily disturbed, even by a mere shaking of the paper, and any touch produces a smear. For this reason pastels are often 'fixed', that is, the surface is treated so that the powder becomes firmly fixed to the paper. The disadvantage here is that fixing results in a marked loss of brilliance and in some cases to a serious deterioration in the general appearance of the picture.

The fixing is carried out by spraying the picture with a 'fixative' solution. Fixatives are sold ready for application from an 'aerosol' pressurized container, but they can also be applied by means of a spray diffuser consisting of two metal tubes which can be set at right angles, so that when one blows through the end of one tube the issuing blast forces, by suction, the fixative solution up the other tube and at the same time scatters it in the form of a spray. (This in principle is the method by which a scent spray works, except that in this case the blast of air is provided by squeezing a rubber ball.) All one has to do is to place one end of the spray in the bottle of fixative, and blow through the open tube; the fixative then issues as a spray.

Pastel fixatives consist of a resin or resin-like material dissolved in a volatile solvent, such as alcohol or benzene; when sprayed over a picture the drops of spray settle on the particles, which collapse and are stuck together and to the paper by the resin, when the solvent has dried off. It is the collapsing of the particles which results in the loss of brightness of the picture. The fixative should therefore not be applied too strongly, and indeed it is best not to aim at complete fixation but at producing just enough adhesion in the particles to prevent any serious damage by slight rubbing or movement of the paper. The picture should be placed flat, and it is best to get the spray going first away from the direction of the picture, as largish drops are sometimes blown out at the beginning. When the spray is well set it is directed over the picture, but not for too long. If the first application does not give enough fixing it can be repeated, whereas a picture that has been rendered dead by over fixing cannot be restored.

There are, however, types of pastels which do not require fixing and are known as 'oil pastels'. They are not powdery like the traditional pastels and in consequence they behave differently. In

a sense they behave almost as if they were sticks of solid oil colours which can be applied directly to paper or other suitable surfaces (not necessarily white ones) — even to prepared canvas. Although they are somewhat greasy they differ in many respects from wax crayons. They are much softer in texture and can be more thickly applied, they are more opaque and will completely obliterate the ground, and colours can be more readily overpainted and blended on the surface of the painting. The final effect can be made to resemble that of a matt oil painting.

Water-colours and pastels are framed behind glass, which not only protects them against dust, but has the effect of a glaze in adding slightly to the depth of the colours. They are usually given a mount, and this means that, within obvious limits, a frame can be adapted to the size of the picture. It is useful to have a few frames in hand, to which mounts are cut to the sizes we will paint to, and pictures can then be framed at once and their effect judged. Mounting boards, white or tinted, can be purchased, but to cut a mount out of a board of any thickness is a skilled job on account of the difficulty of making a bevelled edge — and this is really necessary. Good mounts can, however, be cut with a razor blade out of stiff cartridge or Whatman paper, which can be tinted if desired with a water-colour wash. It is usually preferable to have a mount which is off-white.

8 □ colour

Colour's vital rôle. If we could single out the factors which contribute most to the appeal of painting, colour would probably head the list. Certainly it is the most obvious element which makes for the sheer attractiveness of painting as an activity. For colour, like music, makes its appeal direct to the senses and we do not have to explain it any more than we have to explain a tune; its perception is intuitive and it makes only one demand — that we use our eyes. Thus names and descriptions add nothing to the sensation which colour creates. It is unencumbered with literature, and is to be enjoyed for its own sake.

We have only to imagine a world from which all colour has departed, in which everything is reduced to greyness, in order to convince ourselves of the vital rôle which colour plays in our lives. It is not merely a pleasing adjunct to life, but it draws upon our capacities for discernment, and so leads to the exercise of distinct personal factors which are expressed in selection and arrangement: for we like to choose it for ourselves. Painting presents us with the opportunity of employing these factors on the grand scale. To squeeze out the pigments from tubes on to a palette is to present oneself with an ever-widening field of discovery entirely of one's own making. The thought of being able to marshal and dispose these colours according to one's heart's desire is surely a prospect whose attractions must be apparent to all.

The fact that children left to paint by themselves so often choose, with unerring instinct, colour relations of real distinction only goes to show how far instinct alone can carry us — and incidentally how much of colour sense must reside in all of us. In the long run it must be our instinctive choice which settles the matter, and no amount of reading or learning can make up for it. Yet colour is often used with trepidation, but then it is not our colour instincts which hold us up, but the fear of letting these instincts have full play. Discretion gets the better of our sense of adventure.

There have been many theories of colour, and not all of them have been particularly enlightening. For instance at one time it was held 'wrong' to place bright contrasting colours side by side, or indeed to use colours at all in their full strength. Everything had to be toned with grey, and the 'brown sauce' of the art galleries was held to be very improving in a picture. Such theories can only confuse and annoy us.

What we may need is some guide to the relationships of colour, however these relationships may be employed in our paintings. There are people who find that their confidence is increased if they can see the logical implications of what they are doing. Whether in the case of colour this leads to a better or more adventurous choice is a moot point; nevertheless, properly understood, knowledge of an instinctive process need never be a hindrance to its functioning.

How colour is 'explained'. Everyone knows how it is that the existence of colour is explained. Colour is not an actual property of an object, like its size or hardness, but it is as it were imposed on the object by the light falling on it, and will vary according to the nature of the light it receives. Many people will have noticed how under the conditions of street lighting from sodium lamps all colours except yellow are seen virtually as greys. It is not that under these conditions the other colours are obscured; they are simply not there, because they are not present in the light itself.

We see objects in the light because they reflect back to us part of the light which falls on them. Light rays themselves are invisible. Thus the sky at night is not lit up by the rays of the sun passing over our heads in space. In fact we only become aware of the presence of these rays when they strike against an object such as the moon, which throws them back at us by reflection. Again, when we see the sunlight 'pouring' through a window on a summer's day, it is not the sun's rays that we see, but particles of dust which are lit up in the beam of light.

The white light of the sun contains all the colours of the rainbow combined together. Separated, ribbon-like, as they are in the rainbow, the individual components can be seen. A white object is one which reflects the white light falling on it. If snow is examined under a microscope it is seen to consist of transparent crystals. But these crystals have the property of reflecting the greater part of all the

light falling on them; hence the intense whiteness of snow. By contrast, soot is a substance which is able to absorb the light falling on it and, since very little is reflected, it appears black.

Coloured surfaces act in a selective way. They absorb certain of the colours and throw back others. The colour thrown back in largest quantity is the colour of the object as we see it. Thus a red surface may reflect yellow and blue as well as red, but the red predominates.

Along with these selected rays, a certain amount of white light is always reflected at the same time. All surfaces, even black ones, reflect some of the white light they receive, just as all white surfaces absorb some of the light falling on them. Hence there are degrees of whiteness and of blackness, and colours differ in depth and intensity.

The colour circle. The rainbow, as we know, is composed of bands of colours which are not sharply defined, but melt one into another. If we look carefully enough we can distinguish the principal colours, which go in the definite order violet, blue, green, yellow, orange, red, but as these gradually merge one with another they pass through innumerable intermediate stages. Thus blue passes into green by way of greenish-blues and bluish-greens, and green passes into yellow by way of yellow-greens. In this way the whole range of colours, stretching from violet to red, is continuous, and if we add purple (not itself in the rainbow) to link the violet and red, we can arrange the complete series around the circumference of a circle — called a colour circle — so that all the colours are joined without a break. If at the same time we space them, not quite as they are seen in the rainbow, but so as to get equal gradations from one colour to the next, we arrive at a scheme which can be represented as shown on the facing page.

Such an arrangement enables us to see how the rainbow colours are related to one another. Yellow is the lightest colour, and it therefore seems appropriate to place it at the top of the circle; on either side it merges into colours which darken progressively toward the deepest blue, which is the darkest of all. In doing so it may change in two ways — on the one hand towards red, and on the other towards green.

Let us consider the change towards red. If a scarlet (such as cadmium scarlet) is mixed with a bright yellow (such as cadmium yellow) we get 'orange'. The quotation marks are given because the

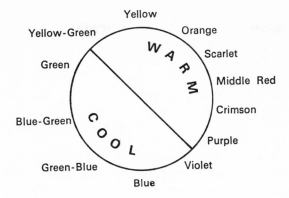

word orange, like all our words for colour, is very indefinite, and the particular orange we get will depend on the relative amounts of yellow and scarlet in the mixture. If in the first place we add touches of scarlet to the yellow, the latter deepens and will assume colours we might call orange-yellow or yellow-orange. In other words the character of yellowness gradually merges into that of orangeness, and obviously a stage will be reached when we will be unable to decide whether to call the mixture yellow or orange; it will be between the two. As more scarlet is added, so a more decided orange is obtained until we get to what we consider to be the maximum orange, that is the orange which seems to fit half-way between the yellow and scarlet. As more scarlet is added the orange itself turns more red, until we begin to think in terms of a name like orange-red, and eventually the orange character merges into that of the definite scarlet itself.

We can see now how the scarlet and yellow are related. Painted side by side they are seen to be somewhat similar colours — both bright and 'warm'. In point of fact they both stand beside orange, which links them together. Each colour of the rainbow can be seen in this light, not as an isolated colour but as related to its next door neighbours which it links together and which, mixed together, produce the colour itself.

Next to scarlet we have a middle red, and then crimson; all of course would be called 'red' in a general way. Suppose now we take some alizarin crimson and paint it beside the scarlet. There is seen to be a marked difference between them, the scarlet being a yellowish-red, the crimson a bluish-red. It is clear, however, that they are

fairly near relations, yet as reds they behave in very different ways; and their relationship is such that when mixed together they form the middle reds which lie between them.

We have now seen how by mixture we can make a continuous flow of colour from yellow to crimson.

Let us now consider the changes which occur on the green side of yellow. If we take a dark bluish type of green, such as viridian, and place it near the yellow, we can see at once that we have a very different kind of colour. It makes a considerable contrast with the yellow — more so than does the scarlet. If now we mix some yellow into the green, we get a green which is more yellowish, depending on the amount of yellow added. By adding more and more yellow we turn the viridian into a very yellow-green, until finally we work our way back to yellow itself. Looking at the procedure now from the opposite direction, we can see the yellow turning slightly towards the green side by introducing into it a small amount of viridian. As more viridian is added so the green swings away from yellow, becomes less yellow-green and more truly green. Naturally at first we will reach a transition stage, the yellow only slightly tinged with green, when we will be unable to decide whether to call the colour yellow or yellow-green; it will be a half-way connecting colour.

As more and more viridian is introduced into the mixture we work our way to viridian itself, and the green will be seen to be turning towards blue. If now we add touches of ultramarine the green will turn decidedly blue-green, will pass through an intermediate stage into a green-blue, and as more ultramarine is added so the blue becomes more dominant until finally we arrive at the full brilliance of ultramarine itself. We have now passed from yellow into blue without a break, and have reached the lowest point in our circle.

But the circle is not quite complete. We are left with crimson on the one side, and ultramarine on the other. These two colours can be linked by mixing them together. Let us begin with the blue and add a touch of crimson. The blue becomes blue-violet, and with more crimson becomes a true violet. This completes the rainbow colours, but not the circle, because we are left with a gap between violet and crimson; and to bridge this gap we pass through purple, a reddish violet, which, though it is not strictly a rainbow colour, may be regarded as one for all practical purposes. Purple stands half-way between violet and crimson and is made by mixing the two together until, as less violet is added, crimson itself is reached.

The circle is now closed up and all the colours run together without a break, forming an uninterrupted series of gradations. There is much we can learn about colour from this circle, and it will be helpful if we can carry a picture of it in our heads so that we can automatically see relationships from this point of view, without having to make reference to an actual colour circle.

Family relationships. First we can see at a glance the family relationships of the rainbow colours. Colours close to one another on the circle are near relations; they are similar colours and blend easily together. On the other hand they do not produce any strong contrasts and do not show each other up to best advantage. The greater the distance between two colours on the circle the more contrast they show, and the more strongly they react against one another. Thus blue-green is a stronger contrast to yellow than is yellow-green or orange. At the farthest points colours are directly opposite in position and are most strongly opposite in effect; hence they provide the greatest contrast. Thus in general reds are opposite to greens, blues to yellow and orange, yellow-greens to violet, and so on. If we take some viridian and paint on one side of it some scarlet and on the other some ultramarine, we will see at once how much greater contrast is shown by the scarlet.

Opposite colours are called 'complementary'. There is an actual physiological effect here, because when we look at a bright colour its complementary colour is registered in the eye. We can easily demonstrate this for ourselves. If we paint a patch of scarlet on a white sheet of paper and look at it steadily for about half a minute, we shall find that on shifting our gaze to a blank space on the paper our eye registers a greenish-blue impression of the scarlet patch. The greenish-blue, which is 'induced' by the scarlet, is called an 'after-image', and we shall see later on that the production of after-images has some influence on our perception of colour relations.

Colour mixing. The circle also helps us to see how colour mixing works. Colour mixing is often thought to be a highly mysterious subject, but so far from being mysterious it is perfectly logical, and follows simply on the family relationships of the colours. Near colours mixed together produce the intermediate colours which link them together. Scarlet and yellow, blue and crimson, yellow and green produce their respective oranges, violets, and yellow-

greens. We have now, however, to introduce an important qualifica-
tion which has so far been ignored for the sake of clarity. When we
mix two coloured pigments together we do not, in practice, attain
the brightness of the colour which strictly lies half-way between
them. The reason is that whenever colours are mixed a certain
amount of grey is introduced at the same time, and this naturally
has the effect of lowering the intensity of the colour obtained. The
colour, in fact, is somewhat darkened as if in the process of mixture
we actually added a touch of dark grey. This is inevitable and
cannot be avoided. The point to bear in mind, however, is that the
nearer two colours are to each other on the circle, the better is the
resultant mixture, the purer and brighter it is; and as the distance
between the two colours is increased, so a greater proportion of grey
is introduced when they are mixed together. For example, we can
get an orange by mixing yellow and crimson, but this orange will
have more grey in its composition (and so will be darker and mud-
dier) than that obtained by mixing yellow and scarlet. When
opposite colours are mixed — when the line connecting them
actually passes through the centre of the circle — the result is pre-
dominantly grey, assuming, that is, that they are mixed in equal
proportions. This is sometimes expressed by saying that 'comple-
mentary colours mixed together make grey'. But although this is a
good working rule, it is only approximately true, because exact
complementary pigments produce greys which are tinged with
colour, and not entirely neutral greys.*

It is clear that we have here a very useful method of making greys
by colour mixture, without resorting to the use of a black pigment.
We shall constantly need greyed colours of all kinds, and reference
to the colour circle will show us how to get them. In general, a
colour is greyed by adding to it colours from the opposite side of the
circle; and widely separated colours will produce, on mixture,
greyed varieties of the colours which lie between them. Thus if a
little crimson is introduced into viridian, the latter is made into a
dark grey-green; if more crimson is added the 'greenness' goes out
of the grey, and finally a dark purplish grey is obtained.

In the light of these considerations let us turn to the well known

* Thus complementary blue and yellow produce a greyed green. If they are
mixed as coloured lights, they produce white.

mixture of yellow and blue to produce green. If we choose a middle
yellow, such as middle cadmium, and a blue like ultramarine, we
shall find that on mixing them in equal proportions we get mainly
grey, tinged with green. In this case we are mixing complementary
colours. To obtain a green of any brilliance we need a yellow and
blue both of which are near to the green side of the circle. Chrome
lemon and Prussian blue* answer to this requirement, and mixed
together they produce the series of greens known as chrome greens.
The rather similar cinnabar greens are made by the same mixture,
except that a deeper chrome yellow is used, and hence these greens
are greyer and more 'earthy'. As there is a shortage of green pig-
ments available to the painter, several greens are made up by
mixture. A more permanent green than chrome or cinnabar is
made, and sold under different trade names, by mixing monastral
blue (which occupies a somewhat similar position on the circle to
Prussian blue) and cadmium yellow. What is called cadmium green
is not a simple compound of cadmium, but a mixture of viridian
and cadmium yellow. These mixed greens are usually sold in differ-
ent varieties, called deep, middle, and light, according to the
relative quantities of blue and yellow in the mixture.

We can see now why it is that the colours yellow, blue, and red
are sometimes referred to as the 'primary colours', because from
these, if we select suitable pigments, it is possible to get greyed
varieties of all the other colours. (The title is, however, misleading,
because there is nothing 'primary' about yellow, blue, and red in
the sense that they take precedence over the other colours of the

* A coloured pigment, like any coloured surface, reflects not only the dominant
colour by which we recognize it, but also the colours which are its neighbours on
the circle. Thus lemon yellow and Prussian blue both reflect green. In addition,
lemon yellow reflects its neighbours on the orange side, and Prussian blue its
neighbours on the violet side. Thus the reflections from lemon yellow are comple-
mentary to those from Prussian blue, except in the case of green — the reflection
which both pigments have in common. When the pigments are mixed the comple-
mentary reflections are neutralized as greys, and we are left therefore with green,
mixed with grey. In the same way the result of every colour mixture with pigments
is a process of *subtraction* of all the colours involved, except the one which is left
as a residue at the end. This is the reverse of what occurs when coloured lights
are mixed, for then the process is one of *addition* of one colour to another. Pigmen-
tary mixture is not, however, entirely subtractive; some additive mixture also
occurs.

rainbow.*) A great deal can be done with a colour box which contains only these colours. The range of possible mixtures will of course depend on the actual pigments selected. We might start with a middle yellow like chrome or cadmium. Then in choosing a blue, we may be torn between one like Prussian or monastral which makes good greens, and one like ultramarine which makes good violets. The choice will have its repercussions on the selection of red. A scarlet type will tend towards good oranges and poor violets, and a crimson will work in the opposite way. It is obvious that we are going to be restricted in certain areas of the colour circle; nevertheless it is surprising what can be done, especially in water-colour, even with subdued colours such as yellow ochre, Indian red, and cobalt or Prussian blue. Undoubtedly there is a certain fascination about three-colour palettes because of their extreme economy of means, but in general they will be found quite unnecessarily restricting. Their advantage lies in their compactness and portability, and they have a definite use when it comes to a question of carrying the minimum of equipment for quick studies.

The mixture of red and green offers a special interest. If these colours are mixed together so that the red predominates, we get the equivalent of a red darkened with grey, and this constitutes brown. Hence to get brown we mix red and green together. Brown is not a pure rainbow colour and, as with the other colours, the word itself covers many varieties, from deep earthy browns (darkened reds) to light yellowish browns (darkened yellows and oranges). For general purposes it is best to start with a scarlet red and work into it a green like viridian. At first reddish browns are obtained, but as more viridian is added they become deeper and more earthy, until finally they pass to greenish browns. A crimson will naturally tend to produce browns which are more purplish. For the yellow varieties it is necessary to add yellow to the mixture, with white if necessary to make it paler. It is interesting to note that this way of making browns can be paralleled by the use of black, for a red can be

* The question of what constitutes the primary colours is the subject of a good deal of discussion. It depends to some extent on our point of view. Although from the standpoint of the scientific study of colour it is certainly inaccurate to speak of red, yellow, and blue as primary colours, there is no doubt that to the painter these colours do have a certain primary significance, since they are the three which give the widest range of rainbow colours on mixture and are the natural choice for a three-colour palette.

darkened directly by adding black to it. Hence if black is added to a red pigment we get brown. To add black to cadmium scarlet is an excellent way of making chocolate browns.

Black and white. So far we have not spoken of black and white as separate colours. Strictly speaking they are not colours. All the colours of the rainbow combined go to produce whiteness; and blackness results from their absence. But the painter is not concerned with blackness and whiteness in any absolute sense, but with actual black and white pigments, and these are by no means equal in their degree of intensity and have distinct characteristics of their own. They can be 'warmed' or 'cooled' or reduced in strength without ceasing to function as blacks and whites; they enter into the relations of a colour scheme, and hence to all intents and purposes they act as colours. Black has assumed a good deal of importance in present day painting, and its influence in association with other colours has been exploited in various directions. Especially against the bright warm colours, yellows and reds, does black have a powerful effect of heightening their intensity; and in the form of black lines it often plays a characteristic part in paintings, particularly in abstract designs. Both black and white, in the form of outlines, can have the effect of harmonizing colours which otherwise would be garish or too strongly contrasting.

Tone: tints and shades. To speak of black and white is to introduce the notion of tone — that is, the light-and-dark relations of a painting. We cannot paint anything lighter than our white pigment (or white paper in the case of water-colour), which therefore represents the lightest or highest tone we can reach in our painting; and similarly black is the darkest or lowest tone available. As regards the effect of light and dark our picture is set by these two limits, but every variation is possible within them. Thus by mixing black and white together in different proportions we can get a series of greys which, starting from black, get gradually lighter until they pass into white. Such a series of greys represents the range of tones possible in a painting.

We can consider colour in terms of lightness or darkness, apart from its quality as redness, blueness, etc. All the colours are lower in tone than white, because the very presence of colour indicates that some part of the white light is being absorbed on the surface.

In the same way all the colours are lighter in tone than black, because the presence of colour is an indication of the reflection of light from the surface. Now when we add white to black we can be said to raise the tone of the black by making it into a grey. In the same way we can raise the tone of any coloured pigment by adding white to it, and in fact we shall find that in practice we constantly do this. The tone of any colour can be raised to any point until it merges with white itself. Colours which are rendered paler by the addition of white are known as 'tints'.

By a similar process we can lower the tone of any colour by adding black to it, until it is impossible to distinguish the darkened colour from black itself. Colours darkened by the addition of black are called 'shades'.* (The word shade is sometimes loosely used in ordinary speech, being applied indiscriminately to colours of all kinds, but strictly speaking it has this limited meaning.) But apart from adding black or white separately, we can add to colours the greys which are formed by mixing black and white together. In this way greyed colours are obtained. They offer an even wider range than tints or shades, for we can vary the strength of the neutral grey as well as the proportion of pigment mixed with it. Thus we can obtain greys which are just tinged with colour, or colours which are only slightly greyed, and so on.

In practice the addition of black to pigments will not be found so useful as the addition of white, because the equivalent of adding black occurs in the greying of colours by their own admixture. We have already seen how this is brought about. It is in fact far better to make greys out of the actual colours of a painting because they then unite with the general colour scheme, whereas if black is introduced simply to produce greys the latter will noticeably stand out on their own.

Intensity and hue. The effect of adding white, black, or grey to a colour is to reduce its intensity. The colours ranged round the circumference of the colour circle are assumed to be of maximum intensity and are therefore said to be 'saturated' since, like a saturated solution of salt, they have reached the state at which

* In practice a true shade is only obtained when black is added to a transparent pigment, because an opaque pigment reflects some white, and this with black turns the colour into a grey.

they cannot be made any stronger — that is, the addition of more colour will not increase their intensity. But each of these saturated colours may be considered to exist in a series of weakened forms as tints, shades, or greys. Under these conditions each colour, so to speak, remains the same, though it is weakened; its relative position on the circle is not changed, as it would be if it were mixed with some neighbouring colour.* Clearly then there is a factor which is independent of intensity, and this is the colour's *hue*, which is simply a measure of the kind of colour we are dealing with, its yellowness, blueness, redness and so on, as determined by its relative position on the circle. Hence all the colours round the circle differ in hue, because they all occupy different points on the circumference.

The colours we see around us are not often saturated. They do, nevertheless, all correspond to some hue on the circle, but modified by white, black, or grey. Theoretically at least, it is possible to reproduce the colour of any surface by selecting the appropriate rainbow hue and adding the necessary quantities of black and white.

Contrast and dominance. The circle can also help us in the working out of colour schemes. It has already been said that colours near to one another blend easily together. But schemes made up only of such colours lack variety and vigour; they require some contrasting colour to give 'bite' to the general effect. Like the members of one family, they need some outside influence to draw out their true characteristics. Thus a colour scheme of yellow and red is enlivened by the presence of some green or blue. The strongest contrast is given by the complementary colours. But care is needed in building up schemes on strongly contrasting colours. If two complementary colours, say yellow and blue, are painted side by side in areas of approximately the same size, the result will not be pleasing. In effect, they simply neutralize one another. The eye is drawn from one to the other and has no sense of rest. In all such cases, to achieve a harmonious effect, the principle of dominance must be called upon. If one complementary colour is present largely in excess of the other, a satisfactory relationship is brought about, for the colour in excess — the dominant colour — takes precedence of the other and the eye is

* In practice the addition of white or black to a colour does bring about a slight change in hue.

no longer equally divided between the two. This can be shown by painting a large area of yellow and placing beside it a small area of blue. The eye is now drawn to the yellow, while the blue acts as a foil to it and gives it contrast without killing it. In fact, both colours now enhance one another. It is worth remarking here, what we may have already found out for ourselves, that by using 'bright' colours we do not necessarily achieve an effect of brightness — they may merely neutralize one another; and in the same way black, though its use will lower the general tone of a picture, may enhance the effect of brightness by its strong contrast.

The principle of dominance is very generally employed, whether deliberately or not, in colour schemes, and provides a very useful guide to their construction. We can make our scheme consist mainly of nearly related colours, with smaller quantities of contrasting colours to add variety and to set them off; in this way the scheme is given a stability and character which is entirely lacking if it is built up on a system of equal proportions of opposites, whose end is a level greyness. If we examine pictures by old and modern masters we will see how this idea of dominance works out in practice.

In this connexion we may note another feature of the colour circle. The yellow-greens, yellows, oranges, and reds are often referred to as 'warm' colours, and the greens, blues, and violets as 'cool'. A reaction to colour in terms of warmth and coolness no doubt differs a good deal with individuals, and certainly to some people the distinction is not at all strongly felt. But whether this 'temperature' assessment commends itself or not, there is no doubt that the bright fiery colours do convey a different sort of feeling from their opposites. Now if we divide the circle by a diagonal which links roughly the areas of purple and yellowish-green, we have two halves which contain respectively the warm and cool colours, and opposite colours are seen to exhibit, in varying degrees, contrasts of warmth and coolness. We can now see how colour schemes can be regarded from this point of view. We can have a scheme in which warm colours are dominant, with contrasting cool ones; or the other way round. Again a study of paintings will reveal how this principle is often applied.

Discords. We are all aware that in certain relations colours 'clash'; they are ill at ease with one another and produce an effect of discord. Yet it is difficult to say precisely what accounts for

this effect or what it is that constitutes a 'discord'. Some light is, however, thrown on this problem by the colour circle.

It is held, with some justification, that discords arise with colours which are neither near neighbours nor are opposite — but come between the two extremes. Such colours are spaced at an awkward interval: they are neither similar nor completely contrasting, and no doubt the eye registers this unsatisfactory relationship. Thus we may agree that yellow is concordant with orange and yellow-green, and with blue, but not with deep crimson or bluish-green. But in considering colour relationships we are not only concerned with the simple question of hue, but the tone of the hue has great importance. The circle may be said to follow a 'natural' order of tones, since it follows that of the rainbow (yellow the lightest, violet-blue the darkest), and this order does seem to be the one in which the colours most readily achieve harmony. It answers to our expectations, for we normally think of red as darker than orange, purple as darker than red, and so on. But when colours are paled with white this order can easily be reversed, and when this occurs it is not surprising that discordant effects are produced. Thus by adding white to blue we can pale it to such an extent that it becomes lighter in tone than a deep yellow. But to paint a pale blue beside a dark yellow will generally be held to be discordant and to clash. This is the general effect of reversing the natural order; in a greater or less degree discords are produced whenever the rainbow order of tones is reversed.

But we must not think that discords are to be avoided. In practice we will find that they constantly arise, and their total effect depends on the extent to which they are used. In large quantities, as we should expect, they are overpowering, and they have the effect of making all the colours of a scheme look 'muddy' and unpleasing. But in small quantities they can effectively add to the appearance of the other colours, and give that sense of unexpectedness which is so valuable in the use of colour. They may help to enliven what would otherwise be a scheme lacking in variety and will give added interest to the final harmony which is achieved by the strong balancing effect of concordant colours.

Adjacent colours. There is no doubt that when we look at a scheme of colours a complicated visual process takes place. The individual colours play their part in the total relationship which

is brought about, and are not independent units. This is emphasized by the fact that, in a subtle way, adjacent colours can affect one another's appearance. This can happen as a result of the complementary after-image which, as we have already seen, is induced by any bright colour we look at. This after-image is carried over in the process of vision into neighbouring colours and in consequence will influence their appearance, the effect of a bright colour being to impart its complementary to its surroundings. Thus when complementary colours are placed side by side they will enhance one another, because the intensity of each will be reinforced by an after-image of its own hue. When the colours are not complementary, however, this will not occur, for then each colour will receive an after-image of a different hue, and so will itself be modified in hue as if by mixture. The tendency will be for the contrast between the two colours, as indicated by their relative positions on the circle, to be increased. An example will help to make this clear. If yellow is placed beside blue it will receive an after-image of yellow, but if it is placed beside crimson it will receive an after-image of green. The latter will give it a greenish tinge, while the crimson, receiving blue from the yellow, will appear more purplish. In other words, the two colours now appear more 'distant' than before.

These colour changes are no doubt subtle and not obvious, but we can test them for ourselves by painting out on paper squares of the same colour, and then surrounding each square with a different colour. On comparing the squares again we will see how each is changed under the influence of its surroundings.

A colour's after-image will also affect neutral colours which are nearby. Black, white, and neutral greys will all be tinged with the complement of the colour concerned. This is a particularly interesting effect which we cannot fail to notice if we are on the look-out for it. It can be tested in the manner indicated above, but substituting neutral grey squares for coloured ones.

Adjacent colours can also affect one another simply by their differences of tone. Thus, quite apart from any differences of hue, a dark colour beside a light one will tend to make the latter appear lighter still, while the dark one will appear darker. As this is a question of tone, the same thing happens with black, white, and greys. A grey will appear deeper when placed beside one lighter than itself, and vice versa. Colours on white or on a light ground will appear darker, and colours on a black or dark ground will appear

lighter. This accounts for the fact that black can have the effect of intensifying the brilliance of a colour scheme.

The whole subject of colour relationships based on a study of the colour circle is a vast one, and has been worked out in great detail for commercial purposes. But the painter does not generally work on the basis of scientific colour theories; indeed too much absorption in theory may lead only to the prescribed relationships, and to seeing colour as a sort of mathematical problem. What we need is to realize the vast possibilities which colour in all its relationships opens up for us, and to make free use of these possibilities; in the long run it is our own taste and judgment which must settle for us the question of its employment.

Choice of colours for a palette. We have seen what is involved in colour mixture and are now in a position to take up the question of the choice of palette — by which is meant the selection of actual pigments we are to use. We want enough to give us a fair range of hues on mixture, bearing in mind the inevitable greying of mixed pigments, but we do not need to have more than will serve this end. Each pigment has its own individuality, which does not reveal itself at once, and it is better to get to know a few well rather than to have a smattering acquaintance with a large number.

Let us see what our basic requirements are. We have already discussed a three-colour palette and seen that it is too restricting; but we might take it as a starting point and aim to fill in the gaps. First we shall need a bright yellow; then two reds seem necessary — a scarlet or middle red (giving oranges with yellow) and a crimson (giving violets with blue). The choice of blue will depend on whether we mean to obtain green by mixture, or include a green pigment. If the former, then a greenish-blue will be necessary, but if we include green we are free to choose a blue more on the violet side. At most we have now increased our three colours to five. Finally there is white and black. White is essential unless we are working in water-colour; and black, though it is not essential, is desirable. Hence we have reduced our requirements to a basic palette of some six or seven colours.

What actual pigments are we to use to fulfil these needs? The answer here depends to some extent on what we are prepared to pay: whether we insist on a completely trustworthy palette of permanent 'Artists' pigments, or whether we are prepared to compromise with cheaper pigments of the 'Students' quality.

Let us assume first that we desire a palette of permanent colours, sparing no expense. We might then choose the following. For yellow, cadmium yellow; for red, cadmium red or scarlet; for crimson, alizarin crimson. The best general purpose blue is probably monastral blue, which makes fair violets and good greens; it is a splendid blue in itself, but on the greenish side. Many people will feel that they need a green, and probably a deep one which can be lightened with yellow; here the choice, in any case restricted, falls on viridian — one of the best of pigments, and absolutely permanent. When it comes to white, in oils we may take our choice of flake white, probably the most popular, and titanium white and zinc white; in water-colour the latter alone is available as Chinese white. As to blacks, lamp black or ivory black may be included; the latter is the most intense, and is definitely to be preferred in oils since lamp black is a poor drier.

Such a palette of seven pigments is a very useful one to start with; all the colours are chemically immune and may be freely mixed together without fear of deterioration. Other pigments may be added as desired, and in particular it may be found useful to introduce certain of the earth colours; yellow ochre and Indian red, for instance, are most useful colours in a palette. Cobalt blue will provide a useful additional blue, and at the same time it will extend the range of violets obtainable on mixture with alizarin crimson.

The weakest point in the palette is alizarin crimson (monastral blue, though a dye colour, is a more stable and permanent pigment), but it is not easy to find a substitute if we need a true deep crimson. This is the more unfortunate since its mixture with ultramarine is one of the chemically 'doubtful' mixtures, and for this reason ultramarine is not mentioned above; but many people will feel that this splendid blue must be included, and will if necessary keep it apart from alizarin crimson.

For a range of 'Students' colours we shall have to make some changes and accommodations. We might here start with chrome yellow, since cadmium tints do not have the quality of 'Artists' cadmium yellow, and chrome yellow has great strength and brilliance. Cadmium reds are usually available as tints; or instead we can obtain vermilion tints. Alizarin crimson offers no difficulties; it is not in any case among the most expensive pigments, and is obtainable in 'Students' colours. Viridian is available as viridian tint. Monastral blue may be inadmissible now, and instead we can

choose Prussian blue, but as this is so greenish we will probably need in addition cobalt blue tint or ultramarine. Flake white, ivory and lamp black, and additional earth colours are all available in 'Students' colours.

It will be found that 'Students' paints, lacking the purity and brilliance of 'Artists', tend to a muddier type of colour on mixing; but we have to make some sacrifices for a reduction in quality, and 'Students' colours are very widely used and give satisfactory enough results.

It is not pretended — lest the reader be fastidious — that this compromise palette is absolutely trustworthy in regard to permanence; apart from the cheaper nature of the colours it has some weaknesses from the strict chemical standpoint. Nevertheless it serves its purpose well enough, and as it resembles the permanent palette from the point of view of handling it can be exchanged for the latter at any time without our having to master a totally different range of pigments.

For ordinary water-colour work the permanent palette is strongly advised, since for anything in the nature of thin transparent washes the permanent pigments alone give the necessary resistance to light.

Poster colours are sold in one series only; the choice available corresponds roughly to 'Students' colours and the substitute palette may therefore be employed here. But gouache colours of superior quality are sold as designers' colours, in which many of the better pigments can be obtained.

In setting the colours out on the palette it is best to adopt an orderly method so that one can get used to a certain arrangement and know where to find a particular colour. It is useless to suggest a sequence in which the colours should be placed, because each person will adopt the order he likes best. In general the colours should be ranged round the perimeter of the palette, not too close to one another, with those which are likely to be mixed together made next door neighbours. White is best placed well away from the other pigments, for convenience at about the centre of the arc made by the others, so as to be more or less equally distant from them all.

Advance and recession : effects of distance. There is no need to labour the point that colour is an extremely subtle vehicle of expression. Its ramifications are far wider than can be suggested by the foregoing considerations of harmony and relationship.

Pattern is the immediate impact of colour, but this is not its sole contribution. It enters into every aspect of painting — shape, structure, distance, light, for example — and in fact in one sense painting *is* colour. Some more general notes on the problems of colour may therefore be found helpful.

One of the first things that may be noticed about colours when they are placed together, even in the 'flat' areas of a pattern, is that they never give the appearance of complete flatness. Some will seem to advance and others to recede, and for this reason it is scarcely appropriate to speak of a 'flat' pattern at all. The general rule often given here is that 'warm colours advance, cold colours recede', but this is a broad generalization which is only true when other factors do not modify it. What will probably be noted at once is that it is the strong colours and strong tones (extremes of lightness or darkness) which tend to advance, and the relatively subdued ones to recede. Paint a dark grey on paper and place beside it a more subdued grey: the latter will seem to recede. On a greyed paper paint a strong black and a strong white; both will advance from the greyed background. Now add beside the black a series of greys which get gradually paler, and beside the white a series of greys which get gradually darker, until both series reach the level greyness of the paper. We will then have two series of recessions, the one starting from black and the other from white, towards the level of the paper. Now paint on paper an area of strong ultramarine and place beside it an area of the same blue somewhat paled with white or grey: the latter will seem to recede. And a greyed red or indeed any subdued colour placed beside the ultramarine will recede from it. What is true in relation to ultramarine is true also in relation to any other intense hue.

Thus we can see that it is in the nature of colours and tones themselves, quite apart from anything they represent, to break up a flat surface in a way that suggests advance or recession. This characteristic can be made use of to symbolize effects in nature where objects are physically separated in space. Consider first the question of tone alone. If we are looking at a large black-and-white poster close to, we will be aware of strong differences of tone between the blackness and the whiteness, the one having the intensity of printers' ink and the other of white paper. If we now look at the poster from a distance, the blackness will appear less black and the whiteness less white; they will both be reduced in intensity and become more grey, the

more so as the distance is increased, until at a far distance they will tend to assume one level of greyness. We can see at once the correspondence between this and our treatment of black and white on greyed paper. If the latter represents the ultimate greyness of the distance, the black and white gradually recede towards this as they are toned towards the greyness of the paper. In the same way colours are greyed by distance, their intensity being reduced until they tend to assume one greyness at a far distance, the colours as we know them at close hand disappearing altogether. The effect of distance, then, as regards both tone and colour, is a levelling process, the tendency being to change colours and tones towards the level of greyness they attain at an extreme distance. And now another effect must be noted, because it is not simply that distance imposes a greyness, but the atmosphere acts like a veil and imposes a blueness on the colours, and thus effects a change of hue in the direction of 'coolness'. This is particularly noticeable at a far distance, where finally the general blue may melt imperceptibly into the light from the sky. But visual experience is essentially unified and these effects of distance do not go single handed. For instance, as we get farther away from our poster we shall eventually be unable to distinguish its letters, and we shall certainly be unaware of any wrinkles or defects in its surface. Thus all details become less noticeable with distance, and all effects of surface and texture are evened out. Lines, contours, and edges become less marked, and shadows become relatively less strong.

Thus on a flat surface we can help to symbolize the effect of distance by eliminating details, softening edges, reducing any effects of surface or texture, and reducing the strength of any shadows. Pale blues, and indeed pale atmospheric colours generally, will tend to go into the distance, while strong colours, especially yellows, oranges, and reds, will come into the foreground. We must not, however, think that these are rules to work by: they are means and not ends in themselves. In a painting we have to remember that we are not dealing with colours in isolation and, as we have seen, colours by their juxtaposition can affect one another. Thus an effect of redness (its intensity) in a painting depends on the surroundings of the red area. A patch of red against green, for instance, is likely to appear stronger than it would against orange, and we have already seen how complementary colours can neutralize as well as enhance one another.

Local colour: effects of light. When we say that colours are modified by distance it is obvious that we have to assume some standard in relation to which the modification can be judged. This standard we do all in fact assume and — whether we recognize it by the name or not — it is called *local colour*. This is simply the colour we refer to when we say that an object is red, blue, or green. In saying this we mean that we are describing its actual colour, seen close to and unmodified by any local accidents or conditions. But this colour can scarcely be said to have an exact existence. If we look at a red curtain by the window we will see that its redness is modified everywhere by highlights, by shadows and reflections; it is paler in some places than others, greyer in some places than others; it will be affected by the light in which it is seen and by the colour of its surroundings, so that the curtain, which we assume to be 'red' all over, does not by any means exhibit a uniform redness to the eye and in fact we should be hard put to it to say precisely where on its surface its true local colour is to be found. The colour of an object, indeed, is one of the most elusive things about it; we can easily arrive at exact measurements of its size and weight, but we have no corresponding rule or scales by which we can determine its colour. It is always subject to conditions and eluding our attempts to pin it down exactly. Yet we assume it is constant when we refer to objects — as we usually do — by their local colour. Herein lies one of the great difficulties of perception, because we tend to project on to objects our knowledge of the local colour, and this knowledge blinds us to the colour — often something quite different — which is actually revealed to the eye. If we can acquire the habit of looking out on nature with an 'innocent' eye — innocent that is of our preconceptions of what colours ought to be — we shall find that the colours of nature are constantly challenging our perceptions, and are vastly different and more varied than we might have supposed.

Colours of course are always modified by the light in which they are seen. We all know how colours change under artificial light. We will also probably have noticed how, under the influence of a red sunset, a whole landscape becomes suffused with the red glow from the sky; or how an evening sun in summer will make a landscape glow with a golden yellow light, so that fields which are greyish-green under a heavy sky are made to appear yellow-green. But it is not only under these special conditions of illumination that

objects reflect the character of the light falling on them: it is simply
then more obvious. We tend to banish light to the sky whence it
comes, and do not think of it as coming down from the heavens and
entering into the scene we are looking at. For instance we will look
at a road and think of it as a blackish mass of tar and rubble. We
know that roads are made from tar and that tar is black, and so we
project our knowledge of the local colour on to every road we look
at. But we must on occasions have noticed a road under a bright
sky following rain, and how it reflects the blue of the sky, so that the
blue comes right into and permeates a street scene. This is simply
an exaggeration of what always happens; the sky colours are never
entirely absent: objects always reflect a certain amount of the total
light falling on them. On a grey day things really are more grey
than under a blue sky.

Thus light by its all-pervading influence has a unifying effect on
the appearances it reveals. This is not so apparent in objects close to,
as in still life objects, where the local colour is strong, but here it
reveals itself strongly in reflected lights, in highlights and in shadows.
In landscape, where the local colour is more evened out by distance,
the pervading character of the light is more apparent and in the far
distance especially colours tend to be absorbed in the general light
from the sky.

When we let light pervade our paintings, by bringing the colours
of the light into the objects it illuminates, then we cease to have
stock-in-trade colours for objects — grass is 'green', tree trunks
'brown' (more often they are grey-green), roofs 'red', etc. — and
instead our colours will correspond each time with a fresh experience
of nature. And the light we bring into our paintings will unify them
and create harmony.

Flat colour. It must not be thought, however, that light
is an essential ingredient of pictures. Many paintings do not have
and are not intended to have effects of light at all; they ignore
altogether this way of looking at nature. They rely instead purely
on colour — the broad effects of local colour unmodulated by the
light in which it is seen. If a table-cloth is red it is painted red, the
same red all over, just as the local colour itself is the same all over.
Such paintings naturally take on a flat appearance. We can indeed
make a broad distinction between paintings which are flat, in which
everything is more or less on a level with the surface of the canvas

and all planes are more or less parallel with this surface, and paintings in which the structure, solidity, and volume of objects are conveyed in a setting of deep space. In the first kind, colour is used for its decorative effect; it is employed in broad flat areas which are often clearly defined and which create a strong sense of pattern. Colour, in keeping with its decorative function, may be used in great brilliance and may take the form of a strong intensification of local colours; shadow if introduced at all is used for purposes of pattern rather than to suggest any sense of volume. Lines are often emphasized, because lines themselves can enter into and help create the decorative pattern; and strong outlines tend to flatten the areas they enclose. The shapes are naturally adjusted to the same end; they are flattened and do not rely on the perspective which sees recession acting from one point of view. Thus a table top may be flattened to a rectangular area (as if it were seen from the top) although the legs may be shown at the same time. It can be seen at once that paintings of this kind will have colour, but no sense of light, which indeed would be quite out of place. There is nothing new in this idea. The paintings of the East have for centuries relied on this treatment of nature; they have banished shadow and adopted a decorative treatment generally.

All this is mentioned so that if our own paintings take on the character of flatness — as they are quite likely to do — we shall know how it comes about, and can see that in itself it is a perfectly logical and authentic effect of painting. But flatness is often a trouble to beginners; they cannot understand why distance does not become an element in their paintings, and they are inclined to think that the reason lies in their lack of knowledge of 'perspective'. But this is very rarely so; most people adjust the scale of objects to their diminishing size in space, but diminution in size does not in itself produce recession — any more than a doll's house creates the impression of a house rendered small by distance. Flatness in beginners' paintings is usually a colour problem, and results from the use of colours in the 'known' and 'local' sense rather than in the visual sense of being modified by distance and light.

We shall find that where a colour is painted flat — where it is laid in an area without any variation — the effect is to suggest an area that lies flat on the surface of the canvas, just as the even whiteness of the canvas suggests a flat area. As we have seen, by modifying a colour we are enabled to suggest recession, and uniformity within

any area suggests neither advance nor recession but one level plane of colour parallel to the plane of the canvas. Hence suppose we are painting what is in nature a flat receding area, such as a sea beach at low tide: if we paint one level sandy colour half over the canvas, the suggestion will be of an area that runs parallel to the canvas, but a suggestion of recession is given at once if we pale the colour of the sand as it goes into the distance. (Since we are now introducing a sense of space, we can appropriately modify the distant colours with reflections they will take up from the sky.) In the same way, areas of identical colour will appear on the same level even though they are separated from one another on the canvas. Identical greens will appear on the same level whether painted in the foreground or background, and if for example we are painting a landscape in which a near tree is separated by a wide expanse of cornfield from a distant tree — if then we paint both trees the same green we will find that the distant one appears to come level with the near one, even though we may have suggested recession in the cornfield itself.

Structure and solidity. Of course paintings will not fall neatly into categories, and it would be quite wrong to imply that a rigid distinction exists between paintings which are either flat, patterned, decorative (whatever we like to call them) or otherwise. This is a distinction we have made clear-cut for the sake of explanation, and is valid only for the extremes of certain tendencies. Yet the broad distinction is useful, and undoubtedly paintings which convey solidity and depth present quite different problems. They usually consist very little of flat areas of colour, and are subject to a great deal of modulation all over. Modulation of colour in itself suggests solidity. If we look at any flat surface in nature, as for instance a wall or field of grass or area of pavement, we will find that the surface is never an even flatness but is subject to many subtle variations of colour and tone. This variation is part of the structure of the surface as revealed by the light on it. Variegated colour in a painting likewise suggests texture and structure, not by illusion or imitation but by its very nature, and so conveys a sense of solidity. A flat mass of colour, in other words, is not an adequate symbol for the experience of surfaces as seen in nature. A flat area of green is scarcely adequate to suggest any structure or solidity in a field of grass, but modulate the green by variations of tone and colour and a sense of structure and surface begins to arise at once.

This is not the same thing as the modification of the green to suggest recession; it is a variegation of the area of green itself.

This variegation and modulation can be brought about by the varied use of brush strokes which by their direction and size can enter into and mould the forms we paint — or by any surface treatments such as are mentioned in the sections on technique. There are many means, depending on the sort of technique we are using, by which an interplay of different colours can be introduced throughout the surface of a painting, and when we see the point of what we are doing we can go our own way and devise our own methods.

Shadows and shading. Solidity is of course suggested by shading. Light has direction, a property which is revealed by the fact that objects are not illuminated equally all round, some sides receiving more light than others. This creates an interplay of light and shade which is a result of the object's having depth in space, and its use in painting is a great aid in suggesting the three-dimensional world. This is pure illusion: shading is not a character of the object but a product of the light falling on it, and it will change with changes in the direction of the light. In Eastern painting this world of shadows has been largely ignored, and there is a good story told of a Japanese painter who saw for the first time some reproductions of portraits by Rembrandt. The strong development of light and shade came as a surprise to him, and he enquired whether all Europeans had faces which were darker on one side than the other. Of course he was perfectly logical. In one sense to paint a face which is illuminated on one side and is in shadow on the other, is to paint two faces at once.

This question of shading often gives rise to difficulty because its nature is not understood. Suppose we have a green object which is strongly lit on one side: the tendency in beginners is to make this side light green and the other dark green, either by using two different greens or by using the same green and introducing white into it on the lighter side. But this does not well suggest the character of a shadow on the darkened side; rather it suggests an object which is more 'green' on this side than the other. It does not give an adequate account of what is really happening. Again, to take a green and mix black in it for the shadow merely conveys a sense of darkness which does not enter into the structure of the object as revealed by the light on it.

Let us consider for a moment how shadows come about. Light, as the textbooks of physics tell us, 'travels in straight lines'; but we all know that we do not have to be in the direct path of the sun's rays in order to have daylight, otherwise almost every room would be in darkness even at midday. The fact is of course that the sun's rays get reflected in all directions from the surfaces they strike against, and are reflected from the whole expanse of the sky itself. On a fine day the blue sky is a direct consequence of our planet's having a belt of atmosphere surrounding it; on a grey day we are not aware of the presence of the sun as a physical object, but its light becomes diffused all over the sky by reflection from the clouds. Thus the light of the sun comes to us indirectly from every quarter of the heavens. But it is also reflected from objects near at hand — just as a bright distemper will lighten a room, not by altering the quantity of light which enters it, but by reflecting more of the light that does enter. If it were not for these facts our world of modulated light and shade could not exist. Shadows are softened and graded because, although they are cut off from the direct rays of the sun, they receive light which is reflected from the sky and from nearby objects; and this light brings colour with it, which will be all the more evident because shadows are subdued areas without strong obscuring elements. On a fine day, for instance, blue from the sky will enter into the shadows of a landscape — into areas, that is, cut off from the yellow light of the sun; and strongly lit surfaces will reflect their colours into shaded areas near to them. In still life objects, shadows will take on colours from the bright surfaces of the assembled group — from curtains, tablecloths, jars, fruits, and the like — and this will create a subtle intermingling of the local colours. It is evident then that shadows are not, as we are inclined to regard them, simply masses of dull greyness, but colour enters into them, making them greys of varied colours — a conclusion which may be unsuspected if we have never noticed it, but which we can quickly test for ourselves by observation. There can be no formula for these shadow colours; they will always depend on the character of the light which creates them and on their surroundings.

Now in painting, when we let light and colour into our shadows we give them reality, because they take on the character of what they actually are — effects of light on objects set in space. Of course here, as always in painting, we are concerned with total effects in the picture space, and the character of the shadow colours will be

related to the style of the painting, its drawing, and general degree of abstraction from nature; and, as with local colours, shadow colours may be adapted freely, without incongruity, in a painting which is itself a free adaptation from nature. In this way shadows take their place in the general colour scheme and so become consistent with the rest of the painting. They are then one means by which the total unity of a picture is achieved.

Shadows are usually seen in association with brightly lit surfaces, and hence they are very liable to be affected by the after-image which such surfaces, when they are coloured, will induce in the eye. Just as on a flat surface a neutral grey will be tinged with the complement of a nearby colour, so there will be a tendency for a shadow to be tinged with the complement of a bright colour in its vicinity. Thus yellow objects will tend to induce blue into their shadows, green objects red, and so on. Complementary shadow colours may therefore often be introduced into paintings with good effect. In practice this will usually mean (as will be realized from the colour circle) that cool colours are given warm shadows and *vice versa*. This can be a way of emphasizing, by contrast, the coolness or warmth of shadows. It is well known that the impressionists introduced blues and violets into the shadows of landscapes they painted outside in the bright sunlight, where the pervading yellowness might be expected to induce a violet-blue reaction. Such shadow colours naturally produced a strong contrast to the warm light of the sun and were themselves enhanced by contrast, and the effect of sunlight was therefore emphasized. It is to be remembered that these pictures were painted under a brighter sun than ours, and in England our reaction to sunlight-and-shadow is not usually of a kind which demands so violent a contrast. It is a mistake to paint too deliberately in terms of strong complementary colours in the shadows, making a principle of it; such effects can easily become garish and devoid of any real experience of nature, and moreover they can degenerate into a mere trick. As before, let us bear in mind the nature of the problem and see our shadows new each time we paint.

Of course when the sun is bright in the heavens the greater part of the total light comes from the one source, and shadows are then intensified and more sharply defined. Under these conditions they may play a large part in contributing to the design of a picture and to a sense of pattern. It should be noted that the intensity of shad-

ows, like that of colours themselves, will depend on their setting in a painting: a light tone set beside a dark shadow will intensify the latter's darkness, and vice versa.

Unifying effect of colour. We are now in a position to see how the colours of a painting can contribute to its unity. The problem may present itself in some such way as this: we may be painting a landscape which (simplified for ease of illustration) consists of a sky, a field, and a cottage. We say to ourselves in effect 'the sky is blue, the field is green, and the cottage is red', and the tendency is to isolate these colours in their respective territories on the canvas. The result is simply — what indeed we have made it —'a sky . . . a field . . . a cottage': three separate items which do not exhibit any necessary connexion. But this does not really symbolize our experience of nature, where colours are unified by light and shade and by subtle modulations everywhere: and so it is that in our painting we can introduce colours from the sky into the landscape and from the landscape into the sky, we can echo the red of the cottage in the shaded parts of the field, we can bring touches of green into the modelling of the cottage, and so on. By carrying our colours throughout the painting we tie them together, and at the same time we bring the forms of the picture into relation with one another.

Sometimes we will find that just one colour will not unite with the rest, but will assert its independence by 'walking out' of the picture; and this again is often the result of isolating the colour in one area of the painting, and can be remedied by echoing it in other parts. Often the mixing of a trace of one colour with another will unite the two together, by giving the one a mere suggestion of the other. Thus a small amount of green or red can be mixed into a sky blue, and will unite the blue with the reds and greens of a landscape. Or the distribution of colours can be carried out by the intermingling of individual brush strokes; indeed a fabric of juxtaposed brush strokes can be built up throughout the painting. Incidentally we shall find that there is a great deal more pleasure to be had out of painting by taking our colours and working them freely throughout the canvas than by restricting our colours to prescribed areas. While the temptation will probably be — there can be nothing against it — to use many colours in our paintings, we should not hesitate to go to the other extreme and experiment in building up schemes of very limited

colours, having perhaps one general overall colour with a few contrasting ones. Such schemes can be quite surprisingly effective; and even schemes built up of greys with a few touches of pure colour can have an interest beyond all expectation.

Colour and shape. An interesting feature of colour, which is not always realized, is that colour and shape are not independent of one another. This is an inexorable law from which there is no escape. We shall find for ourselves how relentlessly it works. It may reveal itself in the following way: we may find that, do what we will with a shape, we can never get it to fit into a picture. However much we may try to adjust it, it never seems to come into place. But it may be that, after all, it is not the shape but its colour which is at fault: adjust the colour, and the shape will automatically come right. Certain colours will fit certain shapes in our paintings, and we cannot satisfactorily alter the one without altering the other. This raises a point often missed about drawing. The way we draw will necessarily be connected with the way we use our colours, and a drawing which is 'right' in certain colours will be totally 'out' in others. Matisse's drawing, for example, is bound up with his colour; we cannot imagine Matisse's drawing superimposed on Braque's colour. Neither can we imagine Giotto's drawing with Rubens' colour; or Raphael's drawing planted on Rembrandt's colour.

Essentially it does not matter how we arrive at our colour schemes so long as in the end we achieve a harmonious and unified result. Shapes which adhere closely to nature demand a close adherence to nature's colours, otherwise the colours do not 'attach' themselves to the forms; the two are out of keeping and create a feeling of disharmony. Where shapes are reduced to pattern or for any reason depart from those of nature, colour may be freely adapted without incongruity arising. Indeed, naturalistic colour is as much out of place on idealized shapes as free decorative colour is on naturalistic shapes. Put in another way — and to introduce a not very relevant word — we can say that 'distorted' shapes demand 'distorted' colour, for the sake of a unified result. In this way a painting becomes a self-contained organization at harmony with itself. What is called distortion, as we said in another connexion, is misleading, because the distorted object is not intended to be 'natural'; its colour, shape, and setting are all in keeping with a reconstructed form, not a form reproduced from nature.

This is no doubt one reason why modern paintings have been associated with brilliant colours. Reducing natural shapes to their own requirements, modern artists have logically placed themselves in a position to employ colours freely, sometimes in their pure brilliance. This does not mean that Gauguin and Matisse are better colourists than Rembrandt, whose colour is more subdued; it is simply that their colour is different, and a product of their different treatment of nature.

For us it means that our drawing and colouring will be related, and if our shapes are strongly at variance with those of nature, it will simply have the effect of setting our colour all the more 'free'.

Backgrounds and boundaries. There is a problem concerned with the application of colours which the beginner sometimes finds tantalizing. It is expressed by the question which is often asked, 'Shall I do the background first?' It is a problem which arises when we are dealing with a separation in space between two objects and one is superimposed on the other by the angle of vision, as when a tree is superimposed against the sky, or the back of a chair against the wall of a room. Essentially what we need is to indicate the separation in space between the two planes. Part of the answer to the problem lies in our showing the connexion which exists between object and background. If we paint the background first without reference to what is coming over it, and then 'dump' the object on top, we are totally disregarding any connexion at all; the two then become not logically separated but simply isolated from each other, and as likely as not the object will appear stuck to the background. We need to paint the background and object so that, while we paint, their relatedness can be seen; then the actual application of the paint will enter into this relationship. For instance, we can begin by roughly indicating the object, with a few pencil lines or in thin paint, so that in dealing with the background some connexion is established from the beginning. Or the background can first be roughly indicated, and developed to more completeness after the object has been worked into it. We have seen that a painting at the beginning may consist of touches of colour disposed freely throughout the canvas, and we need not think of making a principle of doing backgrounds or objects first — as if they were isolated entities calling for separate treatment.

But another difficulty arises at the edges of objects, at the line of

separation of one plane against another. The tendency at first is to bring the background colour up against the object, or vice versa, and leave it at that. But this often fails to show any logical separation between the two things. We are involved here in quite a fundamental problem. In nature, objects are set out in space, but on the flat surface of a canvas the background comes up against and 'touches' the object. We have to adopt procedures which symbolize our experience of nature in terms of paint on a flat surface. In 'flat' paintings strong lines can be used, because their flattening effect will not matter, and indeed they will help to create the character of flatness. In paintings indicating depth, lines which go to the extent of encircling objects will introduce an incompatible element. But if in the first place we deal with the question of relating the actual painting of object and background, as discussed above, the problem of contours and edges will largely solve itself. If one side of the object is in shadow, then the background can be paled where it comes against it — if it is desired to indicate a strong differentiation. On the light side of the object, the background might be darkened and so on; and apart from differences of tone, contrasting colours can be called upon in those parts where background and object meet. In this way the object is set off by colour and light without the use of heavy dark lines.

Lines, however, can still be used without flattening if they are broken and discontinuous. The eye is then not rigidly held by a strong contour. It often happens that, in working in the background, we find that parts of the white paper or canvas remain uncovered by the edge of the object. This especially in water-colour is a useful way of separating planes, and the freshness and sparkle of the painting are lost if the white edges are painted over. They can be left as they come, and often perfectly set off planes separated in space, and at the same time they will symbolize the light which comes from behind the object — as for instance in the case of a tree whose branches spread themselves over the sky. The same kind of thing may be done in oils, though to a more limited extent, by leaving part of the canvas exposed. Often this can be combined with other treatments. There may be parts where the boundary needs special emphasis, and then lines may be added here and there, but not to the extent of encircling whole objects; or edges may be diffused or broken into backgrounds in other places. It is a question of adapting our treatment to the needs of the situation.

Perspective. It is obvious that many factors go to produce volume, solidity, and distance, and what is usually understood as perspective — the converging lines of objects as they go away in the distance — is only one means of achieving this end. Too often perspective (a great bogy to beginners) is spoken of as the one essential means of getting a sense of distance; but in itself it achieves nothing of the kind. A painting in 'correct' perspective carries no sense of distance if colours, textures, details, contours are not at the same time related to our experience of objects in recession. Perspective properly speaking is the sum total of these means, which may be variously employed so long as the final result is harmonious; and the 'laws' of receding lines can be ignored and still a sense of distance achieved by other means. In paintings intended to be flat of course they do not apply at all. Again if, in the manner of the cubists, we refuse to be tied to one point of view in a painting, the 'vanishing points' are meaningless and the illusory convergence of lines may be reversed — and still depth and recession can be attained.

Perspective in the narrow sense of converging lines and vanishing points is really a way of indicating the illusion that objects appear to get relatively smaller as they go into the distance. Railway lines converge upon the distance because the width between the rails appears to decrease as the rails get farther from us. In the same way when we look down a terraced street the houses appear smaller at a distance, and the width of the road and pavement also dwindles.

If we want to get our lines of recession going the way in which they appear to go, we must bear in mind two facts: that the objects appear to get smaller as the distance increases, and that our eye remains on the same level all the time. We must roughly fix this latter point, because it is the starting point; the direction of the lines will depend on our position in relation to them. Suppose we are looking down a straight level road which has beside it a line of telegraph poles. Each succeeding pole will appear to be smaller than the one before it, and the top of each will therefore appear slightly below its forerunner. Hence the line connecting the tops will descend into the distance. On the same reasoning the bottoms will gradually ascend on each other, and the line connecting them will go up. The effect can easily be seen if we draw a series of parallel vertical lines and make each slightly smaller than the other. A special point that arises here is that the poles are considerably taller than ourselves, and so our eye level is nearer to the bottoms than to

the tops of the poles; or put another way, there is more of the pole
above our eye level than below. This means that the tops will
shorten more than the bottoms, and the top line will descend more
sharply than the bottom line will rise. Of course receding lines will
not always, and perhaps not usually, proceed inwards so directly as
do the telegraph poles which lie on a plane perpendicular to the
plane of the picture; some lines will proceed inwards but obliquely
across the picture plane. This will be equivalent to looking towards
the poles from a nearby field: they will still diminish in size as they
go into the distance, but they are now more spread out and their
convergence will be relatively less marked. The lines will, however,
follow the same course — upwards or downwards — according to
whether they are below or above the eye level. Now most of our
problems will be of this kind — the parallel lines of buildings, rooms,
tables, and the like which recede into our picture space. A general
rule to remember here then is that such lines going away from us,
above the level of our eyes, go down on the paper, and those below
the eye level rise up. It should also be remembered that vertical
lines — sides of buildings, corners of rooms, legs of tables—remain
essentially vertical on the paper.

If we can see perspective as directly related to the illusion of
diminishing size, we will not have much difficulty in getting our
lines to go the way in which this illusion is logically preserved. We
need not concern ourselves with the rigid vanishing points; we are
not making perspective an end in itself and the lines of recession can
be emphasized or reduced as we wish. Indeed our feeling for relation-
ship will frequently demand that we do this. The real logic of a
picture is created by the sensibility of the painter, not by the
mathematics of perspective. If we find the orthodox perspective
altogether beyond us, or that it has no appeal for us, then let us
ignore it altogether and introduce our own perspective, by relying
on our instinctive use of colours and shapes to get a sense of dis-
tance — if we want it. And there is no reason in the world why we
should not make our pictures flat if we want to.

Frames and surroundings. Finally in regard to colour
it must be remarked that, when all is said and done, the final
appearance of a painting will depend a good deal on its setting in
a frame and on a wall. An inappropriate frame can kill a painting,
and this happens if the colour of the frame fails to harmonize with

the general colour scheme of the picture; and in the contrary sense, a picture can be surprisingly enhanced and given a look of completeness by a satisfactory frame. Perhaps one cannot speak of a frame as adding to the merits of a picture; yet a frame is a part, and a necessary part, of any picture. It encloses it and isolates it from its surroundings as a thing on its own; establishes its boundaries and gives emphasis to its rectangular limits. The beginner will be well advised to put some of his pictures in frames, if only to judge the effect; he will be surprised at the way in which this confers an air of finality on his work and enables him to judge it far better than is otherwise possible. Quite a good plan is to keep a few frames of useful sizes, painted in a subdued stone grey, and paint pictures to these sizes; they can then be easily framed and can be hung up and looked at, and so may be judged. Under these conditions we can see how a picture 'settles down' after a week or so.

Apart from frames, walls and surroundings can play a large part in destroying or enhancing a picture. A blue or yellow distempered wall can make a great difference to a picture's colours, and strong wall-papers, especially with vivid patterns, can be quite overwhelming; while bright curtains nearby or bright objects in the room too close can easily upset relations in a picture. Some attention is also worth paying to the light a picture receives from windows; and its general setting in a room, which will depend on the extent of the wall space, can make or mar an effect. Some pictures, for almost inexplicable reasons, 'go' in certain situations, and others do not.

9 □ on being a beginner

A solitary occupation. If we are really taking up painting for the first time, we are entering a new world and are bound to feel a little strange in it at first. We have to find our way about and there is a good deal to which we have to accustom ourselves. A few general hints may therefore not be out of place.

Painters, like birds of a feather, tend to flock together, although in truth they do not associate so well as do literary and dramatic people. Painting is a solitary occupation; no one can be other than on his own before his canvas, and perhaps this induces an individualistic turn of mind which does not lend itself to association with others engaged in the same pursuit. Yet painters do associate, and the beginner might do well to seek out and get to know other painters in his district. If he can find some who, like himself, are finding their way, all the better. In many centres classes now exist for the encouragement of painting along free lines; these could be given a trial and might be the means of discussing one's problems with others. A good deal depends on the sort of atmosphere that is fostered in the class; if it is friendly and encouraging to individual creativeness, there are good reasons for joining. It is helpful to see the work of others, not only in its finished state but while it is in the making; and at the same time one's own ideas are stimulated and one is less likely to get into a groove, or to feel that painting is an isolated activity which puts one at odds with everyone else. But there are people to whom any idea of joining a class is out of the question, and to such people it can be said at once that there is no reason whatever why they should not be lone stars. In some ways, indeed, they will be better off, for there is certainly a danger in too much seeking of advice and criticism; one is only confused by the disparity of the advice that is offered, and the more one can stand on one's own two feet, the better.

162

Most towns have art groups which exhibit the work of local amateurs. Often, however, these groups follow exclusively the well-trodden paths and foster only those members of the locality who have been at the same way of painting for decades; and such groups, easily recognizable from their exhibitions, will not do more than accept on sufferance painters who are developing styles of their own. The creative painter will be up against people who have worked at a technique and brought it to a high degree of perfection over many years; they will be the stars of the local group, and they will not easily accommodate people who set out boldly in a technique very different from theirs, more vigorous and less hampered by what is considered to be tradition. While therefore the beginner may find that he is brought into contact with some kindred spirits by joining his local group, he must not feel disappointed if he finds little or no encouragement in that quarter.

Finding motifs. There always arises the question of finding motifs in nature which will give us the necessary stimulus to paint. The finding of such motifs is largely a matter of experience. At first we are likely to have difficulty in finding spots which suggest the possibility of a picture, especially when we are on familiar territory. We will not have considered our own neighbourhood in a paintable light, and when we come to do so we will have to overcome the deadening influence of familiarity. But before long we will be surprised at how much we have missed and wonder how we could possibly have turned a blind eye to so many motifs that cry out for our attention. If we will look afresh at the everyday things that we constantly pass by, we will find an unlimited field of potential themes opened for us at our own doorstep. There is absolutely no need to think of holidays abroad or of visits to picturesque parts of the countryside in order to find our subjects. Indeed, we should beware of hunting for the obviously picturesque; scenes that compose themselves too readily often fail to stimulate our imagination and inventiveness, and, particularly if we have acquired some skill at imitation, they may tempt us to rely on a reproduction of natural beauty at the expense of personal creativeness. It is often in the least expected places that we will find the stimulus we need. The odd street corner, the garden shed, the table by the window, the armchair by the fireplace: they may all under certain conditions give us the motifs we need.

Painting at home. In painting at home we have a seclusion that may be difficult to find outside, and this for the beginner will be a powerful recommendation. Moreover, we can then paint under artificial light. This, because of its yellowness, will affect some of the colours, especially those on the blue side of the colour circle, but it is perfectly possible to paint by artificial light, and we should not hesitate to do so if the evenings are the only times we can spare for painting. The difficulties created by electric light are sometimes exaggerated, and many pictures painted at night are not rendered unharmonious by the light of day. Artificial light at home often means a light coming from a single source, and this naturally leads to an intensification of shadows which may affect appearances far more than any slight changes in the colours themselves. At home we will always be relatively close to the object and local colours will come strongly into the picture; and it will be interesting to note how lights and shadows are affected by the colour of walls, curtains, and carpets. We can if we like set up formal still life groups, but it is best not to compose a group with too much studied care, or it will 'set' itself too deliberately in a painting. It is much better to extract what we want from a group of objects that have come together in the ordinary course of things, haphazardly and unarranged, and indeed it is surprising how such a group will often spontaneously offer all the ingredients for a picture.

Painting in the open air. Painting in the open air has many difficulties, not the least of which is imposed by the weather itself. In the winter it is too cold, and in the summer, apart from the natural hazards of our climate, the conditions of light coming from a broken sky may vary enormously from one moment to the next. We naturally think of fine days as the most suitable, and then we find that sunshine creates its own problems. It is disconcerting how a scene will change from the morning to the afternoon as the sun goes across the heavens. The cast of shadows may be quite changed, and the resulting forms in the scene entirely altered; as the afternoon draws on the sun gets more yellow and 'warm', with consequent changes in the colours of nature. Again, the intensity of light outside even on a dull day, as compared with a room, comes as a shock at first and requires some getting used to. The tendency will be to paint in too low a key; when brought inside the painting, bright enough in full daylight, will seem too dark in tone. Under conditions of sun-

light, the brightness outside makes things even more difficult. The glare from the canvas under the sun itself is most uncomfortable, besides making it difficult to distinguish the colours that are put down; and we naturally seek the shade. Here it is well to remember that it is extremely difficult to paint looking into the direction of the sun: we have a constant glare before our eyes, the colour is bleached out of everything, and the shadows are all cast before the objects. It is much better to ensure that the sun is behind us, coming over our shoulders; the scene is then lit directly by the sun, while we look into a bright sky and not a distracting yellow orb.

Perhaps the greatest drawback of all, amounting almost to a dread, is the thought of observation and comment from passers-by. It is no good minimizing this difficulty or pretending that it does not exist. There can be no doubt that the sight of a painter at work is irresistibly fascinating to the public at large, and not alone to its juveniles; and if one paints in any place at all accessible to the public, one must expect not only intrusion but all the random comments which ignorance is so prone to display. The open-air painter quickly discovers, what might not have been obvious before, that a wealth of unsuspected art criticism resides in the casual strangers of a country walk. These self-appointed critics, who always know what they like, will not hesitate to point out what they do not like about your work, and the knowledge that it is all meant in a spirit of helpfulness does nothing to lessen one's exasperation. Children on the other hand I have always found most sympathetic; they will almost certainly praise your work, and this — whatever we may say — is most strengthening to the morale. It is extraordinary how much more worth while a painting will look if someone praises it, and how dreadful if it is disparaged.

It can be said that one gets used to these intrusions and can in the end ignore them; nevertheless sensitive spirits will probably feel it necessary to incarcerate themselves in impregnable positions, but it is not easy to find sites of this kind which also offer possibilities for painting. We should not forget that there are often good views to be had from windows — if not our own, then those of our friends — where we can be left in peace, and such vantage points are particularly useful in the winter. And we should be quite ruthless in requisitioning our friends' gardens in the summer; in point of fact we will find that our friends will be delighted and, if the truth were known, a little flattered.

Week-ends of course will be the hunting time for most of us, and the term 'Sunday painter' has been coined to describe the activities of the amateur who is otherwise occupied during the week.

In painting landscapes from nature it sometimes helps if, in the first place, we look for the broad tendencies in line and form in what is before us, and to this end, in eliminating details, to look with half-closed eyes. We then see everything in broad masses, and can mark the main sweeps of line and contour. These may give us the starting point for a picture and may stimulate our first putting down of colours — the bare essentials of scaffolding on which the picture will be built up.

Painting from sketches. Some people find it useful to paint from sketches, whether executed in pencil or water-colour. Here it is advisable to make rapid sketches, not over-elaborated; perhaps a few notes to suggest ideas which come in observing a scene. In this way we will not be tempted merely to enlarge and reproduce a sketch, which remains something adapted to its own size and medium; instead the sketch will help towards the making of a picture which will conform to its own requirements and be of its own kind. We can make many sketches in the course of an afternoon, and can make them in places where we could never set up an easel.

Painting from memory. We should always bear in mind painting purely from memory. We are certain constantly to see effects in nature which will stimulate us to paint, and these we can carry away and work on — not so as to reproduce them, but using them as embryo ideas. And several ideas can be incorporated in one picture. Amateur painters are far too prone to rely on motifs derived from one given situation. Yet it is only in comparatively recent times that landscape paintings, other than sketches or notes, have been completed before an actual scene in nature. The monumental landscapes of the seventeenth and eighteenth centuries were painted in the studio and were freely composed from material collected in sketches or drawn from the memory. In this sense they were artificial constructions. Gainsborough used to make models of landscapes out of stones and twigs to give him ideas. We need not then hesitate to employ every means in our power — memories, sketches, imaginary ideas — in order to develop landscape themes

and invent our own scenes. At the back of all this artifice will be our own observation and experience of nature.

The ups and downs of progress. The beginner is warned that his progress is not likely to take an even course; and there will be times when he will feel utterly despondent and hopeless about his work. There is nothing unusual in this: such times come to everyone. Then it is particularly important that we should not give up in despair, for it is by perseverance at periods like this that we will emerge into new fields of discovery. When all is well and our work seems to be making steady progress it is easy to go on, for we are carried onwards by our own enthusiasm. But creative work does not continue on a primrose path and we must not expect it to do so. The impression will come at times that our creative life is dead, and that nothing worth achieving can come from us. It is a sort of black night of the soul. But perhaps such ups and downs are a part of the inexplicable nature of creativity, for at its heart lies a great mystery. It is uncertain as the winds of heaven and quite as incalculable. We may feel all set and in the mood for work, and yet find that nothing transpires as we had hoped; and again we may feel distinctly not in the mood and disinclined to paint on another occasion, and find that things take a turn which is the reverse of our expectations, and our mood is transmuted into one of happiness and enthusiasm. We should never wait for the mood and least of all for inspiration; we may wait for ever, while all the time the state of mind we are waiting for may be ready to accompany us in the act of painting.

Some people find that under the impact of a new activity they are carried on by the very newness of the experience and their enthusiasm knows no bounds. Then the reaction sets in; they exhaust their first run of inventiveness and the thing begins to pall and get stale. This however should by no means be interpreted as a bad sign; it probably means that they have been following one line of development and have been repeating themselves, merely adding variations to one theme. To people with a genuinely creative attitude this is not good enough; they are not content to find a safe formula and keep within it. The realization comes to them with a jolt that that particular line of development has come to an end. At first it looks as if all creativeness has ceased, but in fact it is only a transition to a new experience. This may not be apparent at once; hence it is all the more important not to give up in despair. The new path

will be found, but only if we give ourselves the chance to find it.

Again, some people find that at the beginning it is very difficult to get going at all. It may be weeks before anything that they can consider in the nature of an encouraging sign appears, and it hardly seems worth while continuing an activity that yields so slowly to their efforts. But a slow start does not signify a poor development in the end; indeed, the reverse may be indicated. I do not attempt, because experience has shown me how impossible it is, to assess a person's progress in terms of his beginning. So many factors enter into the question, and they may all take time to reach adjustment. I have known many people who, after a period of struggle at the start, have quite suddenly found their feet and have been genuinely surprised at the way in which their activity unexpectedly begins to yield to their efforts.

No picture succeeds as we would like it to; we are never satisfied in the sense that we feel we could not do better. But this does not mean that we must always groan and torment ourselves by the thought of utter failure, or worse still romanticize our feelings by elevating them to the level of the supposed torment of the artist's soul. No doubt a certain sense of dissatisfaction acts as a necessary stimulus to further endeavour, but no such stimulus will arise out of feelings of hopeless failure. We may feel that we can always do better, but at the same time we can gain satisfaction from the thought of what we have achieved.

We gain as much from our failures as from our successes; but failure and success are only relative terms. We may spend a whole day on a picture and find in the end that it fails to please us at all; and then we can throw off, at the end of the day, in a matter of half an hour, a sketch which compensates for all the hours that seemed wasted. But really they are not wasted; they are spent in adding to our accumulated experience of painting which we carry with us into the future.

We should try to make every picture something which adds to our experience and not merely repeats it. Each picture should have the quickening interest of a new undertaking, and if it does not we are in danger of a certain staleness entering our work. There is a tendency in most of us to stay in a groove, and this is never more insidious than when we try to repeat our successes — forgetting that success in picture making cannot be repeated to order.

One very common characteristic may be mentioned for the

encouragement of the beginner. People are always much more critical of their own pictures than they are of other people's. This is shown strongly in classes where people paint together. A person will think his own work is inferior, but will genuinely admire his neighbour's and feel a little envious. Yet his neighbour will be in an exactly corresponding position. There is undoubtedly something about painting a picture oneself which makes one critical of it in a special way. We know too much about it and the way it was put together, and we concentrate on what are for us the weak parts — the parts that gave special difficulty. The result is that we look on it with a jaundiced eye. We do not see our pictures as other people see them, and they do not see their own as we see them. There is always something fresh for us in another's work which we cannot expect to find in pictures we paint ourselves. It is as well to bear these points in mind when we are inclined to think that ours are particularly inferior.

Every picture goes through certain stages, an inevitable consequence of the fact that painting is progressive in time. First there is the white surface, then its partial breaking up, then a more complete assembling of forms. Some pictures come together easily from the word go; everything seems to fit and the thing arrives almost without our knowing it. This is not, however, likely to be the general rule, nor must we suppose that a picture that comes easily is any the better for that reason. Although it is true that a picture which is constantly 'worried' is likely to bear a worried look, it is also true that in the course of development a picture may require many adjustments which are perfectly logical steps in the process of construction. Under these conditions a picture often reaches a certain critical stage. It looks as if nothing can come of it and that to abandon it is the only thing to do. But if we can keep going beyond this critical point the tide begins to turn; we then see things beginning to take shape and 'come together', and can see our way to linking up the disconnected threads and bringing the picture to a conclusion. This critical stage often occurs when a good deal of the white surface yet remains to be covered; the colours and shapes seem isolated and disjointed, and will not assume coherence until more of the surface is covered and they can be related to the whole. Many times I have been the means of assisting people over this critical stage by merely encouraging them to go on.

Although we dislike flattery and do not desire criticism of our

work which is other than just, yet there is no denying the fact that a little genuine praise can make all the difference. It can cast our work in a new light and give us new incentive. In the same way, unless we are very strong-willed and feel very sure of ourselves, constant derogatory criticism can dry us up and turn all our work into a valley of dry bones. The beginner has a right to receive encouragement. He is all too prone to despise his own efforts, and cannot himself detect the signs of interest and value in his early work. Encouragement can help to bring him into a more expansive relation to his activity, by saving him from the feeling that he is entirely alone. If therefore he has friends who have an understanding of what he is doing, he will do well to show his work to them. Few of us, after all, can work in isolation from our fellow men.

It is often a good thing to see a picture, even in an unfinished state, set in a frame, however improvised, so that it can be set off in some more definite way than when it is pinned to a board at an easel, and this may help us to formulate ideas about it. Again, it is often well to break the continuity of our vision in looking constantly at the picture we are painting. By looking away for a time and interesting ourselves in something else, we can come back with a fresh outlook and can see the sort of obvious thing which eludes us when a sameness deadens our reactions. This also holds good if we reach a stage when it seems impossible to go on with a painting. If we put it away, and return to it at a later time — perhaps some days or even weeks after — it sometimes happens that at a first glance we can see what we can do with it, and with the ideas comes the impulse to continue.

Why do we paint? And now, why do we paint at all? Not surely for any reasons of culture or self-improvement; indeed any such motives can only be suspect, and the more strongly felt, the more likely are they to lead to only a passing interest in the activity. And to engage in painting for any educational reasons seems somehow to place it in too strenuous a light, and to give it a wearisome flavour of uplift. But in fact we need not seek for reasons where no reasons are called for, and perhaps even the attempt to explain a desire to paint is to misunderstand its nature. Certainly we may paint for no known reasons at all: not because we have to, or because we are bored with life, or to express ourselves, or because it is a significant activity; but simply to fulfil a desire to paint. It

is like singing a song or dancing: we do it because we want to.

There is a fairly common notion that we should paint in order to 'express ourselves', but this is at best a limited point of view. The idea of self-expression seems to imply that what is expressed arises entirely from the 'self' within, whereas painting by its very nature implies a looking outwards from oneself to an external environment. It embodies our free, instinctive reactions to something seen, whether this be some aspect of the world of nature or an effect created on our canvas. The physical end of our activity — our arrangement of colours on a flat surface —:we have described as a 're-created world', and as such it may be considered to be a symbolic image. But at least it should employ symbols which have the character of universality as opposed to the private and personal symbols of a projected 'self'. Such private symbols will need to be explained, and the explanation will bring us out of the world of painting into that of literature. The symbols of painting, however, do not have to be explained in words; the extraordinary thing is that their meaning is inherent in themselves, and they do not have to be invented because they arise out of the nature of our activity. Thus we shall only make difficulties for ourselves if we set out to paint pictures with any deliberate intention of expressing ourselves, and it may even be doubted whether an expression of this kind is possible by such a self-conscious process. We shall do well to set our attention on what is outside ourselves; what is self-expressive in our paintings will arise inevitably and without our taking thought.

Painting as an activity which we undertake for its own sake may be said to assume the character of a recreation, and like every recreation into which we can enter with full abandon it refreshes the spirit and brings new interests to life. If painting can really be entered into as an activity bringing colour, enthusiasm, and aware-ness of nature into our lives, it cannot leave us where we were. It will light up certain corners of our lives and increase our happiness in living. This cannot fail to have its repercussions on mental and physical health.

But painting is not merely a time-killing occupation; it is a creative activity. It does not just fill up the hours; it leaves us with a sense of fulfilment. Creativity has an important bearing on any sense of fulfilment we can attach to our lives, and where it is denied we may see a fruitful source of frustration. Perhaps it is here that one of the major frustrations of our age arises, for in a world of great

productive techniques, individual creativeness is only too easily lost sight of. To create is not the same as to produce; it is to bring into being a product whose value derives from its uniqueness — something which is not standardized but individual. And creativity is surely one of the special glories of man, for to him is it given among living creatures to develop his powers of making what serves no evidently useful purpose save that of increasing his pleasure in living. We tend to think of these powers as being the special possession of people called artists, and forget that they are everyone's by right and cannot be denied without loss.

The work of creation is one of integration, and it is this aspect of it which, perhaps more than any other, constitutes its value to ourselves. It is an ordering of experience, of thought, feeling, and physical control to a complete end. It is not that our hands are occupied while our thoughts range at will, nor yet that our intellect or our sensibility is stimulated passively while our hands are idle; all are concentrated in one effort of control. This ordering of awareness in one experience can bring about a total absorption in the activity, and is in marked contrast to the distinct separation of abilities in production for production's sake; it is more human and more balanced, and may have real integrative value for the personality.

Painting may be the means of bringing us into a new and more vital connexion with nature. As life becomes more highly organized and mechanized, the world of nature is thrust more and more into the background of our lives. For most of us there can be no question of seeking a pathway 'back to nature' through a return to a more primitive way of life, and painting offers us no remedies of this kind. But it does open our eyes to the world of light and colour and reveal it in a way which will be new and vital to many people. When we start painting we may for the first time look at the forms and colours of nature for their own sake — and by nature is meant the whole world of appearance that surrounds us in town or country. We will see more than we ever dreamed possible: colours we never saw before, in shadows as well as sunlight; the play of light on buildings and pavements as well as on trees and fields; the relationships between colours and shapes; how the light unifies the colours of a scene, and how the character of a scene changes with the changing character of the light. As the day passes from morning to evening we will see

the changing panorama of pattern; and every walk in town or country will take on an interest which can never tire.

We cannot perceive nature in this way without coming to terms with it ourselves. It is no longer an external environment which merely subtends the interests of our comfort and security; it yields itself to our contemplation and enters into our experience. It enriches our lives. Thus we ourselves will find a place in nature, and it is there also that we will find the stimulus to paint.

But this is not all, because there is also that other world — the world of the art of painting — to which we are introduced in a new way when we take the brush in our own hands. Here is a world that is created for our pleasure and, if we pass it by, we are so much more the losers. The world of art is meant for pure enjoyment, and if in this respect it has failed us in the past, we need not wonder if it has but little meaning for us now. It may be that pictures have not interested us much in the past; or we may have been shamed into visiting art galleries in an attempt to master an aspect of culture which we feel we ought to know something about. We may even have joined those bands of earnest people who patiently submit to being conducted round art galleries, while the things they ought to admire are discoursed upon by the learned guide-lecturer. But here matters get so confused with history, with dates and names which are most difficult to remember; and it is with a sigh of relief that at last we emerge into the fresh air and sunshine outside, and make for the nearest tea shop. This is painting seen from the cultural point of view. Painting ourselves will change all that. It will revitalize our interest in the work of other painters; we will be led to an understanding of what painting is, and we will have our eyes open to the world of pictures; and we will find for ourselves the things that interest us. And then strangely enough we will discover that our concern is not with history but with what is relevant now; it will not matter very much whether we can name the artists or place their dates, for it will be their work that speaks, and that is timeless. And it is more than likely that we will have a key to the appreciation and enjoyment of contemporary paintings, even the kind which are often found puzzling because people regard them as problems that need to be solved, instead of adventures in the world of colour and shape. Again, we will have an interest which cannot be the concern of a person who does not paint: we will have something of a craftsman's interest in another person's work. We will relate our work to

his and will note how this or that effect is obtained; we will note his technique and see something of the mechanics of a picture, and how it is put together.

Nature is constantly on the change, like the sunshine on an April day; but the world of art is more stable and permanent. In paintings we have order and serenity; and we can go back again and again to the same picture and find it as we left it, awaiting our appraisal. Here is an endless world of pleasure, calling out for discovery, and it may well be that our own discoveries with a paint-brush will be the means of leading us to it.

glossary of technical terms

After-Image. An effect of vision, whereby when we look at a colour its complementary colour is registered in the eye. This complementary after-image may, in the process of observation, be imparted to the surroundings of the colour which gave rise to it. This phenomenon is known as 'induced colour'.

Binder. A substance, such as gum or linseed oil, which has the effect of 'binding' or fixing the particles of pigment to the ground.

Body. A colour is said to have 'body' when it possesses opacity. Thus gouache colours are body colours, in contradistinction to transparent water-colours.

Canvas Boards. Boards with a surface of prepared canvas.

Colour Circle. The rainbow colours arranged round the circumference of a circle so that complementary colours stand opposite one another.

Colouring Power. *See* 'Staining Power'.

Complementary Colours. Colours which exhibit the maximum contrast. They appear opposite one another on the colour circle; when mixed together as pigments they tend towards greyness, without producing entirely neutral greys.

Cool and Warm Colours. The colour circle may be divided into two halves, the one consisting of yellow-green, yellow, orange, and red, and the other of green, blue, and violet. The former constitute the 'warm' colours, the latter the 'cool' colours. The warm colours are sometimes called 'advancing colours', because in general they tend to come forward on the canvas, while the cool colours have the opposite effect and are therefore called 'receding colours'.

Copal. A hard resin used in making copal varnish by dissolving it in linseed oil.

Covering Power. Sometimes used as synonymous with Hiding Power (*q.v.*), but more correctly refers to the power of a paint to spread itself in a satisfactory manner over a given area. This is a technical consideration of importance in the manufacture of paint, but hardly concerns the painter of easel pictures.

Designers' Colours. Opaque water-colours (gouache colours) of superior quality to poster colours.

175

Diluent. A liquid used for diluting paint, such as water or turpentine, the liquid evaporating completely and having no binding effect on the pigment.

Dipper. A small metal container which clips on to the side of the palette, for holding the medium for painting in oils.

Discord. A term used to denote any relation of colours which produces an unpleasant or 'clashing' effect. It cannot be defined with any exactness. Examples of discords arise when (1) the 'natural' order of rainbow tones is reversed, (2) colours are neither similar nor complementary.

Dominant Colour. A colour which takes precedence in a colour scheme.

Drier. A substance added to a drying oil to increase its rate of drying in the air. The use of driers in oil painting is dangerous, as they are liable to lead to cracking.

Drying Oil. An oil, such as linseed oil, which when exposed to the air gradually hardens into a firm, semi-elastic layer. The term can also mean a drying oil to which a drier has been added.

Dye Pigment. A pigment made from a dyestuff colour. Most of the dyestuff colours, in being made into pigments, are rendered into Lakes (*q.v.*).

Earth Colours. Pigments dug directly from the earth's crust, and ready for use after suitable treatment and grinding.

Essential Oils. Volatile oils, such as turpentine, which evaporate completely in the air. They are used as diluents in painting.

Fixative. A solution, usually of resin in alcohol, used for 'fixing' pastel paintings, i.e. rendering the particles of pigment firmly attached to the paper.

Fixative Spray. A spray for applying fixative solution to pastel paintings. Also called an atomiser or spray diffuser.

Fugitive Pigments. As usually understood, pigments which fade in the light.

Glaze. A transparent colour applied over a light ground or light colour, so that the latter shines through.

Gouache. As generally understood, gouache colours are water-colour paints, such as poster colours, prepared in an opaque form and applied in an opaque technique — i.e. the colours are applied thickly and white is freely mixed with them as desired. Transparent water-colours, when applied in an opaque form by the addition of white, become gouache colours.

Greyed Colour. A colour modified by the addition of black and white.

Ground. The covering applied to canvas, cardboard, paper, etc., which gives it a suitable surface on which to paint. The two main grounds are (1) the chalk ground, consisting of chalk and size or gelatine; (2) the oil ground, an undercoat of oil paint, preferably white lead, applied over a sized surface.

Hatching. Lines or brush strokes placed parallel and close together. When

they are crossed by other hatching lines, the process is known as cross-hatching.

Hiding Power. The power of a pigment to 'hide' or obscure the ground painted over. It is a property of opaque pigments. Sometimes loosely called 'covering power' (*q.v.*).

Hue. A colour's quality as red, blue, green, etc., quite independent of whether the colour is modified by the presence of white, black, or grey.

Impasto. Paint used in thick, solid layers, as when it is spread thickly with a palette knife.

Imperial Size. A standard size of paper, 22 in. by 30 in.

Induced Colour. See 'After-Image'.

Intensity of Colour. Extent to which a colour is free from the presence of white and black. Equivalent to its purity or degree of saturation.

Keys. Wooden pegs or wedges inserted in the inside corners of a stretcher.

Lake. A pigment prepared from a dyestuff colour, by allowing the latter to dye an intermediate solid such as alumina.

Linoxyn. The name given to the solid layer formed from linseed oil when it has dried in the air.

Local Colour. The true or actual colour of an object, unmodified by any special conditions of lighting or viewpoint. It has no exact existence, because an object's colour is always subject to the conditions in which it is seen.

Mastic. A soft resin used in making mastic varnish by dissolving it in turpentine.

Medium. In a general sense, the word medium refers to the technical means by which painting is carried out, as water-colours, oils, pastels. It may also refer to the liquid with which pigments are ground in being made into paint, and in a more restricted sense still to the liquid used to render paint more fluid and amenable to the brush. In the latter sense, when the medium evaporates completely, like turpentine, without having any binding qualities of its own, it is called a diluent or thinner.

Megilp. A medium used in oil painting, obtainable in tubes from which it is expressed as a gelatinous liquid. It is valued for its smooth working qualities and it imparts a buttery quality to the paint, but its use is dangerous as it renders the painting impermanent.

Mineral Pigments. Any pigment made from a solid mineral substance, whether the latter is found directly in nature (earth pigment) or artificially manufactured. Sometimes called 'inorganic pigments'.

Neutral Grey. A grey (black and white) free from admixture with any hue.

Oil Absorption. Pigments differ in the quantity of oil they absorb in reaching the consistency in which they are found in the tube. A pigment like burnt sienna has a 'high' oil absorption, and therefore requires more oil than does flake white, which has a 'low' oil absorption.

Oil Pastels. Dustless pastels having a matt 'oil' effect. They do not readily smear when rubbed after application.

Oil Sketching Paper. Paper prepared with a ground on which oil painting can be carried out.

Opaque Pigment. A pigment which reflects the light from its surface, i.e. does not transmit it to the surface below. It therefore possesses 'hiding power' (*q.v.*). Opaque pigments are rendered transparent in effect if they are applied in a very diluted state.

Organic Pigment. Another name for a dye pigment (*q.v.*). In chemistry, 'organic' compounds are those containing carbon, and dyestuff colours come into this class. In this nomenclature, non-dye pigments are called 'inorganic pigments'.

Painting Knife. A knife, usually trowel-shaped, made of very thin, flexible steel, used in place of a brush for applying paint in 'palette knife painting'. Many different sizes and shapes of painting knives are obtainable.

Palette. In general, when we speak of an artist's palette, we mean the range of pigments which he employs in his paintings. More specifically the word refers to the flat piece of wood, glass, porcelain, etc., on which the colours are set out and mixed.

Palette Knife. A knife with a flexible steel blade, obtainable in different sizes, used for mixing paint, for scraping paint off the palette or canvas, and for applying the paint in 'palette knife painting'.

Pastels. Powdered body colours loosely bound with gum.

Permanent Pigments. The word permanent is usually taken to refer to pigments which are permanent in the light, i.e. do not fade. What are classed as permanent pigments are not always absolutely permanent, but are considered sufficiently permanent for nearly all purposes.

Pigment. A coloured solid capable of being ground to a fine powder and prepared as a paint when mixed with a binding medium, such as linseed oil or gum and water. The particles of pigment remain insoluble in the medium, i.e. they are dispersed or suspended in the liquid but not dissolved. Mineral or inorganic pigments are those made from mineral substances; dye or organic pigments are made from dyestuff colours, which are usually rendered into pigment form as lakes (*q.v.*).

Plastic Emulsion Paints. Water paints having a plastic substance as binder which becomes waterproof when dry.

Poster Colour. An opaque water-colour (gouache colour) of pastelike consistency, obtainable in pots or tubes.

Powder Colour. An opaque water-colour (gouache colour) sold in the dry state as a powder. When mixed with water it forms a paste similar to poster colour.

Prepared Canvas. Canvas prepared with a surface ready for painting on.

Primary Colours. The primary colours of painting are often stated to be red, blue, and yellow, since from them it is possible to get by mixture

greyed varieties of the other rainbow hues. This conception of primary colours is more practical than theoretical; colour theories lead to a different selection — red, blue, and green, or red, blue, green, and yellow. What we regard as primary colours depends on our point of view.

Priming. The ground (*q.v.*) applied to a support (canvas, cardboard, etc.) to render it suitable for painting on.

Pure Colour. A colour which is free from the presence of black and white. It is a 'saturated' colour.

Resin. A transparent solid of vegetable origin; many varieties are now made synthetically. Resins are often ingredients in the prepared mediums of oil painting, and are the basis of varnishes (*q.v.*).

Saturated Colour. A colour free from the presence of white and black. 'Pure colour' and 'colour of maximum intensity' are equivalent terms.

Scumble. A scumble is the reverse of a glaze, i.e. it is a film of light opaque colour placed over a darker colour, so that the latter is lightened but not entirely obscured.

Shade. A colour rendered darker by the addition of black only.

Siccative. Another name for a drier (*q.v.*).

Sinking-in. A term applied to those parts of an oil painting where the colours have dried out matt compared with the rest, and give the impression of having 'sunk into' the ground.

Size. An animal glue obtained in powder form, and prepared for use by first soaking in cold water and then warming.

Staining Power. The power of a pigment to impart its colour to white, and so is a measure of its colouring strength in mixture generally. Thus Prussian blue has more staining power than ultramarine. Also called tinting power and colouring power.

Stippling. A method of applying paint in small spots, usually carried out by dabbing with the extreme end of the brush.

Stretcher. A wooden frame on which canvas is stretched in preparation for painting.

Support. The material, such as canvas, cardboard or paper, on which painting is carried out. It is first treated with a ground (*q.v.*).

Thinner. A diluent, i.e. a liquid such as water or turpentine which dilutes or 'thins' the paint.

Tint. A colour rendered paler by the addition of white only.

Tinting Power. See 'Staining Power'.

Tone. Degree of lightness or darkness. The upper limit of tone in painting is white, the lower limit black; greys come between these limits. A colour's tone is its lightness or darkness considered independently of its quality as redness, blueness, greenness, etc.

Transparent Pigment. A pigment which transmits the light to the ground or colour underneath. It is therefore without 'hiding power' (*q.v.*). A transparent pigment is rendered opaque by the addition of white.

Turpentine Substitute. A volatile oil which resembles spirits of turpentine in general use.

Value. A word often used as equivalent to tone. A colour's value or tone value is its degree of lightness or darkness.

Varnish. A transparent protective film applied over a finished painting. The varnishes in general use consist of solutions of resins in turpentine ('spirit varnishes') or in linseed oil ('oil varnishes'). A varnish of a different type is made by dissolving wax in turpentine.

Vehicle. The word vehicle is often used as equivalent to medium. It may refer to the liquid with which pigments are ground in being made into paint, or to the liquid mixed with the paint to render it more fluid and workable.

Warm Colours. See 'Cool and Warm Colours'.

Wash. A wash is a thin, even transparent film of water-colour usually considered as applied over a fairly large area of the paper. The process of applying such a film is called 'laying a wash'.

index

181

A CATALOGUE OF SELECTED DOVER BOOKS
IN ALL FIELDS OF INTEREST

A CATALOGUE OF SELECTED DOVER BOOKS
IN ALL FIELDS OF INTEREST

WHAT IS SCIENCE?, *N. Campbell*
The role of experiment and measurement, the function of mathematics, the nature of scientific laws, the difference between laws and theories, the limitations of science, and many similarly provocative topics are treated clearly and without technicalities by an eminent scientist. "Still an excellent introduction to scientific philosophy," H. Margenau in *Physics Today*. "A first-rate primer . . . deserves a wide audience," *Scientific American*. 192pp. 5⅜ x 8.
60043-2 Paperbound $1.25

THE NATURE OF LIGHT AND COLOUR IN THE OPEN AIR, *M. Minnaert*
Why are shadows sometimes blue, sometimes green, or other colors depending on the light and surroundings? What causes mirages? Why do multiple suns and moons appear in the sky? Professor Minnaert explains these unusual phenomena and hundreds of others in simple, easy-to-understand terms based on optical laws and the properties of light and color. No mathematics is required but artists, scientists, students, and everyone fascinated by these "tricks" of nature will find thousands of useful and amazing pieces of information. Hundreds of observational experiments are suggested which require no special equipment. 200 illustrations; 42 photos. xvi + 362pp. 5⅜ x 8.
20196-1 Paperbound $2.75

THE STRANGE STORY OF THE QUANTUM, AN ACCOUNT FOR THE GENERAL READER OF THE GROWTH OF IDEAS UNDERLYING OUR PRESENT ATOMIC KNOWLEDGE, *B. Hoffmann*
Presents lucidly and expertly, with barest amount of mathematics, the problems and theories which led to modern quantum physics. Dr. Hoffmann begins with the closing years of the 19th century, when certain trifling discrepancies were noticed, and with illuminating analogies and examples takes you through the brilliant concepts of Planck, Einstein, Pauli, Broglie, Bohr, Schroedinger, Heisenberg, Dirac, Sommerfeld, Feynman, etc. This edition includes a new, long postscript carrying the story through 1958. "Of the books attempting an account of the history and contents of our modern atomic physics which have come to my attention, this is the best," H. Margenau, Yale University, in *American Journal of Physics*. 32 tables and line illustrations. Index. 275pp. 5⅜ x 8.
20518-5 Paperbound $2.00

GREAT IDEAS OF MODERN MATHEMATICS: THEIR NATURE AND USE, *Jagjit Singh*
Reader with only high school math will understand main mathematical ideas of modern physics, astronomy, genetics, psychology, evolution, etc. better than many who use them as tools, but comprehend little of their basic structure. Author uses his wide knowledge of non-mathematical fields in brilliant exposition of differential equations, matrices, group theory, logic, statistics, problems of mathematical foundations, imaginary numbers, vectors, etc. Original publication. 2 appendixes. 2 indexes. 65 ills. 322pp. 5⅜ x 8.
20587-8 Paperbound $2.50

THE MUSIC OF THE SPHERES: THE MATERIAL UNIVERSE — FROM ATOM TO QUASAR, SIMPLY EXPLAINED, *Guy Murchie*
Vast compendium of fact, modern concept and theory, observed and calculated data, historical background guides intelligent layman through the material universe. Brilliant exposition of earth's construction, explanations for moon's craters, atmospheric components of Venus and Mars (with data from recent fly-by's), sun spots, sequences of star birth and death, neighboring galaxies, contributions of Galileo, Tycho Brahe, Kepler, etc.; and (Vol. 2) construction of the atom (describing newly discovered sigma and xi subatomic particles), theories of sound, color and light, space and time, including relativity theory, quantum theory, wave theory, probability theory, work of Newton, Maxwell, Faraday, Einstein, de Broglie, etc. "Best presentation yet offered to the intelligent general reader," *Saturday Review*. Revised (1967). Index. 319 illustrations by the author. Total of xx + 644pp. 5⅜ x 8½.
21809-0, 21810-4 Two volume set, paperbound $5.00

FOUR LECTURES ON RELATIVITY AND SPACE, *Charles Proteus Steinmetz*
Lecture series, given by great mathematician and electrical engineer, generally considered one of the best popular-level expositions of special and general relativity theories and related questions. Steinmetz translates complex mathematical reasoning into language accessible to laymen through analogy, example and comparison. Among topics covered are relativity of motion, location, time; of mass; acceleration; 4-dimensional time-space; geometry of the gravitational field; curvature and bending of space; non-Euclidean geometry. Index. 40 illustrations. x + 142pp. 5⅜ x 8½. 61771-8 Paperbound $1.50

HOW TO KNOW THE WILD FLOWERS, *Mrs. William Starr Dana*
Classic nature book that has introduced thousands to wonders of American wild flowers. Color-season principle of organization is easy to use, even by those with no botanical training, and the genial, refreshing discussions of history, folklore, uses of over 1,000 native and escape flowers, foliage plants are informative as well as fun to read. Over 170 full-page plates, collected from several editions, may be colored in to make permanent records of finds. Revised to conform with 1950 edition of Gray's Manual of Botany. xlii + 438pp. 5⅜ x 8½. 20332-8 Paperbound $2.50

MANUAL OF THE TREES OF NORTH AMERICA, *Charles Sprague Sargent*
Still unsurpassed as most comprehensive, reliable study of North American tree characteristics, precise locations and distribution. By dean of American dendrologists. Every tree native to U.S., Canada, Alaska; 185 genera, 717 species, described in detail—leaves, flowers, fruit, winterbuds, bark, wood, growth habits, etc. plus discussion of varieties and local variants, immaturity variations. Over 100 keys, including unusual 11-page analytical key to genera, aid in identification. 783 clear illustrations of flowers, fruit, leaves. An unmatched permanent reference work for all nature lovers. Second enlarged (1926) edition. Synopsis of families. Analytical key to genera. Glossary of technical terms. Index. 783 illustrations, 1 map. Total of 982pp. 5⅜ x 8.
20277-1, 20278-X Two volume set, paperbound $6.00

IT'S FUN TO MAKE THINGS FROM SCRAP MATERIALS,
Evelyn Glantz Hershoff
What use are empty spools, tin cans, bottle tops? What can be made from
rubber bands, clothes pins, paper clips, and buttons? This book provides
simply worded instructions and large diagrams showing you how to make
cookie cutters, toy trucks, paper turkeys, Halloween masks, telephone sets,
aprons, linoleum block- and spatter prints — in all 399 projects! Many are easy
enough for young children to figure out for themselves; some challenging
enough to entertain adults; all are remarkably ingenious ways to make things
from materials that cost pennies or less! Formerly "Scrap Fun for Everyone."
Index. 214 illustrations. 373pp. 5⅜ x 8½. 21251-3 Paperbound $2.00

SYMBOLIC LOGIC and THE GAME OF LOGIC, *Lewis Carroll*
"Symbolic Logic" is not concerned with modern symbolic logic, but is instead
a collection of over 380 problems posed with charm and imagination, using
the syllogism and a fascinating diagrammatic method of drawing conclusions.
In "The Game of Logic" Carroll's whimsical imagination devises a logical game
played with 2 diagrams and counters (included) to manipulate hundreds of
tricky syllogisms. The final section, "Hit or Miss" is a lagniappe of 101 addi-
tional puzzles in the delightful Carroll manner. Until this reprint edition,
both of these books were rarities costing up to $15 each. Symbolic Logic:
Index. xxxi + 199pp. The Game of Logic: 96pp. 2 vols. bound as one. 5⅜ x 8.
 20492-8 Paperbound $2.50

MATHEMATICAL PUZZLES OF SAM LOYD, PART I
selected and edited by M. Gardner
Choice puzzles by the greatest American puzzle creator and innovator. Selected
from his famous collection, "Cyclopedia of Puzzles," they retain the unique
style and historical flavor of the originals. There are posers based on arithmetic,
algebra, probability, game theory, route tracing, topology, counter and sliding
block, operations research, geometrical dissection. Includes the famous "14-15"
puzzle which was a national craze, and his "Horse of a Different Color" which
sold millions of copies. 117 of his most ingenious puzzles in all. 120 line
drawings and diagrams. Solutions. Selected references. xx + 167pp. 5⅜ x 8.
 20498-7 Paperbound $1.35

STRING FIGURES AND HOW TO MAKE THEM, *Caroline Furness Jayne*
107 string figures plus variations selected from the best primitive and modern
examples developed by Navajo, Apache, pygmies of Africa, Eskimo, in Europe,
Australia, China, etc. The most readily understandable, easy-to-follow book in
English on perennially popular recreation. Crystal-clear exposition; step-by-
step diagrams. Everyone from kindergarten children to adults looking for
unusual diversion will be endlessly amused. Index. Bibliography. Introduction
by A. C. Haddon. 17 full-page plates, 960 illustrations. xxiii + 401pp. 5⅜ x 8½.
 20152-X Paperbound $2.50

PAPER FOLDING FOR BEGINNERS, *W. D. Murray and F. J. Rigney*
A delightful introduction to the varied and entertaining Japanese art of
origami (paper folding), with a full, crystal-clear text that anticipates every
difficulty; over 275 clearly labeled diagrams of all important stages in creation.
You get results at each stage, since complex figures are logically developed
from simpler ones. 43 different pieces are explained: sailboats, frogs, roosters,
etc. 6 photographic plates. 279 diagrams. 95pp. 5⅝ x 8⅜.
 20713-7 Paperbound $1.00

PRINCIPLES OF ART HISTORY,
H. Wölfflin
Analyzing such terms as "baroque," "classic," "neoclassic," "primitive," "picturesque," and 164 different works by artists like Botticelli, van Cleve, Dürer, Hobbema, Holbein, Hals, Rembrandt, Titian, Brueghel, Vermeer, and many others, the author establishes the classifications of art history and style on a firm, concrete basis. This classic of art criticism shows what really occurred between the 14th-century primitives and the sophistication of the 18th century in terms of basic attitudes and philosophies. "A remarkable lesson in the art of seeing," *Sat. Rev. of Literature*. Translated from the 7th German edition. 150 illustrations. 254pp. 6⅛ x 9¼. 20276-3 Paperbound $2.50

PRIMITIVE ART,
Franz Boas
This authoritative and exhaustive work by a great American anthropologist covers the entire gamut of primitive art. Pottery, leatherwork, metal work, stone work, wood, basketry, are treated in detail. Theories of primitive art, historical depth in art history, technical virtuosity, unconscious levels of patterning, symbolism, styles, literature, music, dance, etc. A must book for the interested layman, the anthropologist, artist, handicrafter (hundreds of unusual motifs), and the historian. Over 900 illustrations (50 ceramic vessels, 12 totem poles, etc.). 376pp. 5⅜ x 8. 20025-6 Paperbound $2.50

THE GENTLEMAN AND CABINET MAKER'S DIRECTOR,
Thomas Chippendale
A reprint of the 1762 catalogue of furniture designs that went on to influence generations of English and Colonial and Early Republic American furniture makers. The 200 plates, most of them full-page sized, show Chippendale's designs for French (Louis XV), Gothic, and Chinese-manner chairs, sofas, canopy and dome beds, cornices, chamber organs, cabinets, shaving tables, commodes, picture frames, frets, candle stands, chimney pieces, decorations, etc. The drawings are all elegant and highly detailed; many include construction diagrams and elevations. A supplement of 24 photographs shows surviving pieces of original and Chippendale-style pieces of furniture. Brief biography of Chippendale by N. I. Bienenstock, editor of *Furniture World*. Reproduced from the 1762 edition. 200 plates, plus 19 photographic plates. vi + 249pp. 9⅛ x 12¼. 21601-2 Paperbound $4.00

AMERICAN ANTIQUE FURNITURE: A BOOK FOR AMATEURS,
Edgar G. Miller, Jr.
Standard introduction and practical guide to identification of valuable American antique furniture. 2115 illustrations, mostly photographs taken by the author in 148 private homes, are arranged in chronological order in extensive chapters on chairs, sofas, chests, desks, bedsteads, mirrors, tables, clocks, and other articles. Focus is on furniture accessible to the collector, including simpler pieces and a larger than usual coverage of Empire style. Introductory chapters identify structural elements, characteristics of various styles, how to avoid fakes, etc. "We are frequently asked to name some book on American furniture that will meet the requirements of the novice collector, the beginning dealer, and . . . the general public. . . . We believe Mr. Miller's two volumes more completely satisfy this specification than any other work," *Antiques*. Appendix. Index. Total of vi + 1106pp. 7⅞ x 10¾.
 21599-7, 21600-4 Two volume set, paperbound $10.00

The Bad Child's Book of Beasts, More Beasts for Worse Children, and A Moral Alphabet, *H. Belloc*
Hardly and anthology of humorous verse has appeared in the last 50 years without at least a couple of these famous nonsense verses. But one must see the entire volumes — with all the delightful original illustrations by Sir Basil Blackwood — to appreciate fully Belloc's charming and witty verses that play so subacidly on the platitudes of life and morals that beset his day — and ours. A great humor classic. Three books in one. Total of 157pp. 5⅜ x 8.
20749-8 Paperbound $1.25

The Devil's Dictionary, *Ambrose Bierce*
Sardonic and irreverent barbs puncturing the pomposities and absurdities of American politics, business, religion, literature, and arts, by the country's greatest satirist in the classic tradition. Epigrammatic as Shaw, piercing as Swift, American as Mark Twain, Will Rogers, and Fred Allen, Bierce will always remain the favorite of a small coterie of enthusiasts, and of writers and speakers whom he supplies with "some of the most gorgeous witticisms of the English language" (H. L. Mencken). Over 1000 entries in alphabetical order. 144pp. 5⅜ x 8.
20487-1 Paperbound $1.25

The Complete Nonsense of Edward Lear.
This is the only complete edition of this master of gentle madness available at a popular price. *A Book of Nonsense, Nonsense Songs, More Nonsense Songs and Stories* in their entirety with all the old favorites that have delighted children and adults for years. The Dong With A Luminous Nose, The Jumblies, The Owl and the Pussycat, and hundreds of other bits of wonderful nonsense. 214 limericks, 3 sets of Nonsense Botany, 5 Nonsense Alphabets, 546 drawings by Lear himself, and much more. 320pp. 5⅜ x 8. 20167-8 Paperbound $1.75

The Wit and Humor of Oscar Wilde, *ed. by Alvin Redman*
Wilde at his most brilliant, in 1000 epigrams exposing weaknesses and hypocrisies of "civilized" society. Divided into 49 categories—sin, wealth, women, America, etc.—to aid writers, speakers. Includes excerpts from his trials, books, plays, criticism. Formerly "The Epigrams of Oscar Wilde." Introduction by Vyvyan Holland, Wilde's only living son. Introductory essay by editor. 260pp. 5⅜ x 8.
20602-5 Paperbound $1.50

A Child's Primer of Natural History, *Oliver Herford*
Scarcely an anthology of whimsy and humor has appeared in the last 50 years without a contribution from Oliver Herford. Yet the works from which these examples are drawn have been almost impossible to obtain! Here at last are Herford's improbable definitions of a menagerie of familiar and weird animals, each verse illustrated by the author's own drawings. 24 drawings in 2 colors; 24 additional drawings. vii + 95pp. 6½ x 6. 21647-0 Paperbound $1.00

The Brownies: Their Book, *Palmer Cox*
The book that made the Brownies a household word. Generations of readers have enjoyed the antics, predicaments and adventures of these jovial sprites, who emerge from the forest at night to play or to come to the aid of a deserving human. Delightful illustrations by the author decorate nearly every page. 24 short verse tales with 266 illustrations. 155pp. 6⅝ x 9¼.
21265-3 Paperbound $1.50

THE PRINCIPLES OF PSYCHOLOGY,
William James
The full long-course, unabridged, of one of the great classics of Western literature and science. Wonderfully lucid descriptions of human mental activity, the stream of thought, consciousness, time perception, memory, imagination, emotions, reason, abnormal phenomena, and similar topics. Original contributions are integrated with the work of such men as Berkeley, Binet, Mills, Darwin, Hume, Kant, Royce, Schopenhauer, Spinoza, Locke, Descartes, Galton, Wundt, Lotze, Herbart, Fechner, and scores of others. All contrasting interpretations of mental phenomena are examined in detail—introspective analysis, philosophical interpretation, and experimental research. "A classic," *Journal of Consulting Psychology.* "The main lines are as valid as ever," *Psychoanalytical Quarterly.* "Standard reading . . . a classic of interpretation," *Psychiatric Quarterly.* 94 illustrations. 1408pp. 5⅜ x 8.
20381-6, 20382-4 Two volume set, paperbound $6.00

VISUAL ILLUSIONS: THEIR CAUSES, CHARACTERISTICS AND APPLICATIONS,
M. Luckiesh
"Seeing is deceiving," asserts the author of this introduction to virtually every type of optical illusion known. The text both describes and explains the principles involved in color illusions, figure-ground, distance illusions, etc. 100 photographs, drawings and diagrams prove how easy it is to fool the sense: circles that aren't round, parallel lines that seem to bend, stationary figures that seem to move as you stare at them — illustration after illustration strains our credulity at what we see. Fascinating book from many points of view, from applications for artists, in camouflage, etc. to the psychology of vision. New introduction by William Ittleson, Dept. of Psychology, Queens College. Index. Bibliography. xxi + 252pp. 5⅜ x 8½.
21530-X Paperbound $1.75

FADS AND FALLACIES IN THE NAME OF SCIENCE,
Martin Gardner
This is the standard account of various cults, quack systems, and delusions which have masqueraded as science: hollow earth fanatics. Reich and orgone sex energy, dianetics, Atlantis, multiple moons, Forteanism, flying saucers, medical fallacies like iridiagnosis, zone therapy, etc. A new chapter has been added on Bridey Murphy, psionics, and other recent manifestations in this field. This is a fair, reasoned appraisal of eccentric theory which provides excellent inoculation against cleverly masked nonsense. "Should be read by everyone, scientist and non-scientist alike," R. T. Birge, Prof. Emeritus of Physics, Univ. of California; Former President, American Physical Society. Index. x + 365pp. 5⅜ x 8.
20394-8 Paperbound $2.00

ILLUSIONS AND DELUSIONS OF THE SUPERNATURAL AND THE OCCULT,
D. H. Rawcliffe
Holds up to rational examination hundreds of persistent delusions including crystal gazing, automatic writing, table turning, mediumistic trances, mental healing, stigmata, lycanthropy, live burial, the Indian Rope Trick, spiritualism, dowsing, telepathy, clairvoyance, ghosts, ESP, etc. The author explains and exposes the mental and physical deceptions involved, making this not only an exposé of supernatural phenomena, but a valuable exposition of characteristic types of abnormal psychology. Originally titled "The Psychology of the Occult." 14 illustrations. Index. 551pp. 5⅜ x 8. 20503-7 Paperbound $3.50

FAIRY TALE COLLECTIONS, *edited by Andrew Lang*
Andrew Lang's fairy tale collections make up the richest shelf-full of traditional children's stories anywhere available. Lang supervised the translation of stories from all over the world—familiar European tales collected by Grimm, animal stories from Negro Africa, myths of primitive Australia, stories from Russia, Hungary, Iceland, Japan, and many other countries. Lang's selection of translations are unusually high; many authorities consider that the most familiar tales find their best versions in these volumes. All collections are richly decorated and illustrated by H. J. Ford and other artists.

THE BLUE FAIRY BOOK. 37 stories. 138 illustrations. ix + 390pp. 5⅜ x 8½.
21437-0 Paperbound $1.95

THE GREEN FAIRY BOOK. 42 stories. 100 illustrations. xiii + 366pp. 5⅜ x 8½.
21439-7 Paperbound $2.00

THE BROWN FAIRY BOOK. 32 stories. 50 illustrations, 8 in color. xii + 350pp. 5⅜ x 8½.
21438-9 Paperbound $1.95

THE BEST TALES OF HOFFMANN, *edited by E. F. Bleiler*
10 stories by E. T. A. Hoffmann, one of the greatest of all writers of fantasy. The tales include "The Golden Flower Pot," "Automata," "A New Year's Eve Adventure," "Nutcracker and the King of Mice," "Sand-Man," and others. Vigorous characterizations of highly eccentric personalities, remarkably imaginative situations, and intensely fast pacing has made these tales popular all over the world for 150 years. Editor's introduction. 7 drawings by Hoffmann. xxxiii + 419pp. 5⅜ x 8½.
21793-0 Paperbound $2.25

GHOST AND HORROR STORIES OF AMBROSE BIERCE,
edited by E. F. Bleiler
Morbid, eerie, horrifying tales of possessed poets, shabby aristocrats, revived corpses, and haunted malefactors. Widely acknowledged as the best of their kind between Poe and the moderns, reflecting their author's inner torment and bitter view of life. Includes "Damned Thing," "The Middle Toe of the Right Foot," "The Eyes of the Panther," "Visions of the Night," "Moxon's Master," and over a dozen others. Editor's introduction. xxii + 199pp. 5⅜ x 8½.
20767-6 Paperbound $1.50

THREE GOTHIC NOVELS, *edited by E. F. Bleiler*
Originators of the still popular Gothic novel form, influential in ushering in early 19th-century Romanticism. Horace Walpole's *Castle of Otranto*, William Beckford's *Vathek*, John Polidori's *The Vampyre*, and a *Fragment* by Lord Byron are enjoyable as exciting reading or as documents in the history of English literature. Editor's introduction. xi + 291pp. 5⅜ x 8½.
21232-7 Paperbound $2.00

BEST GHOST STORIES OF LEFANU, *edited by E. F. Bleiler*
Though admired by such critics as V. S. Pritchett, Charles Dickens and Henry James, ghost stories by the Irish novelist Joseph Sheridan LeFanu have never become as widely known as his detective fiction. About half of the 16 stories in this collection have never before been available in America. Collection includes "Carmilla" (perhaps the best vampire story ever written), "The Haunted Baronet," "The Fortunes of Sir Robert Ardagh," and the classic "Green Tea." Editor's introduction. 7 contemporary illustrations. Portrait of LeFanu. xii + 467pp. 5⅜ x 8.
20415-4 Paperbound $2.50

EASY-TO-DO ENTERTAINMENTS AND DIVERSIONS WITH COINS, CARDS, STRING, PAPER AND MATCHES, *R. M. Abraham*
Over 300 tricks, games and puzzles will provide young readers with absorbing fun. Sections on card games; paper-folding; tricks with coins, matches and pieces of string; games for the agile; toy-making from common household objects; mathematical recreations; and 50 miscellaneous pastimes. Anyone in charge of groups of youngsters, including hard-pressed parents, and in need of suggestions on how to keep children sensibly amused and quietly content will find this book indispensable. Clear, simple text, copious number of delightful line drawings and illustrative diagrams. Originally titled "Winter Nights' Entertainments." Introduction by Lord Baden Powell. 329 illustrations. v + 186pp. 5⅜ x 8½. 20921-0 Paperbound $1.25

AN INTRODUCTION TO CHESS MOVES AND TACTICS SIMPLY EXPLAINED, *Leonard Barden*
Beginner's introduction to the royal game. Names, possible moves of the pieces, definitions of essential terms, how games are won, etc. explained in 30-odd pages. With this background you'll be able to sit right down and play. Balance of book teaches strategy — openings, middle game, typical endgame play, and suggestions for improving your game. A sample game is fully analyzed. True middle-level introduction, teaching you all the essentials without oversimplifying or losing you in a maze of detail. 58 figures. 102pp. 5⅜ x 8½. 21210-6 Paperbound $1.25

LASKER'S MANUAL OF CHESS, *Dr. Emanuel Lasker*
Probably the greatest chess player of modern times, Dr. Emanuel Lasker held the world championship 28 years, independent of passing schools or fashions. This unmatched study of the game, chiefly for intermediate to skilled players, analyzes basic methods, combinations, position play, the aesthetics of chess, dozens of different openings, etc., with constant reference to great modern games. Contains a brilliant exposition of Steinitz's important theories. Introduction by Fred Reinfeld. Tables of Lasker's tournament record. 3 indices. 308 diagrams. 1 photograph. xxx + 349pp. 5⅜ x 8.20640-8Paperbound $2.50

COMBINATIONS: THE HEART OF CHESS, *Irving Chernev*
Step-by-step from simple combinations to complex, this book, by a well-known chess writer, shows you the intricacies of pins, counter-pins, knight forks, and smothered mates. Other chapters show alternate lines of play to those taken in actual championship games; boomerang combinations; classic examples of brilliant combination play by Nimzovich, Rubinstein, Tarrasch, Botvinnik, Alekhine and Capablanca. Index. 356 diagrams. ix + 245pp. 5⅜ x 8½. 21744-2 Paperbound $2.00

HOW TO SOLVE CHESS PROBLEMS, *K. S. Howard*
Full of practical suggestions for the fan or the beginner — who knows only the moves of the chessmen. Contains preliminary section and 58 two-move, 46 three-move, and 8 four-move problems composed by 27 outstanding American problem creators in the last 30 years. Explanation of all terms and exhaustive index. "Just what is wanted for the student," Brian Harley. 112 problems, solutions. vi + 171pp. 5⅜ x 8. 20748-X Paperbound $1.50

SOCIAL THOUGHT FROM LORE TO SCIENCE,
H. E. Barnes and H. Becker
An immense survey of sociological thought and ways of viewing, studying,
planning, and reforming society from earliest times to the present. Includes
thought on society of preliterate peoples, ancient non-Western cultures, and
every great movement in Europe, America, and modern Japan. Analyzes hun-
dreds of great thinkers: Plato, Augustine, Bodin, Vico, Montesquieu, Herder,
Comte, Marx, etc. Weighs the contributions of utopians, sophists, fascists and
communists; economists, jurists, philosophers, ecclesiastics, and every 19th
and 20th century school of scientific sociology, anthropology, and social psy-
chology throughout the world. Combines topical, chronological, and regional
approaches, treating the evolution of social thought as a process rather than
as a series of mere topics. "Impressive accuracy, competence, and discrimina-
tion . . . easily the best single survey," *Nation.* Thoroughly revised, with new
material up to 1960. 2 indexes. Over 2200 bibliographical notes. Three volume
set. Total of 1586pp. 5⅜ x 8.
20901-6, 20902-4, 20903-2 Three volume set, paperbound $10.50

A HISTORY OF HISTORICAL WRITING, *Harry Elmer Barnes*
Virtually the only adequate survey of the whole course of historical writing
in a single volume. Surveys developments from the beginnings of historiog-
raphy in the ancient Near East and the Classical World, up through the
Cold War. Covers major historians in detail, shows interrelationship with
cultural background, makes clear individual contributions, evaluates and
estimates importance; also enormously rich upon minor authors and thinkers
who are usually passed over. Packed with scholarship and learning, clear, easily
written. Indispensable to every student of history. Revised and enlarged up
to 1961. Index and bibliography. xv + 442pp. 5⅜ x 8½.
20104-X Paperbound $3.00

JOHANN SEBASTIAN BACH, *Philipp Spitta*
The complete and unabridged text of the definitive study of Bach. Written
some 70 years ago, it is still unsurpassed for its coverage of nearly all aspects
of Bach's life and work. There could hardly be a finer non-technical introduc-
tion to Bach's music than the detailed, lucid analyses which Spitta provides
for hundreds of individual pieces. 26 solid pages are devoted to the B minor
mass, for example, and 30 pages to the glorious St. Matthew Passion. This
monumental set also includes a major analysis of the music of the 18th century:
Buxtehude, Pachelbel, etc. "Unchallenged as the last word on one of the
supreme geniuses of music," John Barkham, *Saturday Review Syndicate.* Total
of 1819pp. Heavy cloth binding. 5⅜ x 8.
22278-0, 22279-9 Two volume set, clothbound $15.00

BEETHOVEN AND HIS NINE SYMPHONIES, *George Grove*
In this modern middle-level classic of musicology Grove not only analyzes all
nine of Beethoven's symphonies very thoroughly in terms of their musical
structure, but also discusses the circumstances under which they were written,
Beethoven's stylistic development, and much other background material. This
is an extremely rich book, yet very easily followed; it is highly recommended
to anyone seriously interested in music. Over 250 musical passages. Index.
viii + 407pp. 5⅜ x 8.
20334-4 Paperbound $2.50

THE TIME STREAM
John Taine
Acknowledged by many as the best SF writer of the 1920's, Taine (under the name Eric Temple Bell) was also a Professor of Mathematics of considerable renown. Reprinted here are *The Time Stream*, generally considered Taine's best, *The Greatest Game*, a biological-fiction novel, and *The Purple Sapphire*, involving a supercivilization of the past. Taine's stories tie fantastic narratives to frameworks of original and logical scientific concepts. Speculation is often profound on such questions as the nature of time, concept of entropy, cyclical universes, etc. 4 contemporary illustrations. v + 532pp. 5⅜ x 8⅜.
21180-0 Paperbound $3.00

SEVEN SCIENCE FICTION NOVELS,
H. G. Wells
Full unabridged texts of 7 science-fiction novels of the master. Ranging from biology, physics, chemistry, astronomy, to sociology and other studies, Mr. Wells extrapolates whole worlds of strange and intriguing character. "One will have to go far to match this for entertainment, excitement, and sheer pleasure . . ."*New York Times*. Contents: The Time Machine, The Island of Dr. Moreau, The First Men in the Moon, The Invisible Man, The War of the Worlds, The Food of the Gods, In The Days of the Comet. 1015pp. 5⅜ x 8.
20264-X Clothbound $5.00

28 SCIENCE FICTION STORIES OF H. G. WELLS.
Two full, unabridged novels, *Men Like Gods* and *Star Begotten*, plus 26 short stories by the master science-fiction writer of all time! Stories of space, time, invention, exploration, futuristic adventure. Partial contents: *The Country of the Blind, In the Abyss, The Crystal Egg, The Man Who Could Work Miracles, A Story of Days to Come, The Empire of the Ants, The Magic Shop, The Valley of the Spiders, A Story of the Stone Age, Under the Knife, Sea Raiders,* etc. An indispensable collection for the library of anyone interested in science fiction adventure. 928pp. 5⅜ x 8.
20265-8 Clothbound $5.00

THREE MARTIAN NOVELS,
Edgar Rice Burroughs
Complete, unabridged reprinting, in one volume, of Thuvia, Maid of Mars; Chessmen of Mars; The Master Mind of Mars. Hours of science-fiction adventure by a modern master storyteller. Reset in large clear type for easy reading. 16 illustrations by J. Allen St. John. vi + 490pp. 5⅜ x 8½.
20039-6 Paperbound $2.50

AN INTELLECTUAL AND CULTURAL HISTORY OF THE WESTERN WORLD,
Harry Elmer Barnes
Monumental 3-volume survey of intellectual development of Europe from primitive cultures to the present day. Every significant product of human intellect traced through history: art, literature, mathematics, physical sciences, medicine, music, technology, social sciences, religions, jurisprudence, education, etc. Presentation is lucid and specific, analyzing in detail specific discoveries, theories, literary works, and so on. Revised (1965) by recognized scholars in specialized fields under the direction of Prof. Barnes. Revised bibliography. Indexes. 24 illustrations. Total of xxix + 1318pp.
21275-0, 21276-9, 21277-7 Three volume set, paperbound $7.75

HEAR ME TALKIN' TO YA, *edited by Nat Shapiro and Nat Hentoff*
In their own words, Louis Armstrong, King Oliver, Fletcher Henderson, Bunk Johnson, Bix Beiderbecke, Billy Holiday, Fats Waller, Jelly Roll Morton, Duke Ellington, and many others comment on the origins of jazz in New Orleans and its growth in Chicago's South Side, Kansas City's jam sessions, Depression Harlem, and the modernism of the West Coast schools. Taken from taped conversations, letters, magazine articles, other first-hand sources. Editors' introduction. xvi + 429pp. 5⅜ x 8½. 21726-4 Paperbound $2.50

THE JOURNAL OF HENRY D. THOREAU
A 25-year record by the great American observer and critic, as complete a record of a great man's inner life as is anywhere available. Thoreau's Journals served him as raw material for his formal pieces, as a place where he could develop his ideas, as an outlet for his interests in wild life and plants, in writing as an art, in classics of literature, Walt Whitman and other contemporaries, in politics, slavery, individual's relation to the State, etc. The Journals present a portrait of a remarkable man, and are an observant social history. Unabridged republication of 1906 edition, Bradford Torrey and Francis H. Allen, editors. Illustrations. Total of 1888pp. 8⅜ x 12¼.
20312-3, 20313-1 Two volume set, clothbound $30.00

A SHAKESPEARIAN GRAMMAR, *E. A. Abbott*
Basic reference to Shakespeare and his contemporaries, explaining through thousands of quotations from Shakespeare, Jonson, Beaumont and Fletcher, North's *Plutarch* and other sources the grammatical usage differing from the modern. First published in 1870 and written by a scholar who spent much of his life isolating principles of Elizabethan language, the book is unlikely ever to be superseded. Indexes. xxiv + 511pp. 5⅜ x 8½. 21582-2 Paperbound $3.00

FOLK-LORE OF SHAKESPEARE, *T. F. Thistelton Dyer*
Classic study, drawing from Shakespeare a large body of references to supernatural beliefs, terminology of falconry and hunting, games and sports, good luck charms, marriage customs, folk medicines, superstitions about plants, animals, birds, argot of the underworld, sexual slang of London, proverbs, drinking customs, weather lore, and much else. From full compilation comes a mirror of the 17th-century popular mind. Index. ix + 526pp. 5⅜ x 8½.
21614-4 Paperbound $3.25

THE NEW VARIORUM SHAKESPEARE, *edited by H. H. Furness*
By far the richest editions of the plays ever produced in any country or language. Each volume contains complete text (usually First Folio) of the play, all variants in Quarto and other Folio texts, editorial changes by every major editor to Furness's own time (1900), footnotes to obscure references or language, extensive quotes from literature of Shakespearian criticism, essays on plot sources (often reprinting sources in full), and much more.

HAMLET, *edited by H. H. Furness*
Total of xxvi + 905pp. 5⅜ x 8½.
21004-9, 21005-7 Two volume set, paperbound $5.50

TWELFTH NIGHT, *edited by H. H. Furness*
Index. xxii + 434pp. 5⅜ x 8½. 21189-4 Paperbound $2.75

LA BOHEME BY GIACOMO PUCCINI,
translated and introduced by Ellen H. Bleiler
Complete handbook for the operagoer, with everything needed for full enjoyment except the musical score itself. Complete Italian libretto, with new, modern English line-by-line translation—the only libretto printing all repeats; biography of Puccini; the librettists; background to the opera, Murger's La Boheme, etc.; circumstances of composition and performances; plot summary; and pictorial section of 73 illustrations showing Puccini, famous singers and performances, etc. Large clear type for easy reading. 124pp. 5⅜ x 8½.
20404-9 Paperbound $1.50

ANTONIO STRADIVARI: HIS LIFE AND WORK (1644-1737),
W. Henry Hill, Arthur F. Hill, and Alfred E. Hill
Still the only book that really delves into life and art of the incomparable Italian craftsman, maker of the finest musical instruments in the world today. The authors, expert violin-makers themselves, discuss Stradivari's ancestry, his construction and finishing techniques, distinguished characteristics of many of his instruments and their locations. Included, too, is story of introduction of his instruments into France, England, first revelation of their supreme merit, and information on his labels, number of instruments made, prices, mystery of ingredients of his varnish, tone of pre-1684 Stradivari violin and changes between 1684 and 1690. An extremely interesting, informative account for all music lovers, from craftsman to concert-goer. Republication of original (1902) edition. New introduction by Sydney Beck, Head of Rare Book and Manuscript Collections, Music Division, New York Public Library. Analytical index by Rembert Wurlitzer. Appendixes. 68 illustrations. 30 full-page plates. 4 in color. xxvi + 315pp. 5⅜ x 8½.
20425-1 Paperbound $3.00

MUSICAL AUTOGRAPHS FROM MONTEVERDI TO HINDEMITH,
Emanuel Winternitz
For beauty, for intrinsic interest, for perspective on the composer's personality, for subtleties of phrasing, shading, emphasis indicated in the autograph but suppressed in the printed score, the mss. of musical composition are fascinating documents which repay close study in many different ways. This 2-volume work reprints facsimiles of mss. by virtually every major composer, and many minor figures—196 examples in all. A full text points out what can be learned from mss., analyzes each sample. Index. Bibliography. 18 figures. 196 plates. Total of 170pp. of text. 7⅞ x 10¾.
21312-9, 21313-7 Two volume set, paperbound $5.00

J. S. BACH,
Albert Schweitzer
One of the few great full-length studies of Bach's life and work, and the study upon which Schweitzer's renown as a musicologist rests. On first appearance (1911), revolutionized Bach performance. The only writer on Bach to be musicologist, performing musician, and student of history, theology and philosophy, Schweitzer contributes particularly full sections on history of German Protestant church music, theories on motivic pictorial representations in vocal music, and practical suggestions for performance. Translated by Ernest Newman. Indexes. 5 illustrations. 650 musical examples. Total of xix + 928pp. 5⅜ x 8½.
21631-4, 21632-2 Two volume set, paperbound $5.00

THE METHODS OF ETHICS, *Henry Sidgwick*
Propounding no organized system of its own, study subjects every major methodological approach to ethics to rigorous, objective analysis. Study discusses and relates ethical thought of Plato, Aristotle, Bentham, Clarke, Butler, Hobbes, Hume, Mill, Spencer, Kant, and dozens of others. Sidgwick retains conclusions from each system which follow from ethical premises, rejecting the faulty. Considered by many in the field to be among the most important treatises on ethical philosophy. Appendix. Index. xlvii + 528pp. 5⅜ x 8½.
21608-X Paperbound $3.00

TEUTONIC MYTHOLOGY, *Jakob Grimm*
A milestone in Western culture; the work which established on a modern basis the study of history of religions and comparative religions. 4-volume work assembles and interprets everything available on religious and folkloristic beliefs of Germanic people (including Scandinavians, Anglo-Saxons, etc.). Assembling material from such sources as Tacitus, surviving Old Norse and Icelandic texts, archeological remains, folktales, surviving superstitions, comparative traditions, linguistic analysis, etc. Grimm explores pagan deities, heroes, folklore of nature, religious practices, and every other area of pagan German belief. To this day, the unrivaled, definitive, exhaustive study. Translated by J. S. Stallybrass from 4th (1883) German edition. Indexes. Total of lxxvii + 1887pp. 5⅜ x 8½.
21602-0, 21603-9, 21604-7, 21605-5 Four volume set, paperbound $12.00

THE I CHING, *translated by James Legge*
Called "The Book of Changes" in English, this is one of the Five Classics edited by Confucius, basic and central to Chinese thought. Explains perhaps the most complex system of divination known, founded on the theory that all things happening at any one time have characteristic features which can be isolated and related. Significant in Oriental studies, in history of religions and philosophy, and also to Jungian psychoanalysis and other areas of modern European thought. Index. Appendixes. 6 plates. xxi + 448pp. 5⅜ x 8½.
21062-6 Paperbound $2.75

HISTORY OF ANCIENT PHILOSOPHY, *W. Windelband*
One of the clearest, most accurate comprehensive surveys of Greek and Roman philosophy. Discusses ancient philosophy in general, intellectual life in Greece in the 7th and 6th centuries B.C., Thales, Anaximander, Anaximenes, Heraclitus, the Eleatics, Empedocles, Anaxagoras, Leucippus, the Pythagoreans, the Sophists, Socrates, Democritus (20 pages), Plato (50 pages), Aristotle (70 pages), the Peripatetics, Stoics, Epicureans, Sceptics, Neo-platonists, Christian Apologists, etc. 2nd German edition translated by H. E. Cushman. xv + 393pp. 5⅜ x 8.
20357-3 Paperbound $3.00

THE PALACE OF PLEASURE, *William Painter*
Elizabethan versions of Italian and French novels from *The Decameron*, Cinthio, Straparola, Queen Margaret of Navarre, and other continental sources — the very work that provided Shakespeare and dozens of his contemporaries with many of their plots and sub-plots and, therefore, justly considered one of the most influential books in all English literature. It is also a book that any reader will still enjoy. Total of cviii + 1,224pp.
21691-8, 21692-6, 21693-4 Three volume set, paperbound $8.25

The Wonderful Wizard of Oz, *L. F. Baum*
All the original W. W. Denslow illustrations in full color—as much a part of "The Wizard" as Tenniel's drawings are of "Alice in Wonderland." "The Wizard" is still America's best-loved fairy tale, in which, as the author expresses it, "The wonderment and joy are retained and the heartaches and nightmares left out." Now today's young readers can enjoy every word and wonderful picture of the original book. New introduction by Martin Gardner. A Baum bibliography. 23 full-page color plates. viii + 268pp. 5⅜ x 8.
20691-2 Paperbound $1.95

The Marvelous Land of Oz, *L. F. Baum*
This is the equally enchanting sequel to the "Wizard," continuing the adventures of the Scarecrow and the Tin Woodman. The hero this time is a little boy named Tip, and all the delightful Oz magic is still present. This is the Oz book with the Animated Saw-Horse, the Woggle-Bug, and Jack Pumpkinhead. All the original John R. Neill illustrations, 10 in full color. 287pp. 5⅜ x 8.
20692-0 Paperbound $1.75

Alice's Adventures Under Ground, *Lewis Carroll*
The original *Alice in Wonderland*, hand-lettered and illustrated by Carroll himself, and originally presented as a Christmas gift to a child-friend. Adults as well as children will enjoy this charming volume, reproduced faithfully in this Dover edition. While the story is essentially the same, there are slight changes, and Carroll's spritely drawings present an intriguing alternative to the famous Tenniel illustrations. One of the most popular books in Dover's catalogue. Introduction by Martin Gardner. 38 illustrations. 128pp. 5⅜ x 8½.
21482-6 Paperbound $1.00

The Nursery "Alice," *Lewis Carroll*
While most of us consider *Alice in Wonderland* a story for children of all ages, Carroll himself felt it was beyond younger children. He therefore provided this simplified version, illustrated with the famous Tenniel drawings enlarged and colored in delicate tints, for children aged "from Nought to Five." Dover's edition of this now rare classic is a faithful copy of the 1889 printing, including 20 illustrations by Tenniel, and front and back covers reproduced in full color. Introduction by Martin Gardner. xxiii + 67pp. 6⅛ x 9¼.
21610-1 Paperbound $1.75

The Story of King Arthur and His Knights, *Howard Pyle*
A fast-paced, exciting retelling of the best known Arthurian legends for young readers by one of America's best story tellers and illustrators. The sword Excalibur, wooing of Guinevere, Merlin and his downfall, adventures of Sir Pellias and Gawaine, and others. The pen and ink illustrations are vividly imagined and wonderfully drawn. 41 illustrations. xviii + 313pp. 6⅛ x 9¼.
21445-1 Paperbound $2.00

Prices subject to change without notice.

Available at your book dealer or write for free catalogue to Dept. Adsci, Dover Publications, Inc., 180 Varick St., N.Y., N.Y. 10014. Dover publishes more than 150 books each year on science, elementary and advanced mathematics, biology, music, art, literary history, social sciences and other areas.